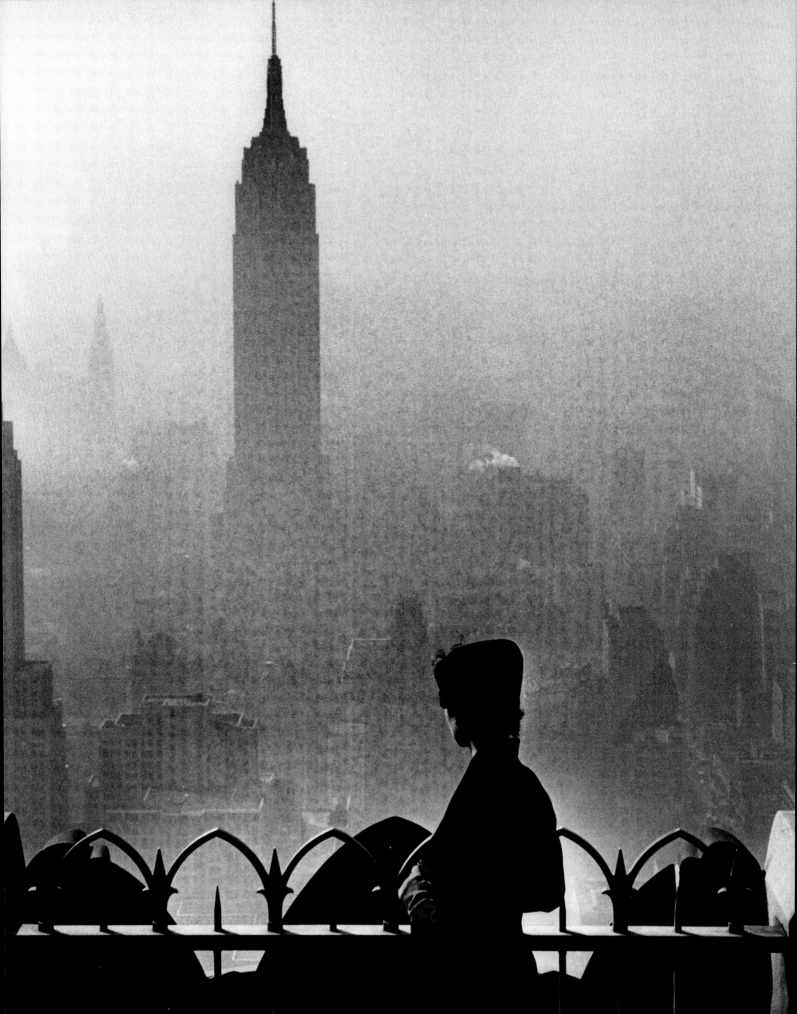

LIFE
The Seven Wonders
of the World

LIFE

Editor Robert Sullivan
Creative Director Ian Denning
Picture Editor Barbara Baker Burrows
Executive Editor Robert Andreas
Associate Picture Editor Christina Lieberman
Senior Reporter Hildegard Anderson
Writer-Reporter Lauren Nathan
Copy JC Choi (Chief), Mimi McGrath, Wendy Williams
Production Manager Michael Roseman
Picture Research Lauren Steel
Photo Assistant Joshua Colow
Consulting Picture Editors
Suzanne Hodgart (London), Mimi Murphy (Rome),
Tala Skari (Paris)

Publisher Andrew Blau
Director of Business Development Marta Bialek
Business Manager Craig Ettinger
Assistant Finance Manager Karen Tortora

Editorial Operations Richard K. Prue (Director), Richard Shaffer
(Manager), Brian Fellows, Raphael Joa, Stanley E. Moyse
(Supervisors), Keith Aurelio, Gregg Baker, Charlotte Coco,
Scott Dvorin, Kevin Hart, Rosalie Khan, Po Fung Ng, Barry Pribula,
David Spatz, Vaune Trachtman, Sara Wasilausky, David Weiner

Time Inc. Home Entertainment

President Rob Gursha
Vice President, Branded Businesses David Arfine
Vice President, New Product Development Richard Fraiman
Executive Director, Marketing Services Carol Pittard
Director, Retail & Special Sales Tom Mifsud
Director of Finance Tricia Griffin
Assistant Marketing Director Ann Marie Doherty
Prepress Manager Emily Rabin
Book Production Manager Jonathan Polsky
Associate Product Manager Jennifer Dowell

Special thanks to Bozena Bannett, Alex Bliss, Robert Dente,
Gina Di Meglio, Anne-Michelle Gallero, Peter Harper,
Suzanne Janso, Robert Marasco, Natalie McCrea,
Mary Jane Rigoroso, Steven Sandonato, Grace Sullivan

Published by

LIFE Books

Time Inc.
1271 Avenue of the Americas,
New York, NY 10020

ISBN: 1-932273-07-7
Library of Congress Control
Number: 2003105220

"LIFE" is a trademark
of Time Inc.

We welcome your comments
and suggestions about LIFE
Books. Please write to us at:
LIFE Books, Attention:
Book Editors, PO Box 11016,
Des Moines, IA 50336-1016

If you would like to order any
of our hardcover Collector's
Edition books, please call us
at 1-800-327-6388 (Monday
through Friday, 7:00 a.m.–
8:00 p.m. or Saturday, 7:00
a.m.–6:00 p.m. Central Time).

Please visit us, and sample
past editions of LIFE, at
www.LIFE.com.

Iconic images from the LIFE Picture Collection are now available as
fine art prints and posters. The prints are reproductions on archival,
resin-coated photographic paper, framed in black wood, with an
acid-free mat. Works by the famous LIFE photographers—Eisenstaedt,
Parks, Bourke-White, Burrows, among many others—are available.
The LIFE poster collection presents large-format, affordable, suitable-
for-framing images. For more information on the prints, priced
at $99 each, call 888-933-8873 or go to www.purchaseprints.com.
The posters may be viewed and ordered at www.LIFEposters.com.

The Seven Wonders of the
Ancient World

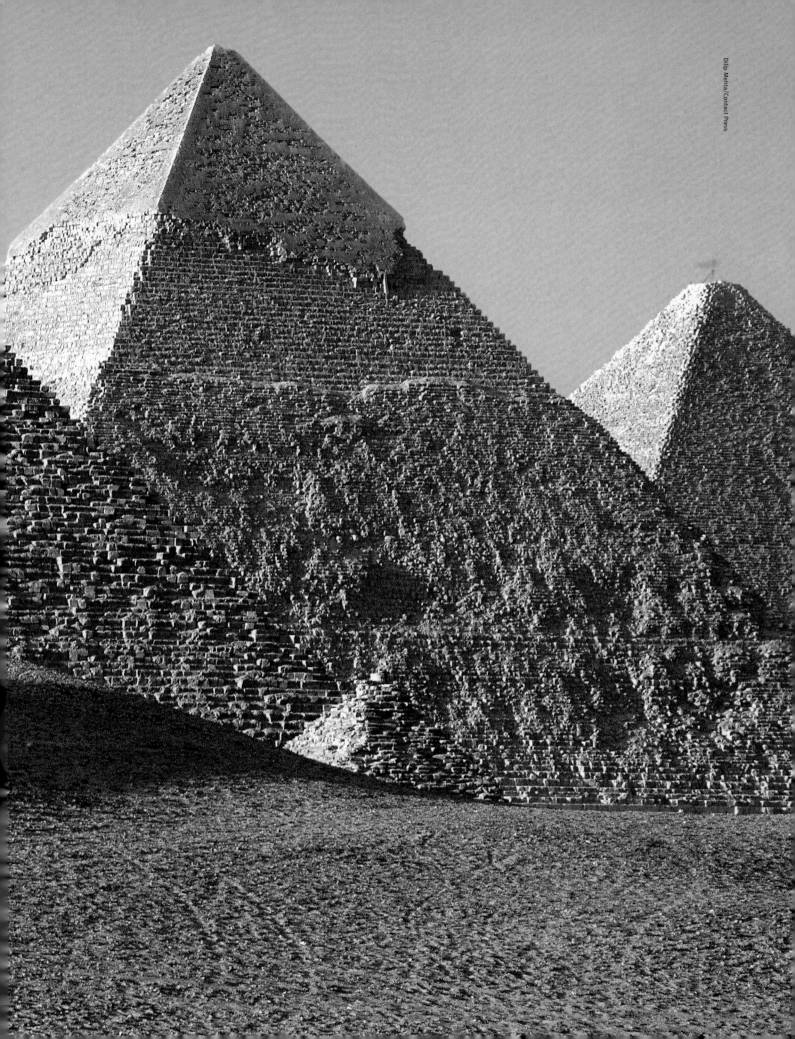

The **Magnificent** Seven

Even as we address the question "Why these seven?" it is reasonable to wonder, "Why seven?" We'll never know the answer to the first, for we don't know whom to ask. The Seven Wonders of the World, now often called the Seven Wonders of the Ancient World (to distinguish from the other lists of Wonders that have come in their wake), are ascribable to no single author. The idea of ranking man's (as opposed to God's) most wondrous creations can be traced all the way back to the 5th century B.C., when the Greek historian Herodotus of Halicarnassus, a well-traveled man, listed some must-sees in his *History*. These included the Great Pyramid of Khufu, which Herodotus had marveled at during a visit to Giza in Egypt around 450 B.C., the Hanging Gardens of Babylon, and other constructs. But Herodotus's was hardly the final list. In fact, four of the seven canonical Wonders didn't yet exist in his lifetime.

Again, why seven? Quite clearly because institutions and individuals of a mythological, religious, philosophical, scientific or superstitious bent have long esteemed the number. God rested on the seventh day; Apollo played a seven-stringed lyre; there are seven virtues and seven deadly sins. Seven is a sacred number in religious traditions such as Judaism and that of the Native American Lakotas. The Greek mathematician Pythagoras, who predated Herodotus by roughly a century, deemed seven both a lucky and a perfect number—prime, the sum of the already special numbers of three plus four. Sets of seven, from the seven priests with seven trumpets, to the seven seas to the seven hills of Rome, have always been seen as noble groupings. And so, seven Wonders.

But which seven? Even in the ancients' time and place, there were candidates galore. Athens's Parthenon, begun in 447 B.C., is not on the sanctioned list, nor is the Palace of Knossos on Crete, the ruins of which, quite as mind-boggling as Pharaoh's tomb, date to nearly 2000 B.C. It is easy to explain why the Great Wall of China, the Temple of Angkor Wat in Cambodia, the Inca city of Machu Picchu in Peru, England's Stonehenge and Easter Island's Moai Statues were not cited—the Greek listmakers could not have known they existed. But what debate ensued concerning Herodotus's choices? What discussion went on during the several subsequent edits of his list? We'll never know.

Particularly tantalizing and unknowable are the contents of a book called *A Collection of Wonders Around the World,* written in the 3rd century B.C. by Callimachus of Cyrene, chief librarian of the Alexandria Mouseion. All that survived the destruction of that library was the book's title. A century later, in the Phoenician city of Sidon, there was a minor poet named Antipater who also published an account of the world's Wonders. Like Herodotus, Antipater sought to serve as a Baedeker by recommending certain tourist sites that shouldn't be missed in one's lifetime. His seven included the Great Pyramid, which had been built c. 2551–2528 B.C.; both the Walls and Gardens of Babylon, dating from between 605 and 562 B.C.; Phidias's mammoth statue of Zeus, which rose in Olympia around 430 B.C.; the Temple of Artemis at Ephesus, completed circa 325 B.C.; the tomb of King Mausollos at Halicarnassus, finished in about 350 B.C.; and the Colossus of Rhodes, which first dominated that city's harbor in 282 B.C.

As we see, Antipater felt no obligation to limit his list to the antiquities: The last few would have been considered modern in his time. He also did not discriminate geographically: One of his Wonders was in Europe (Greece's Zeus), four in Asia (the two Babylon entries, plus the Artemis temple and mausoleum both in Asia Minor, now Turkey), one in Africa (the Egyptian pyramid) and one on an island in the Aegean Sea, Rhodes.

Antipater, in his day, had competition from other compilers, but his collection obviously caught the public's fancy and proved durable. Over the centuries commentators have urged additions and deletions; Rome's Colosseum was often nominated after it was dedicated in 80 A.D. But only Babylon's walls have fallen from the list, supplanted by the great lighthouse in the Egyptian port city Alexandria, built about the same time as Rhodes's Colossus.

The magnificent seven that we today regard as the Wonders of the Ancient World received their final codification late in the Middle Ages when Dutch architect and artist Maerten van Heemskerck (1498–1574), working from Greek source material, depicted them in a series of dramatic engravings. Since then, the list has traveled through time unchallenged. But the Wonders themselves have not. Natural and man-made forces have conspired to deprive the world of six of these tremendous achievements, and only one—the very oldest, the Great Pyramid—remains to thrill the modern traveler much as it did Herodotus some 25 centuries ago.

Optical illusions on the Giza plateau, where sit the great and near great. Previous pages: In the foreground is Menkaure's pyramid, then Khafre's, then Khufu's. In this aerial photo, Khufu's sits behind Khafre's. Though Khufu's is taller, Khafre challenged Dad by having his built on higher ground.

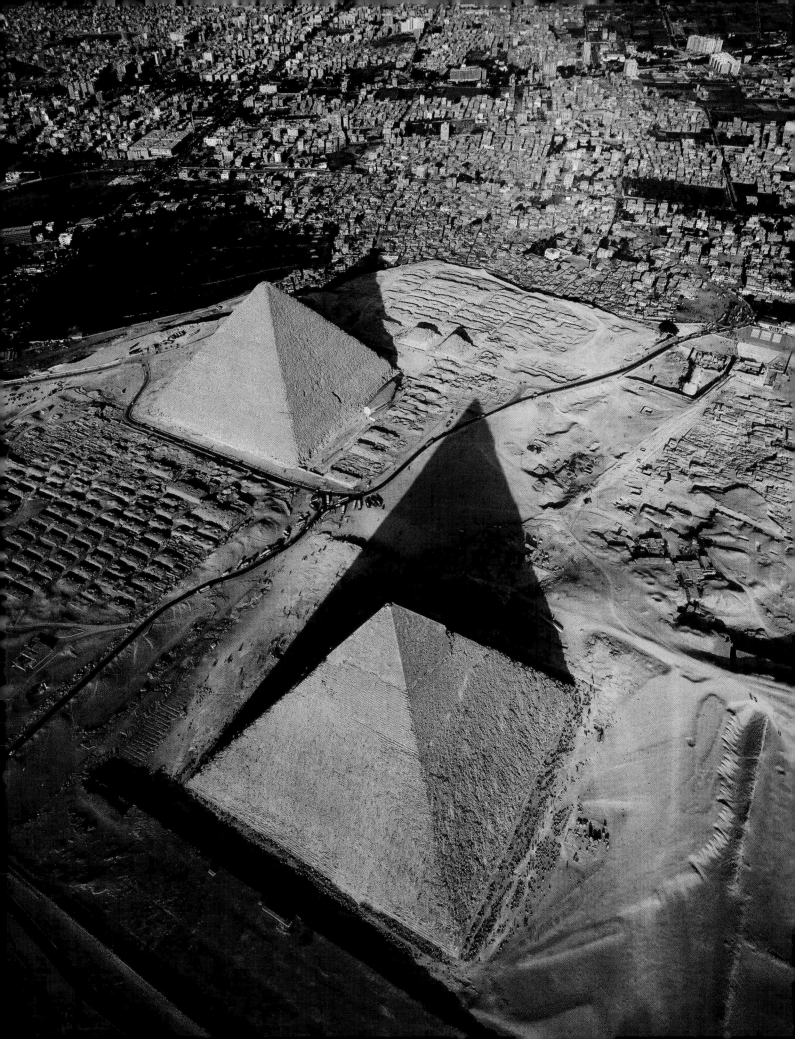

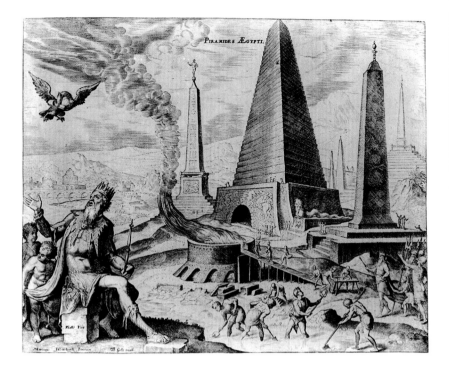

PIRAMIDES ÆGYPTI.

The Great Pyramid of Khufu

I n the eyes of man, it is the original Wonder, the Wonder from which all others descend. Prehistoric tribes on unknown islands or deep within unpenetrated forests surely constructed remarkable cities and spectacular totems to their God or gods. But this, a monumental tomb that Egypt's King Khufu ordered more than 4,500 years ago to honor and accommodate none but himself, is the Wonder of Wonders.

Khufu (c. 2551–2528 B.C.; also known as Cheops or Suphis) ruled for two dozen years during the Fourth Dynasty (2574–2465 B.C.) and was rumored to have been quite a tyrant. Beyond that, and the fact that he was the son of a pyramid-building king named Snefru, precious little is known. He clearly approved of Egypt's Old Kingdom tradition of erecting pyramid-shaped superstructures to encase royal tombs, and chose the plateau of Giza, on the west bank of the Nile across from Cairo, as the site for his own.

It is believed that 100,000 men, probably farmers displaced by the river's annual floods, worked on the pyramid for up to four months each year for at least 20 and perhaps 30 years. The word "toil" doesn't begin to tell the tale. Consider that the pyramid's 2,300,000 blocks of stone average 2.5 tons apiece (the heaviest are 15 tons; the smaller ones

The illustrations by Heemskerck, seven of which adorn this chapter, were quite influential in ratifying the final list of Wonders but were not necessarily true to form. The artist's Great Pyramid (above), drawn from later accounts, hardly resembled the real thing.

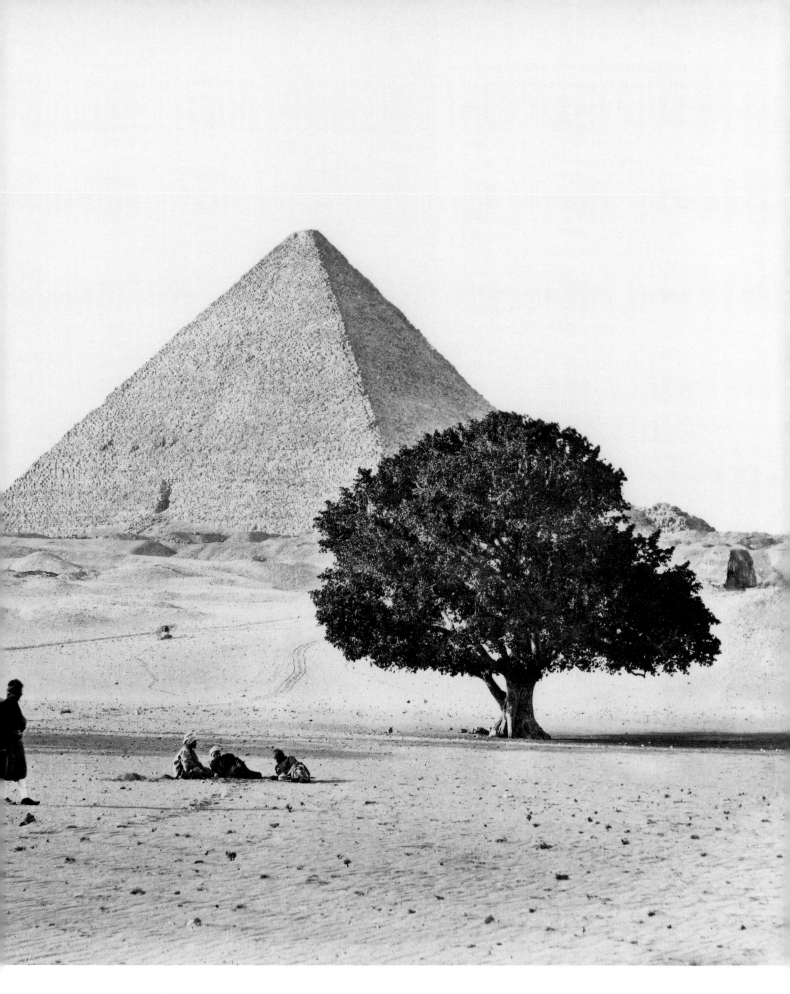

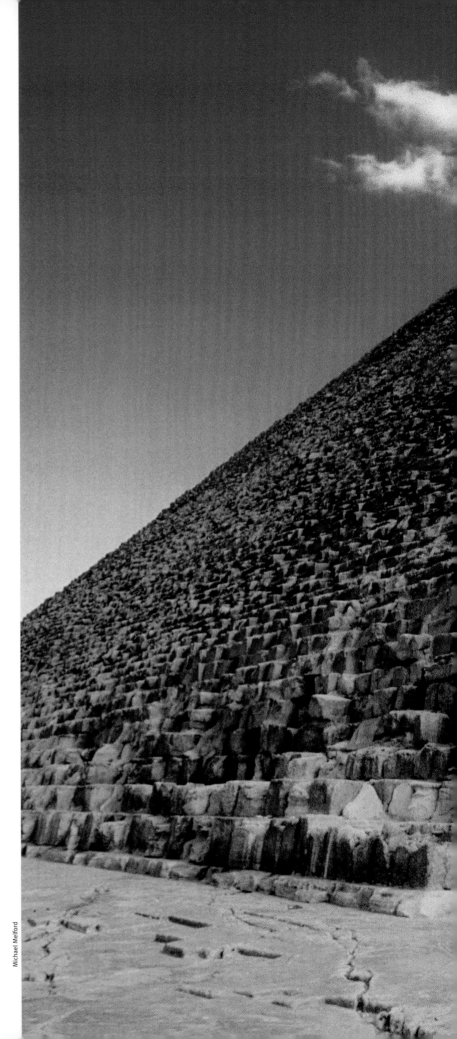

What is on display today in Giza is hardly a ruin, but it is something of a wreck—especially when compared with what once was. Imagine the Great Pyramid in Herodotus's day: thirty feet taller, still smooth on its flanks, its outer layer of finest limestone gleaming porcelain-white in the sun.

are placed nearer the top); consider that the blocks needed to be dragged by teams of men up ramps made of mud and brick, and that the ramps then had to be raised for the edifice's next level; consider that only the interior stones were quarried nearby because Khufu's architect wanted a better quality white limestone for his casing layer, and this high-grade rock needed to be brought from quarries on the other side of the Nile at Tura, then up from a harbor at the plateau's edge; consider that dense granite blocks were needed for the burial chamber in the pyramid's center and to serve as plugs for the corridors, and that the heavy granite could be supplied only by a quarry in Aswan, nearly 600 miles south; consider that the pyramid as designed was required to grow to a height of 481 feet (having lost its uppermost stones to Arab invaders circa 650 A.D., it is now about 450 feet tall) and that its base spread over some 13 acres . . . and then consider that ancient man, through blood, sweat and no doubt a considerable flow of tears, pulled it off. As a physical specimen it is a great Wonder (and was once even more wondrous, since its current eroded, uneven surface used to be perfectly smooth and white). And as a study in engineering and human endeavor, it is a marvel beyond compare.

There are other terrific structures and statuaries in the realm of Khufu's pyramid on the Giza plain, all installed between 2500 and 2400 B.C. Two other gargantuan pyramids contain the tombs of King Khafre, who was Khufu's son, and of King Menkaure. Nestled in the shadows of the three tremendous constructs are smaller but still grand pyramids containing the remains of the kings' several queens. And then there's the Great Sphinx, which lies serenely near Khafre's tomb and was probably built for him. But, properly, it is only Khufu's pyramid—the Great Pyramid, the highest building on earth for more than 43 centuries—that is considered a Wonder of the World. It is the Wonder by which all others are measured.

Michael Melford

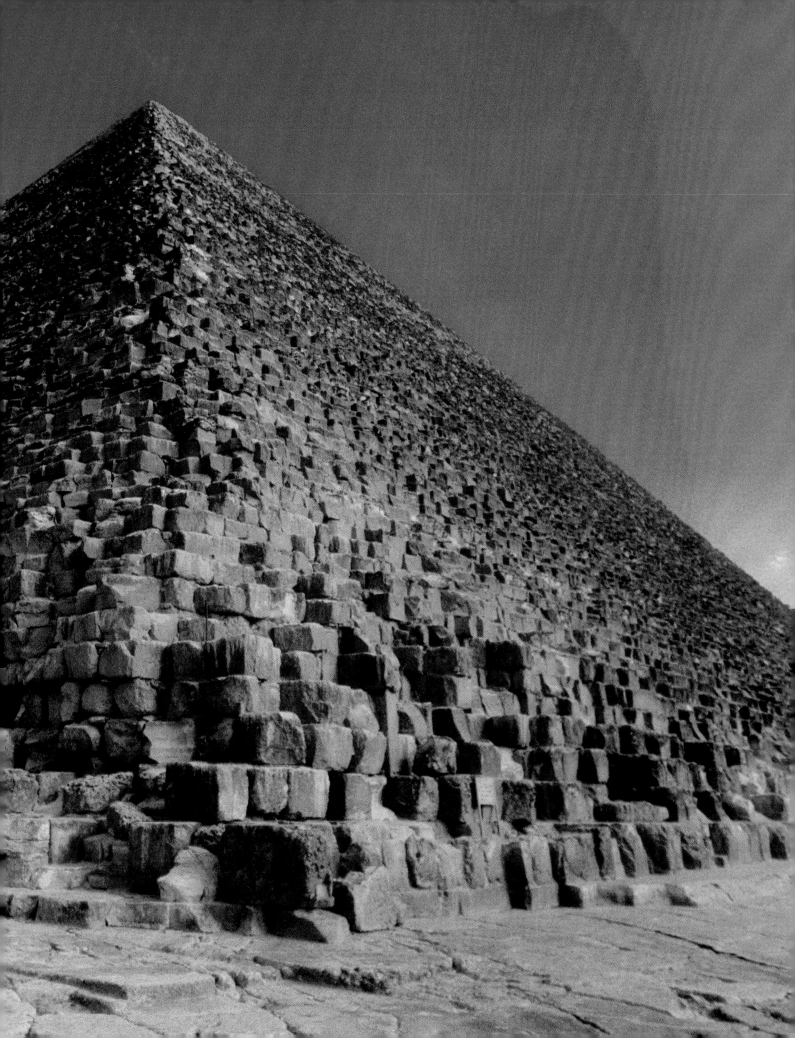

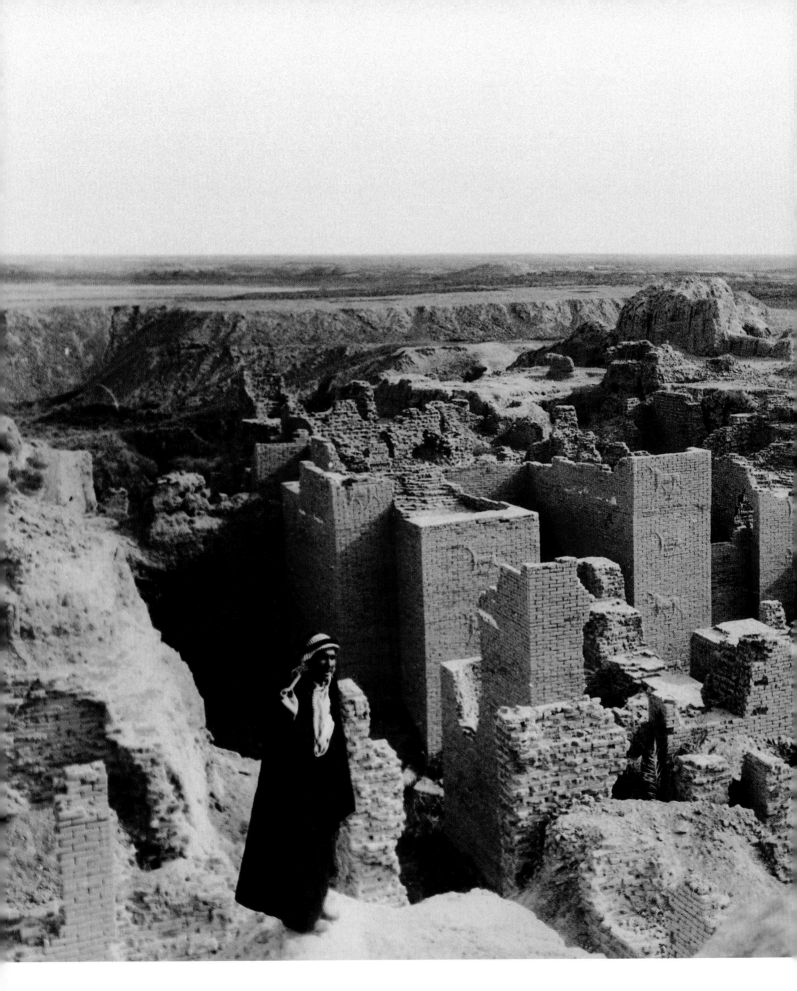

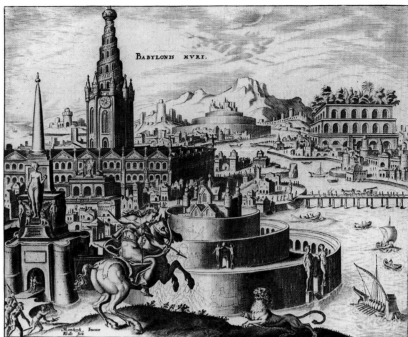

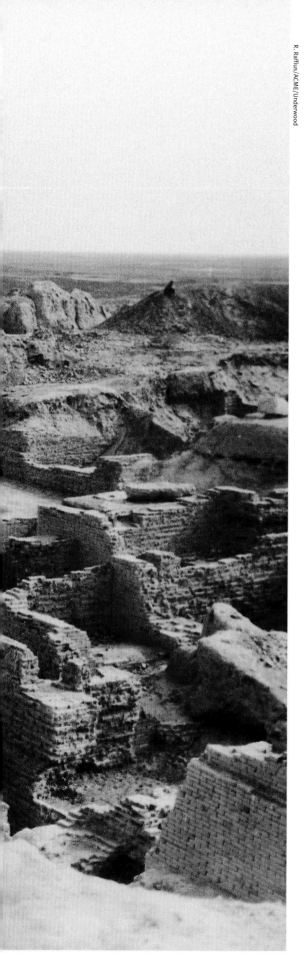

The Hanging Gardens of Babylon

There is no certainty that there were those gardens or a Tower of Babel, but digs have revealed the city's famous wall and the legendary tower gate called Ishtar, which is seen at the center of this 1932 photograph. Babylon was more compelling in ruins, before Saddam Hussein sought to spruce it up.

The story of the Hanging Gardens reads like a fairy tale, and that is as it should be. Set in the 6th century B.C., it goes like this: Nebuchadrezzar II, ruler of Babylon, senses that his wife's lassitude is due to the bland, baked Mesopotamian landscape, a dreary contrast to the lush mountain greenery of her Persian birthplace, Media. To ameliorate Amyitis's gloom, the king orders a fantastic, many-storied, brick-and-bitumen structure with terraces from which all manner of flora are to sprout, their life support being a complex irrigation system that draws water from the Euphrates. Amyitis is delighted by her husband's sympathetic gesture, and Nebuchadrezzar is pleased to see his wife's spirits brighten. Everyone in Babylon lives happily ever after (at least until Nebuchadrezzar dies in 562 B.C. and the kingdom begins a rapid decline that will lead to its conquest by the Persians in 539 B.C.).

Some of the above might actually have happened, or none of the above might have happened. There are no contemporaneous accounts of any majestic gardens, hanging or otherwise, and it is an interesting if melancholy fact that one of the most inspiring and poetic of the Seven Ancient Wonders may be purely mythical.

What we think we know of them, unconfirmed

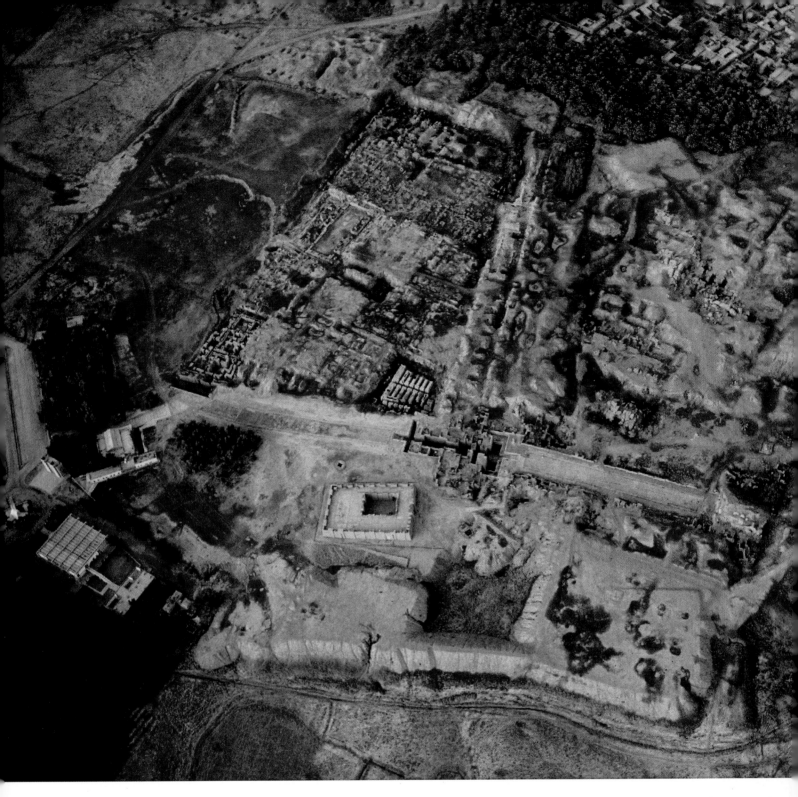

The Southern Palace was at left, the Northern at right. Were the gardens in vaulted structures found in the lower right quadrant of the Southern Palace? Or up top, near the river?

by any Babylonian cuneiform or the evidence in archaeological digs, springs from the accounts of Greeks writing just before the time of Christ's birth. Perhaps finally putting oral tradition to page, Strabo, a geographer, wrote, "It consists of vaulted terraces, raised one above another, and resting upon cube-shaped pillars. These are hollow and filled with earth to allow trees of the largest size to be planted." Quintus Curtius, who came after Strabo,

put the trees at "twelve feet in circumference, and fifty feet in height . . . Supporting these are twenty thick walls, eleven feet distant from each other, surmounted with ranges of stone arches, over which is extended a four-sided pavement of stone, strong enough to bear earth piled high, and water supplied for irrigation." The historian Diodorus Siculus wrote most gloriously of the entire effect: "This garden was four hundred feet square, and the ascent up to

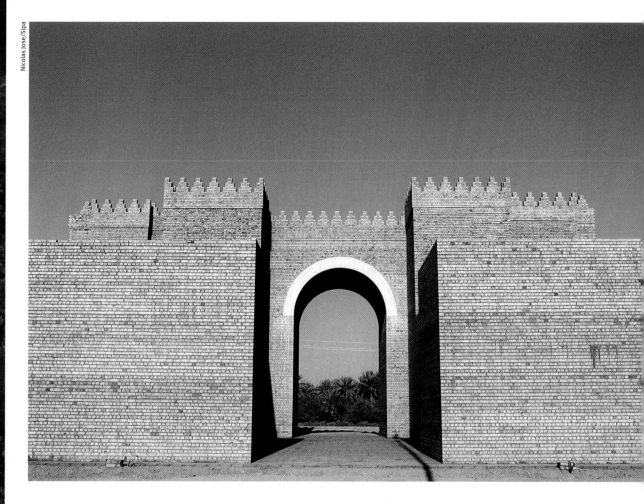

Nebuchadrezzar's seal was stamped onto bricks used in the original palace. Saddam's motto on the new stones read: "[R]econstructed during the era of the victorious Saddam Hussein . . . protector of the great Iraq, the modernizer of its renaissance and builder of its civilization."

it was as to the top of a mountain, and it had buildings and apartments, out of one into another, like unto a theater."

Stunning. If it ever existed.

In the ruins of ancient Babylon vaulted structures have been found within the site of the Southern Palace, and theories have blossomed. But while the city's famous surrounding wall has been located, the gardens have not been. Which isn't to say there haven't been believers. Saddam Hussein was one, and his harebrained scheme in the 1980s to rebuild Nebuchadrezzar's golden city as a sort of theme-park attraction—a project halted first by lack of funds and then by war—included not only a spanking new Ishtar Gate and a repaired wall, but also a Tower of Babel and, yes, Hanging Gardens.

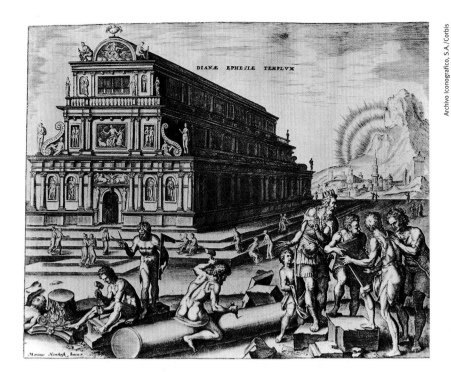

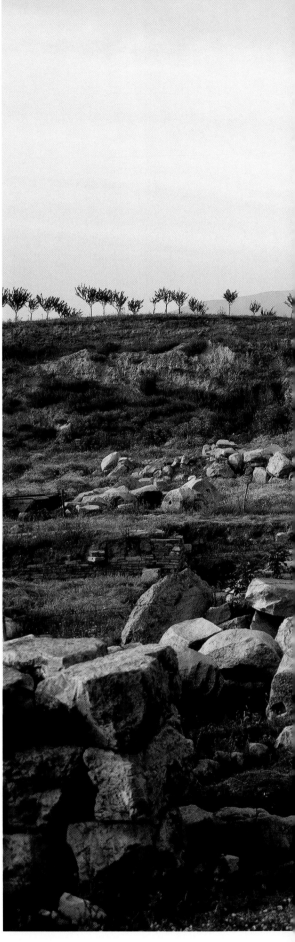

Archivo Iconografico, S.A./Corbis

The Temple of Artemis at Ephesus

Modern man may speculate as to what might have been the most sensational or beautiful—the most wondrous—of the Ancient Wonders. If, however, we lean on our listmaking friend Antipater of Sidon as supreme authority on the magnificent seven, then we have sworn testimony as to what might have held primacy of place. Antipater did have a personal favorite, and when you consider that such as Zeus, the Great Pyramid and the Colossus were in the running, it is perhaps a surprising one. "But when I saw the sacred house of Artemis that towers to the clouds," Antipater wrote rapturously, "the [other six Wonders] were placed in the shade, for the Sun himself has never looked upon its equal outside Olympus."

Artemis, goddess of fertility in Asia Minor, held a particular thrall in Ephesus, a city approximately 30 miles south of what is now the Turkish city of Izmir. (As evidence of Artemis's power in the area, consider that, when Saint Paul tried evangelizing in Ephesus in the wake of Christ's dramatic life, he couldn't budge the locals from their devotion to the goddess.) While the foundation of the temple that would honor her was built in the 7th century B.C., the base lay bare for decades until Croesus, the fabulously wealthy king of Lydia who had recently

The site of ancient Ephesus and the adjacent town of Selcuk are rife with ruins from various periods, piled up on one another. This Artemisian pillar stands very nearby the remains of a 6th century basilica built by Emperor Justinian, and just down the hill from a Byzantine fort built by the Turks.

conquered Ephesus, commissioned a plan from the architect Chersiphron. This man's masterwork was of marble and it was wider and longer than a football field—much larger than the Parthenon—and surrounded by rows of columns on four sides. There was a large altar in a separate building that faced the temple, and the entire site inspired deep reverence in worshipers of Artemis in much the same

Not all the Ancient Wonders have been as fortunate as the Temple of Artemis in the way that their artifacts have been preserved. Above: a column from Ephesus.

way that the Vatican influences Catholic pilgrims today.

Modern excavations have revealed that the goddess—and the temple—received offerings from pilgrims from as far away as Persia and India. But one man, clearly, was troubled by all this. After standing for two centuries, the temple was burned down in 356 B.C. by a disturbed individual named Hero-

Far right: a face from the temple, now in the British Museum. Near right: an Artemis from the museum at Ephesus. The Asia Minor Artemis was all about fertility. Here, her many breasts are fashioned after bulls' testicles.

stratus who was seeking either notoriety or immortality, or both. Artemis herself could not be so easily destroyed, and in the next several decades a similar but even larger temple, sponsored in part by Alexander the Great, the new conqueror of Persia, rose on the spot. In 262 A.D., the Goths wrecked this second iteration, and by then, Christianity was on the march, with converts being made day by day. When St. John Chrysostom ordered the temple destroyed for good in 401, it was the rare Ephesian who much cared. The city itself slowly followed its once glorious building into ruin, and the narrative of Antipater's favorite Wonder of the World was essentially forgotten until 19th century excavations rekindled interest, an interest that extends to the present day.

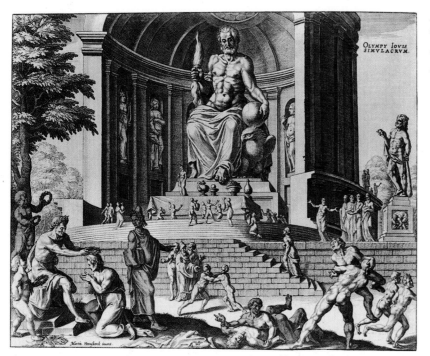

The Statue of Zeus at Olympia

In the 5th century B.C., a statue was wanted for a Doric temple that had been built in Olympia, a Grecian town best known for having hosted those eponymous athletic events every quadrennial since 776 B.C. The right man for the job was clearly Phidias, the Athenian sculptor who had mastered a technique for making massive replicas out of wood, ivory and gold, and whose 40-foot-tall statue of Athena was the main attraction in the Parthenon's central hall. Soon after that masterwork was dedicated in 438 B.C., Phidias ventured west and set up camp in Olympia, there to create Zeus.

In his workshop adjacent to the temple, he fashioned pieces of the statue's core, which would eventually contain 27,545 cubic feet of wood, for later assembly in the temple. To these would be affixed ivory and plates of gold. The figure that Phidias designed was of a seated Zeus, a scepter in his left hand. "On his head is a sculpted wreath of olive sprays," wrote Pausanias. "In his right hand he holds a figure of Victory made from ivory and gold . . . His sandals are made of gold, as is his robe."

The completed statue—40 feet tall upon a base 20 feet wide and three feet high, thoroughly filling the temple's west end—honored the god of gods, and drew flocks of worshipers to Olympia. However, when religious observance in the region changed

The foundation of the temple as it exists in ruins continues to impress, suggesting the power that the place, and its centerpiece statue, once held. Zeus's throne room was in the shaded area two thirds of the way up, as seen in the aerial photo at right.

with the rise of the Roman Empire, the statue's fate became questionable, even dicey. The emperor Caligula tried to have it moved to Rome in the 1st century A.D., but it proved impossible to build a scaffolding that would stand up to the task. In 393 the Christian emperor Theodosius I declared the Olympic Games a pagan extravaganza and shut

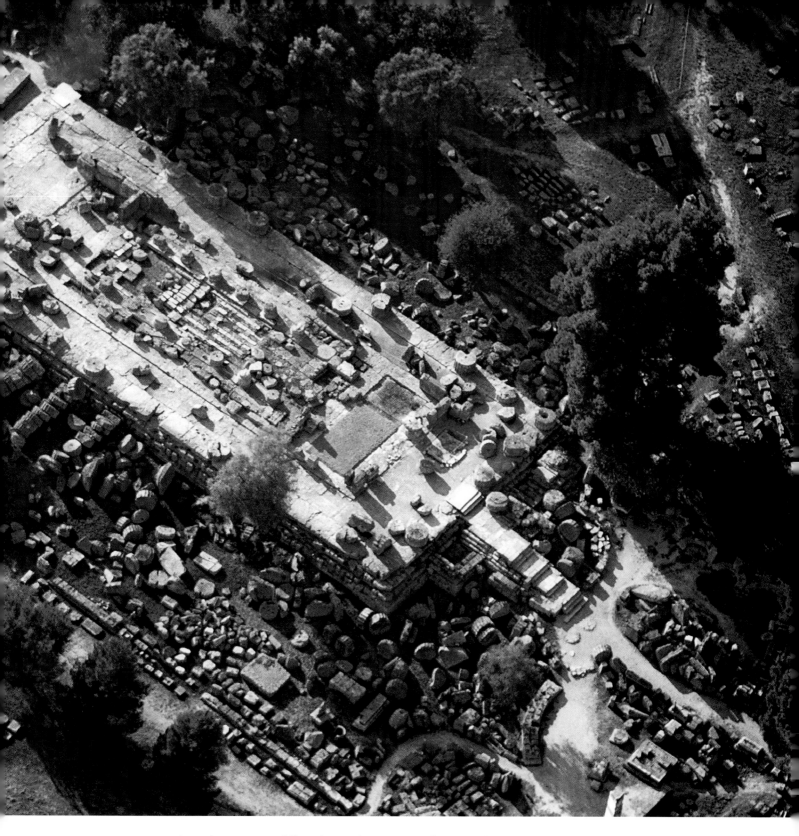

them down, meanwhile ordering the Zeus temple closed. One report has it that the statue was finally transported from Olympia to Constantinople, where it was consumed in a fire. Another maintains that Theodosius II ordered it and the temple demolished in the 5th century, and remnants of Zeus that existed in Olympia were pulverized in an earthquake. Fragments of the statue turned up in an 1875 dig. Later excavations found the site of Phidias's workshop and clay molds that served in making the statue of Zeus. They testify to an artistic creation of a superhuman scale, suggesting the awe Olympians must have felt for the giant god overlooking them from the hilltop.

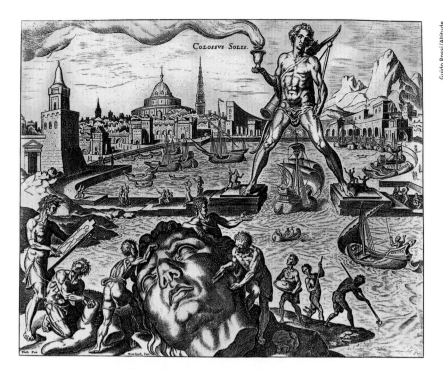

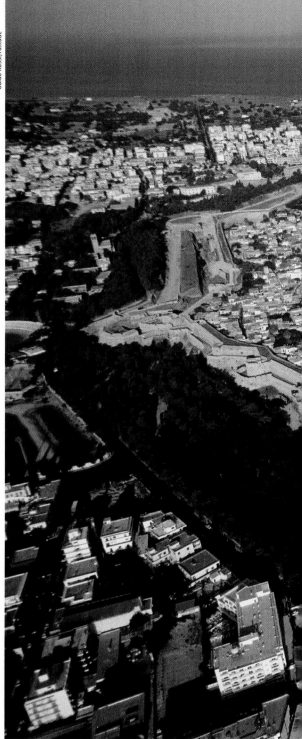

The Colossus of Rhodes

But even lying on the ground, it is a marvel," observed Pliny the Elder. Good thing, for the Colossus was upright for a mere 60 years or so, the shortest-lived Wonder of the Ancient Wonders (unless, of course, the Hanging Gardens never lived at all).

By accounts, it was a celebratory tribute to the Greek sun god Helios, patron of the island of Rhodes, just off what is now Turkey in the Aegean. After successfully weathering a siege and reaching a peace agreement with the expansionist Macedonians in 304 B.C., the Rhodians decided to build a statue. Planning took several years, and construction another dozen. No machine existed to hoist materials, so a hill surrounding the statue had to be built higher at each stage, and as much as 10 tons of iron (for the frame) and 15 tons of hammered bronze (for the skin) were brought up and put in place. With sun rays crowning Helios's head, the 110-foot-tall Colossus was finished in 282 B.C.

In the years after its untimely demise, Colossus was usually depicted as straddling the entrance to Mandraki's harbor, one of the principal gateways to Rhodes. This was almost certainly not the case in antiquity. Such a Colossus would have been impossibly huge, even if his legs were spread very, very wide. And when he collapsed, as this Helios

Heemskerck depicted the Colossus in the classical, impossible pose; today, bronze deer on the pillars are said to mark the footprints (opposite, with Fort St. Nicholas in the background). Circa 226 B.C., a violent tremor shook Rhodes, and the big guy suffered a knee injury. With such huge statuary, a lower joint is among the weakest points, and the Colossus came crashing down.

did, he would have blocked entrance to the harbor—and there is no written or other evidence of this. The Colossus was probably on a point east of Mandraki, or elsewhere in Rhodes.

The ruins of Rhodes's monument lay in state for nearly a thousand years. In 654 A.D., Arabs invaded, sacked and sold the Colossus's remaining parts to a Syrian. It was said that 900 camels were required to transport the metal from the island.

The question many have asked, inspired by old

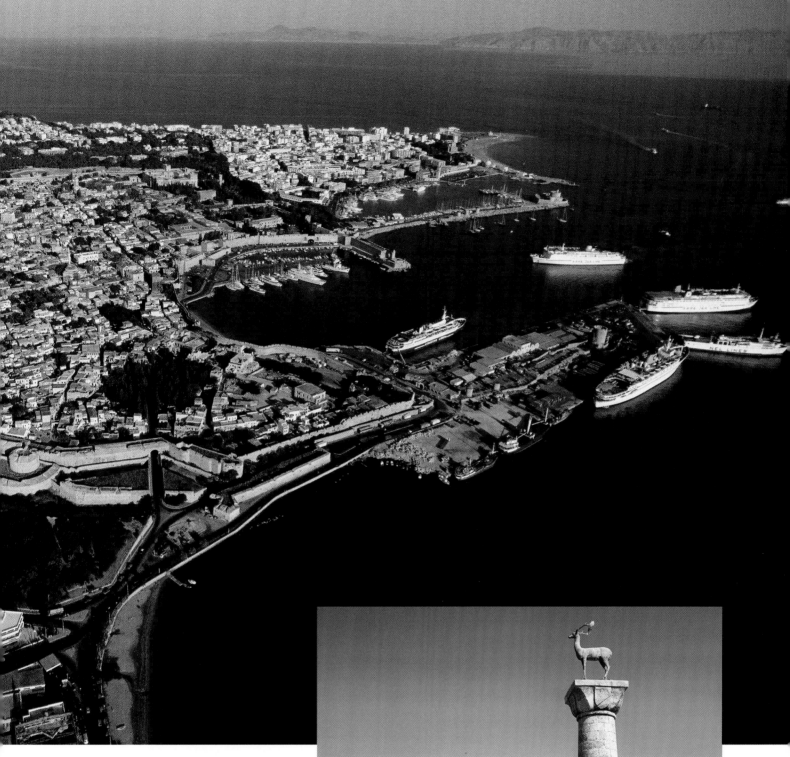

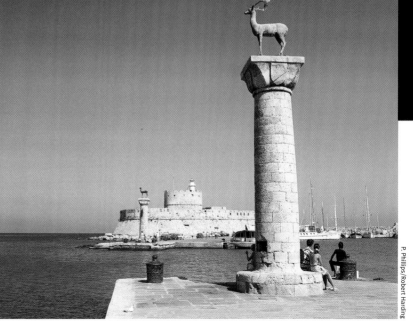

P. Phillips/Robert Harding

etchings and engravings, appears to have a simple answer, and that is yes. The Colossus of Rhodes did inspire French sculptor Frédéric-Auguste Bartholdi when, in the 19th century, he fashioned his most famous work as an offering to the United States of America. The Statue of Liberty was not only Colossal in conception; in framework and covering, it was built in much the same way, extraordinary testimony to the engineering and artistry that was in effect so long, long ago.

MAVSOLÆVM

The Mausoleum at Halicarnassus

It might be supposed that this structure had everything to do with King Mausollos of Caria, not least since the grandiose tomb bequeathed to the world a word for all grandiose tombs, and did so in his name. But, in fact, the construction of the world's first mausoleum has as much to do with a woman named Artemisia, who was Mausollos's sister, wife and grief-stricken widow.

Mausollos, a leader of the kingdom of Caria in Asia Minor in the 4th century B.C., was a study in contrasts, a man from a society of shepherds and rustics who, himself, had Grecian impulses and manners; a ruthless warlord who nevertheless dreamed of a Greek and non-Greek brotherhood, and who tried to build his capital in Halicarnassus into a mini-Athens. Besides the marvelous brick-and-marble palace that rose there for Mausollos and Artemisia, other public works during his tenure included a splendid shrine of Apollo and a park by the waterfront worthy of any resort destination.

Mausollos died in 353 B.C. Either just before or just after, Artemisia commissioned a memorial suitable for her sibling-spouse. She would not challenge the pyramid-mad Egyptians in erecting the world's biggest tomb but would outdo them in style. She pillaged Greece for its best architects and artists, assembling a veritable all-star roster. Pythias drew

When these statues were discovered during digs at Halicarnassus, the initial excitement held that they were of King Mausollos and Queen Artemisia. It is believed today that they represent nothing more than noble Carian citizens. The statues are now at the British Museum.

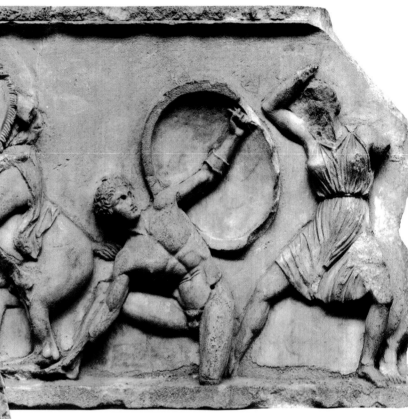

designs; Timotheus, Bryaxis and Leochares made statues. Scopas, sculptor of sculptors, left his job at the Temple of Artemis at Ephesus to help with this other major project. The fruits of their labor—a six-acre site whose focus was a burial chamber encased within a temple, which sat upon a 125-by-105-foot podium and included a crowning 24-step pyramid with a four-horse chariot statue for a hat—were beyond stunning.

The tomb was unfinished when Artemisia followed Mausollos to the grave in 351 B.C. But the craftsmen stayed on because they felt they were working on something special, a sublime resting place for the king and queen. They did rest in peace for many centuries. An earthquake shook them up along the way, knocking blocks from the mausoleum's roof, but it wasn't until the Crusades of the late 15th century that the tomb came under mortal pressure. The invading Knights of St. John of Malta decided to build a castle. In 1494 they began disassembling the temple, and by 1522 all major stones had been carted away for other uses.

Today, a foundation and a few ruins in Halicarnassus hint at what once was. In the still-standing crusader castle in nearby Bodrum, massive marble blocks glisten, whispering that they were intended for Mausollos, with love, from Artemisia.

Remarkable sculptures and friezes reflecting Mausollos's schizophrenic war's-inevitable, give-peace-a-chance weltanschauung were everywhere in the tomb. Top: The Greeks battle the amazons.

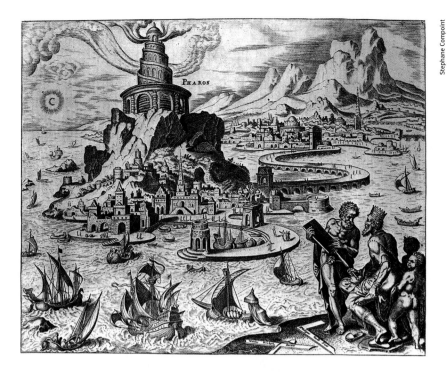

Stephane Compoint

The Pharos of Alexandria

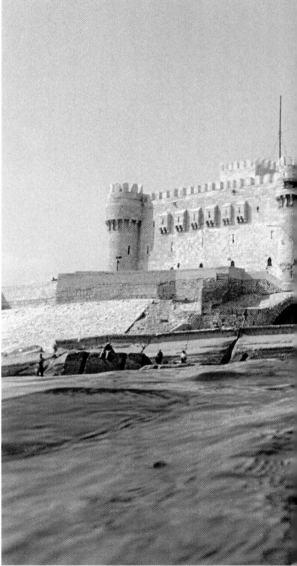

First an island lent its name to a strange building, then the building gave the world a word meaning "lighthouse." The island in Alexandria's harbor was Pharos, and after two Egyptian rulers, Ptolemy I and II, oversaw construction of a skyscraper with a fire at its summit, the phrase "sailing in by Pharos" circulated among mariners. Soon the island and its beacon were synonymous, and today *faro* means lighthouse in Italian, while *phare* is the word in French.

Ptolemy I was Alexander the Great's successor and enjoyed a four-decade reign, during which Alexandria grew to be a golden city, the Paris or New York of its day. The bustle in Alexandria's port was increasing daily when, in 290 B.C., Ptolemy ordered a lighthouse built—one larger, more splendid and more effective than any other. The enormous project was already seven years old when Ptolemy died circa 283 B.C. His son and successor watched as perhaps another 15 years of work went into the lighthouse. Limestone and granite blocks of up to 75 tons were quarried and dragged to the site; newly devised hoisting systems, perhaps involving early cranes, lifted them into place while, elsewhere, sculptors fashioned immense statues of Poseidon and Ptolemy to grace the lighthouse. The lower, square tier was finished, then the octagonal

An earthquake destroyed the lighthouse in the 14th century. Remnants sat at the bottom of the bay till recent retrieval efforts began. (Right, part of the Pharos's door emerges.) A museum is planned, which is suitable: In its glory years, the Pharos, which could be climbed to the top of its second tier for a sublime view, was not only a Wonder—it was a top tourist site.

middle level and, finally, the cylindrical cupola to house the flame. The 400-plus-foot lighthouse, which finally came online circa 270 B.C., was the world's second tallest building after the Great Pyramid, and would retain that status for nearly 17 centuries. Even today it would stand proudly—if curiously—alongside 40-story office towers.

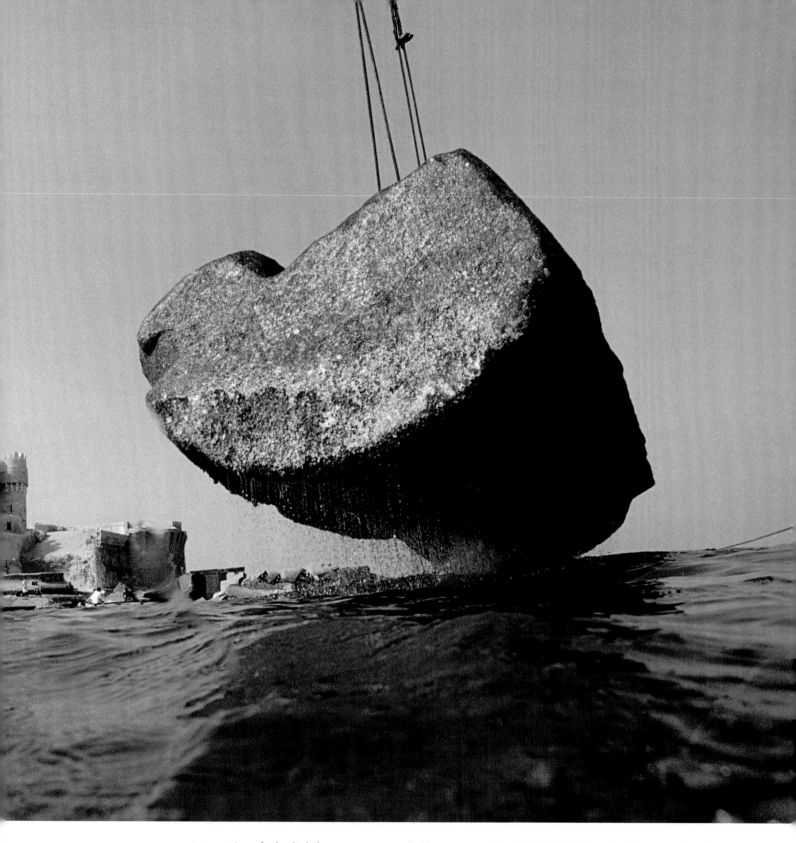

As mentioned, the lighthouse was remarkably long-lived, and so we have historical accounts. In the 10th century A.D., the Moorish scholar Idrisi offered this description: "It is kept lit night and day as a beacon for navigators throughout the whole sailing season; mariners know the fire and direct their course accordingly, for it is visible a day's sail away. By night it looks like a brilliant star; by day one can perceive its smoke." A day's sail in Idrisi's time could have been a hundred miles, so the Pharos's reach was vast indeed. Various reports have it that a large glass or a magnifying device of some other sort served to intensify the fire's glow—beckoning seamen, shouting of Alexandria's glory.

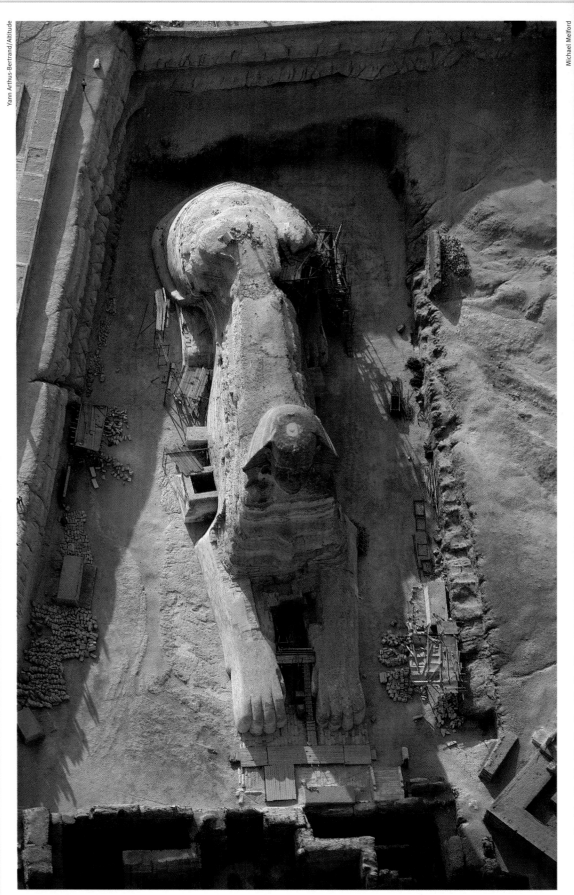

Sculpted from an outcropping of limestone, the Sphinx needs near-constant attention. Sand can fill back in (opposite, bottom). There have been at least four major clearings and several renovations.

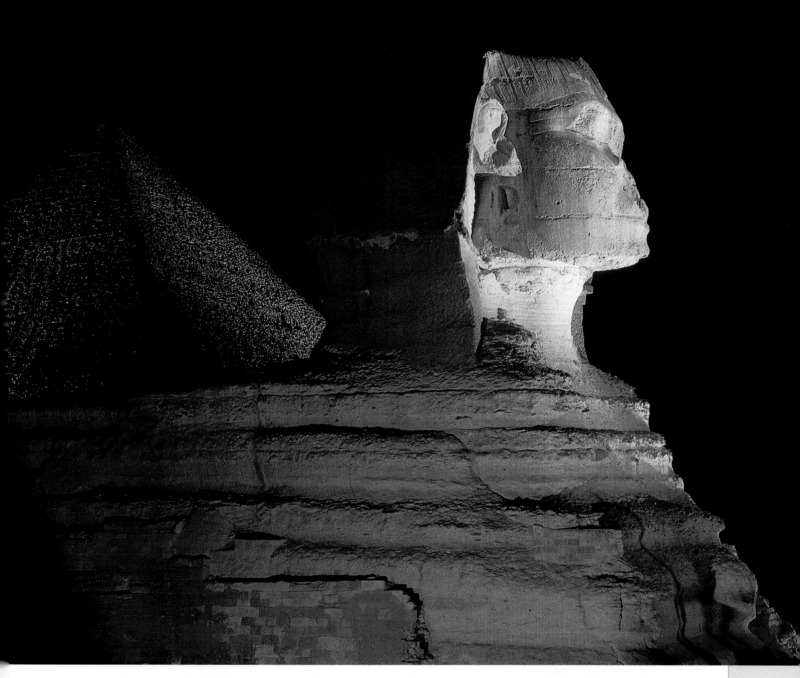

The Great Sphinx

Just as there were many pyramids built in Egypt, there were many sphinxes. The Greek word means "strangler," and applied originally to a hybrid with the head of a woman, the body of a lion and the wings of a bird. The so-called Great Sphinx, with its man's head, lies hard by Khafre's pyramid, and for centuries the theory was that this 240-foot-long, 66-foot-tall statue was another tribute to King Khufu's son. But in the late 20th century, doubts were raised about the monument's age. The Great Sphinx has its secrets, and isn't talking.

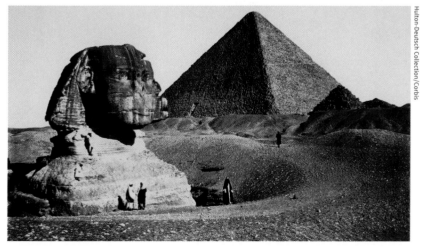

The Seven Wonders of the
Medieval Mind

One of the supreme accomplishments of any age, the Great Wall of China is at once awesome, inspired—and an eternal reminder of the hostilities that have haunted the peoples of our world.

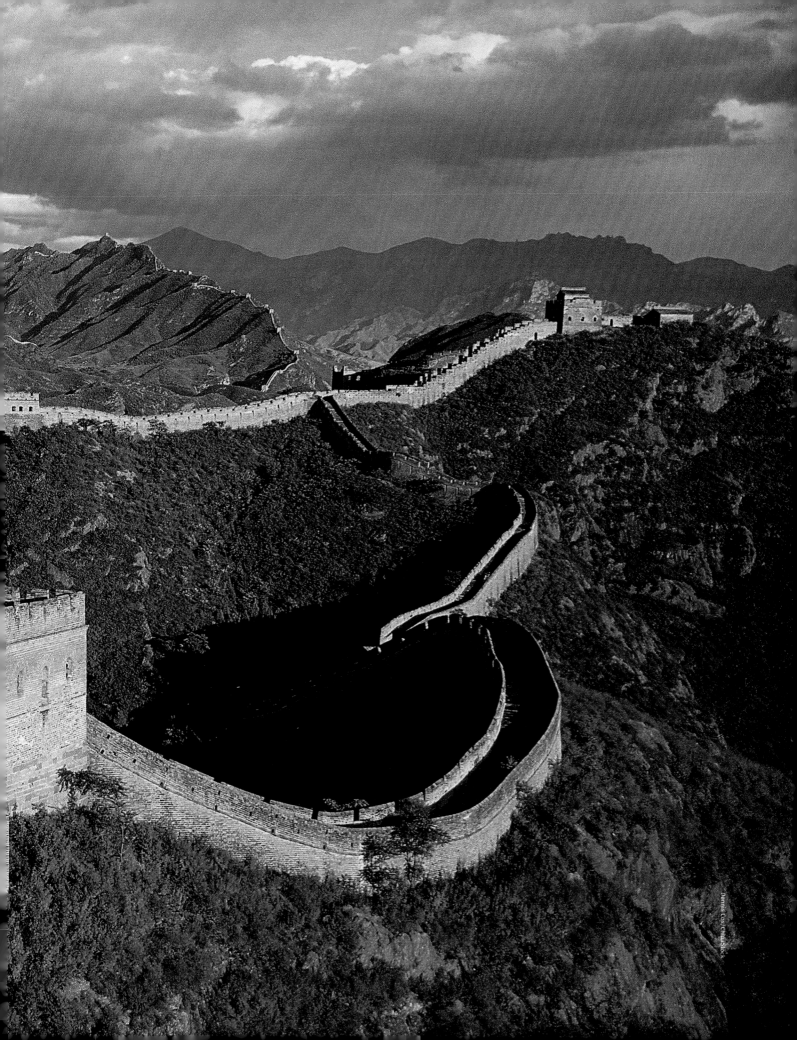

Mysteries of the **Middle Ages**

" Let barbarous Memphis speak no more of the pyramids, nor Assyrian toil boast of Babylon; nor let the soft Ionians be extolled for Artemis's temple; let the altar of many horns say nothing of Delos; nor let the Carians exalt to the skies with extravagant praises the Mausoleum poised in empty air. All labor yields to Caesar's Amphitheatre. Fame shall tell of one work in place of all. " — **Martial**

The parade of Wonders that was the classical Roman Empire sounded its coda in 410 A.D. when a leader known as Alaric the Visigoth sacked the great city. Although Rome, not yet Eternal, lingered in steady decay for a few more decades, any accomplishments of the once effulgent society were finally relegated to the whims of fate. What ensued is more than ever open to debate, but in essence the next thousand years saw the social and artistic achievements of Rome fall by the wayside. Europe, transformed from a place with an exemplary central point of leadership to a segmented area in the thrall of a Germanic tribal system, descended into its aptly termed Dark Ages. A leaden mantle settled for centuries over the land, and human attainments were in the main confined to survival. Each day, it seemed, was another gauntlet, fraught with famine, pestilence and floods, with dense, impenetrable forests and bogs rife with feral animals and . . . much, much worse . . . with demons.

This was not an epoch for mathematics, or theater, or demonstrations of athletic prowess. While it is true that some societies in this time found spiritual nourishment in Christendom, endless clashing between popes and emperors resulted in a European populace whose very imagination was provincial if not stillborn, enslaved to a world devoid of mobility, proper nutrition and intellectual progress. Generations of a given family lived together, in the same house, often accompanied by their livestock. Communities were tightly bound, sometimes even by stricture of oath. News from the outside was anything but new, and likely inaccurate. There were certainly adventurers—Marco Polo,

for example—but their impact on the continent was peripheral.

At long last, some light. Over many decades, Germanic tribalism grudgingly gave way to feudalism, guilds and an increasingly dominant Church, and improvements were realized in agriculture and general productivity. With the 12th and 13th centuries came developments in learning and building, travel and navigation. Feudal systems were transformed, and in their place rose potent city-states in Italy, along with monarchies in France, Spain and England. The Renaissance—another concept that is today being reconsidered and redefined, but which still signifies a profound florescence—was afoot.

Interestingly, the term "Middle Ages" didn't arise until the late 15th century when humanist scholars, feeling that they were on the brink of something vital, sought to herald their advances by putting a label on the previous era. In this attempt to distance themselves from the murky prior time period, and thereby to diminish it, they succeeded; and yet the Middle Ages—a full millennium of human history—remain significant by their sheer dint, and indispensable if one is to appreciate who and what came both before and after.

Even as some late Middle Age historians put a final stamp of approval on a codified list of the Ancient Wonders, others, equally anonymous, came up with this second list—the Wonders of the Medieval Mind. That only some of this second septet were in fact created during the Middle Ages provides a delightful if disarming clue to the nature of what the world was like, both during its darkest days and in the brighter ones immediately following. These Wonders allow us to peer into the minds of Medieval man, and to consider what he accomplished—and what he wished he had.

This aerial photograph of the Colosseum, which was taken in 1956, provides an excellent sense of the Roman Wonder as a distinctly urban phenomenon, as indeed it was when it was created so many centuries ago. Rabid fans came from all over to see the elaborate spectacles.

Bettmann/Corbis

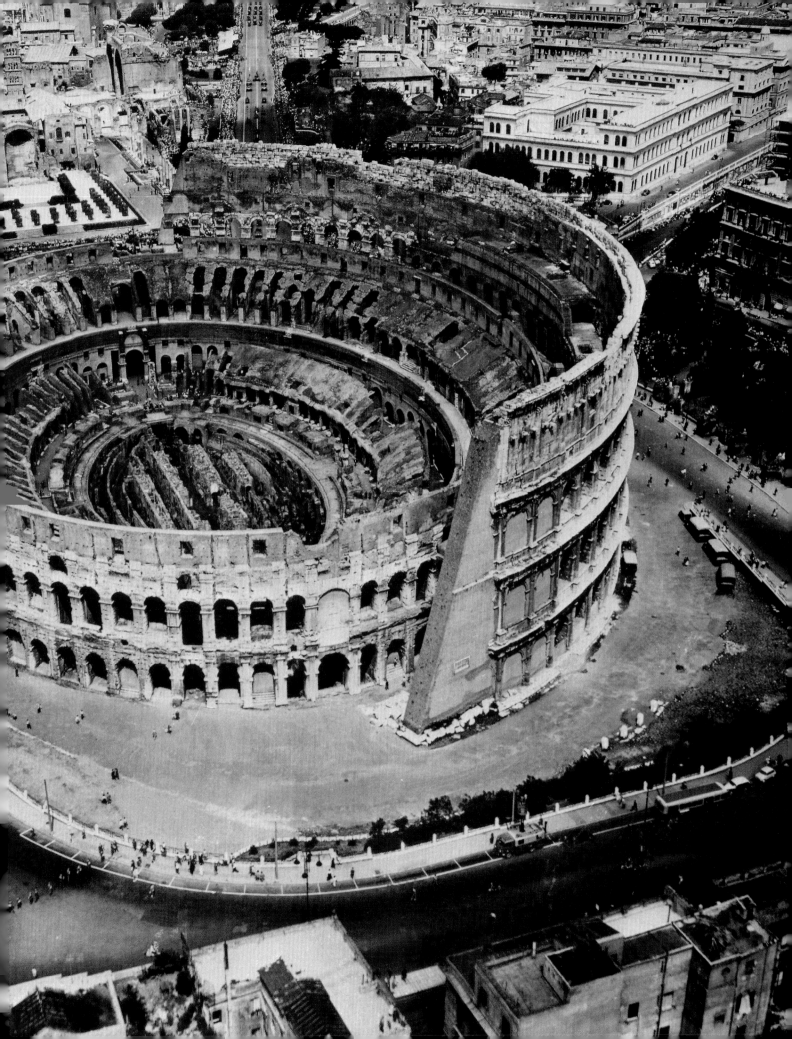

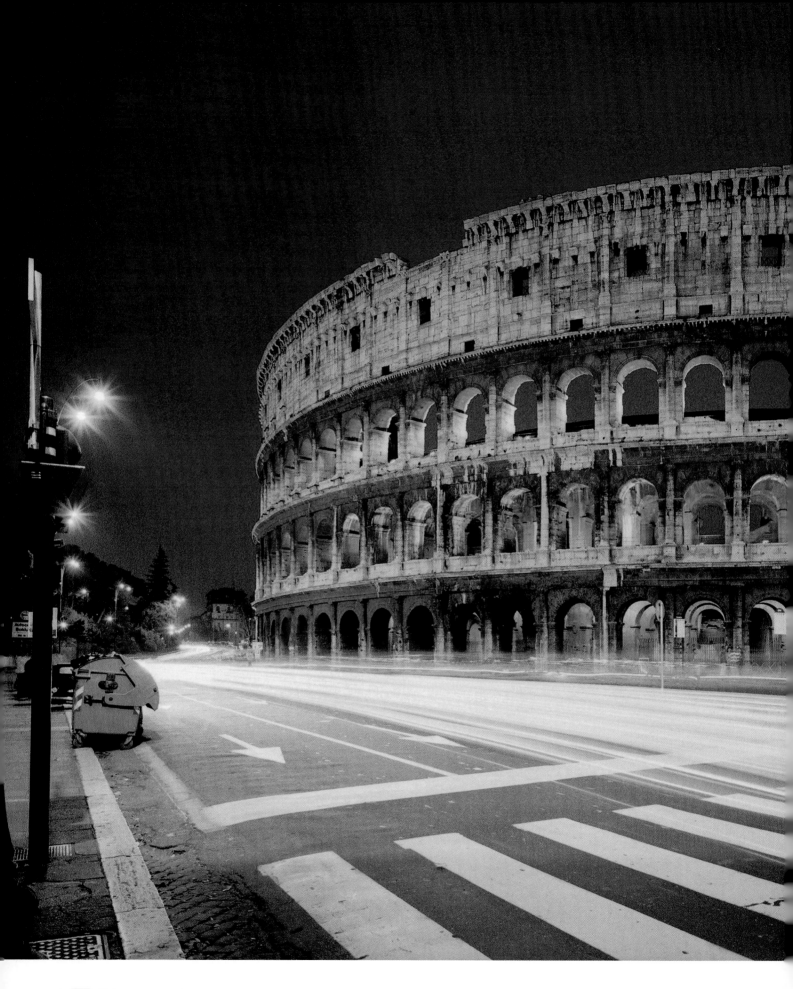

André Rival/Agentur Focus/Contact Press Images

The Colosseum

This most awesome of arenas was often cited as more worthy of inclusion on the sanctioned list of Wonders than some of the original seven, and in fact it would have fit snugly among the Ancients, since its construction and centuries of use predated the Middle Ages. Work on the Flavian Amphitheatre, as it was originally called, was begun about 72 A.D. by the emperor Vespasian on the site of a villa that had belonged to Nero. (A nearby 100-foot statue that Nero had erected of himself, known as a colossus, led to the Flavian's popular name, the Colosseum.) And the gladiators last fought in the Colosseum in the year 404—just a trident's toss from the accepted inception of the Middle Ages—so the great stadium could not be considered a product of the medieval mind.

It was, however, a masterwork of a truly frenzied imagination. We all know that Rome wasn't built in a day, but that this engineering opus was wrapped up in less than a decade verges on the incomprehensible. Sitting on a foundation 42 feet deep, the walls rose 159 feet around an ellipse 615 feet long and 510 feet wide. The infrastructure was of brick, concrete and tufa, and the exterior facade was fashioned from blocks of travertine limestone. As the quarries for the travertine were located a dozen miles outside Rome, and since 3.5 million cubic feet of travertine were required, the logistical problems alone were Sisyphean.

The three classical columns were represented: Doric on the first floor, Ionic on the second and

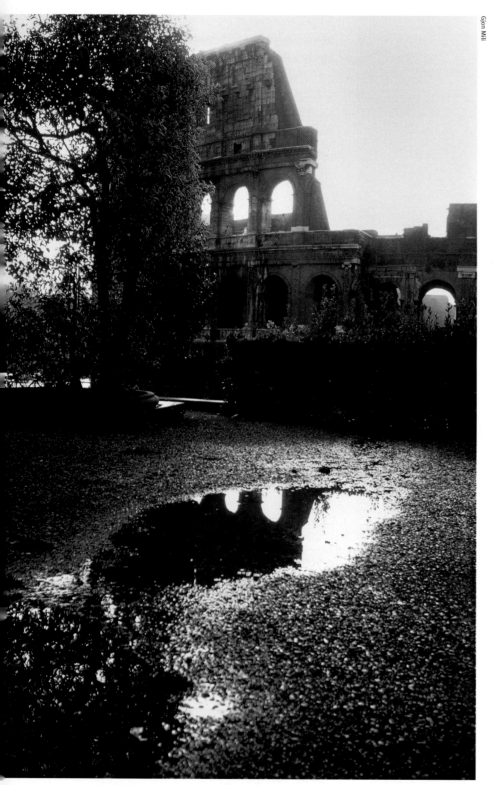

Corinthian on the third. An attic story boasted Corinthian pilasters, and from the attic an awning could be stretched to provide relief for the spectators from the midday sun.

There were 80 entrances: 76 for ticket-holders, two for gladiators, and two for the emperor. At least 50,000 spectators could attend, and one of the many practical achievements of the building is apparent when one learns that the crowd could be evacuated in just five minutes.

Vespasian's son Titus dedicated the building in the year 80, setting off a 100-day series of events. Early shows at the Colosseum were often headlined by clashes between different species of animals, but soon the shows became increasingly outré. The morning often began with mock, comic sparring, which gave way to wild animal events that culminated in the afternoon with humans pitted against animals or against one another. Trained fighters would battle to the death, or occasionally be permitted to live if the warrior had done something special that pleased the crowd. Sometimes the stadium was filled with water, and naval battles were played out.

Rome being a pagan state, Christians along with slaves and criminals were fodder for gladiators. The clashes were waged with a variety of weapons; one of the most chilling forms of combat involved men who fought while wearing huge helmets with no eyeholes. Sometimes, in a manner somewhat redolent of the scene that accompanies the contemporary running of the bulls in Pamplona, free Romans would leap into the fray to capture a moment of personal glory.

The entire day's menu was served up with music from flautists, trumpeters, drummers and even a hydraulic organ that kept the death fights humming. Sand on the wooden floor served to soak up bloodshed. And always the theme remained: We who are about to die salute you!

May it suffice to say, the medievals could never have ideated, let alone assembled, something of this scale. Theirs were simpler times, hardly the birthplace of spectacles. In fact, it was during the Middle Ages that the Colosseum was marred by lightning, earthquakes, quarrying of stone for other buildings, and, worst of all, vandals. But even in its ruination, the Colosseum remained the largest amphitheater on earth for nearly two millennia.

The Colosseum had a wooden floor that covered the chambers below in which gladiators and animals were housed before their moment in the sun. There is no documentation that proves the familiar notion that Christians were fed to the lions, although both parties certainly took part in shows. Gjon Mili took the artful photo above.

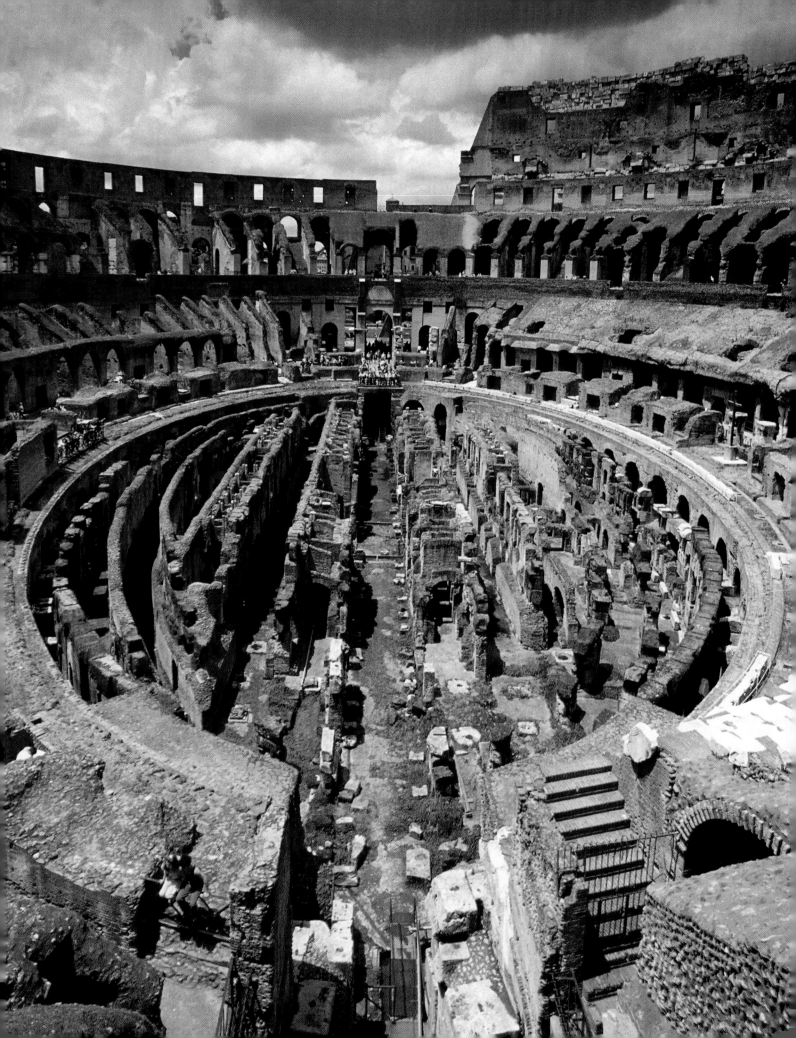

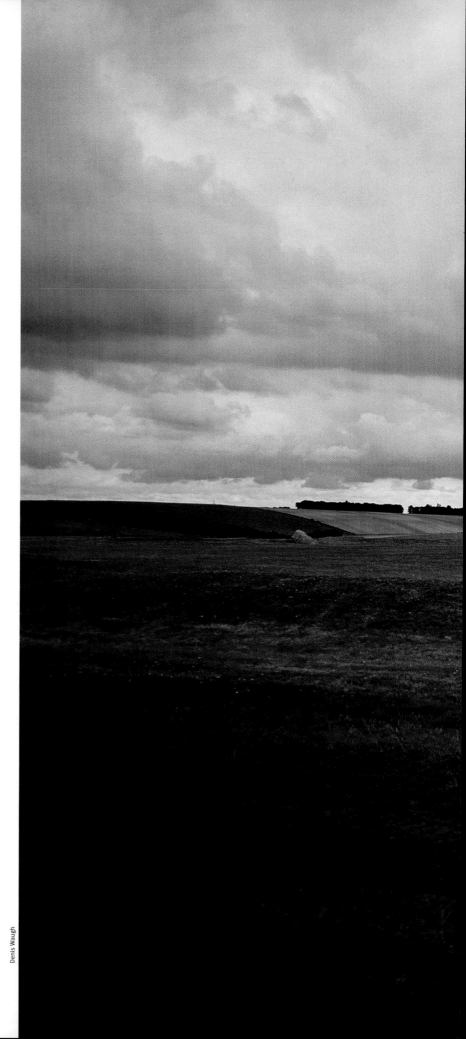

Visitors to Stonehenge are often taken aback that this internationally celebrated construct lies seemingly in the middle of nowhere, as the Salisbury Plain is so considerable. Of course, when the tourists are flocking, it seems significantly less isolated if nonetheless spiritual.

Stonehenge

As much as any other entry in this volume, Stonehenge literally excites the sense of wonder in people. Everything about it is delightfully uncertain. Where did it come from? Who created it? Why? When? And for heaven's sake, what is it? Armies of archaeologists and engineers, of historians and ethnologists, of kooks and crazies of every stripe, have tried to answer these questions. One aspect, however, is without doubt. Stonehenge is no crop circle or Bigfoot. It represents a very serious undertaking, one that required intelligence, purpose, strategy and persistence.

The word "Stonehenge" has an Anglo-Saxon meaning of "hanging stones." But the composition actually began around 3100 B.C. on the Salisbury Plain in southern England when a ditch with a diameter of 320 feet was excavated, likely by Neolithic people using deer antlers. Evidence of such a primitive implement suggests the obstacles yet to be faced by Stonehenge's creators. Their ditch was banked, and along with other features there were two parallel entry stones. This building, now often referred to as Stonehenge I, was in use for some five centuries before being abandoned.

Stonehenge II, commencing about 2100 B.C., saw the site dramatically altered. About fourscore bluestone pillars, as heavy as four tons apiece, were placed vertically in two concentric circles, which were probably never completed and years later were dismantled. In 1923 it was established that the bluestones had likely been sourced at the Pre-

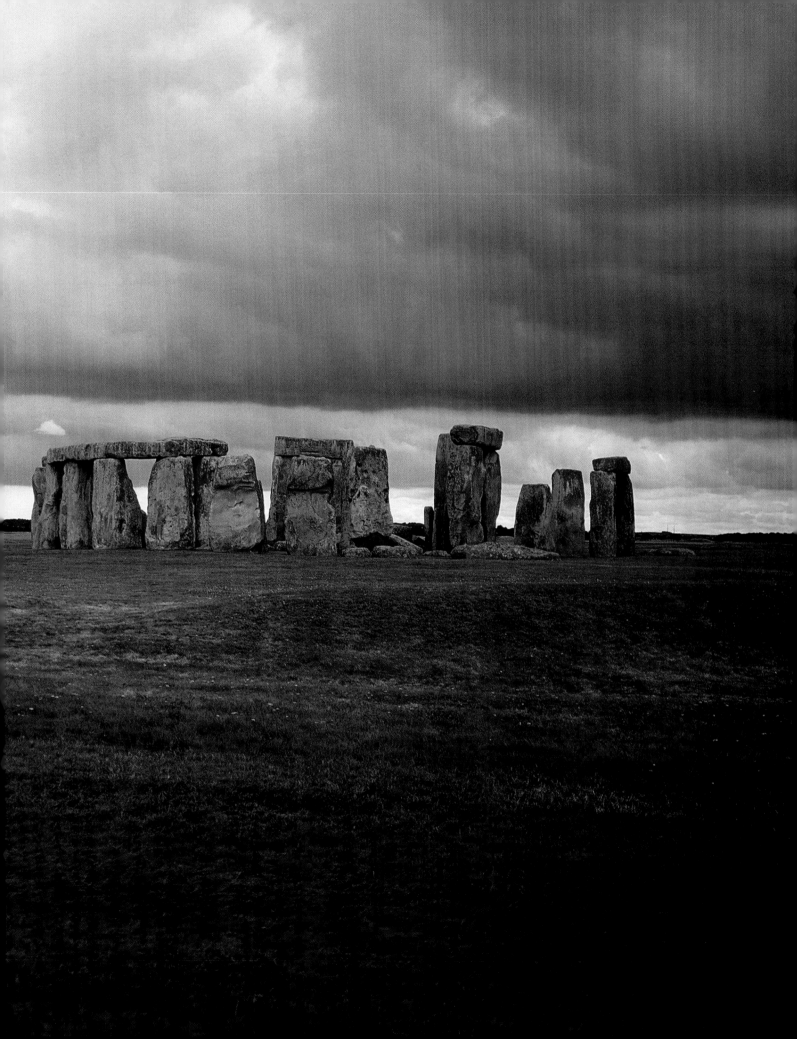

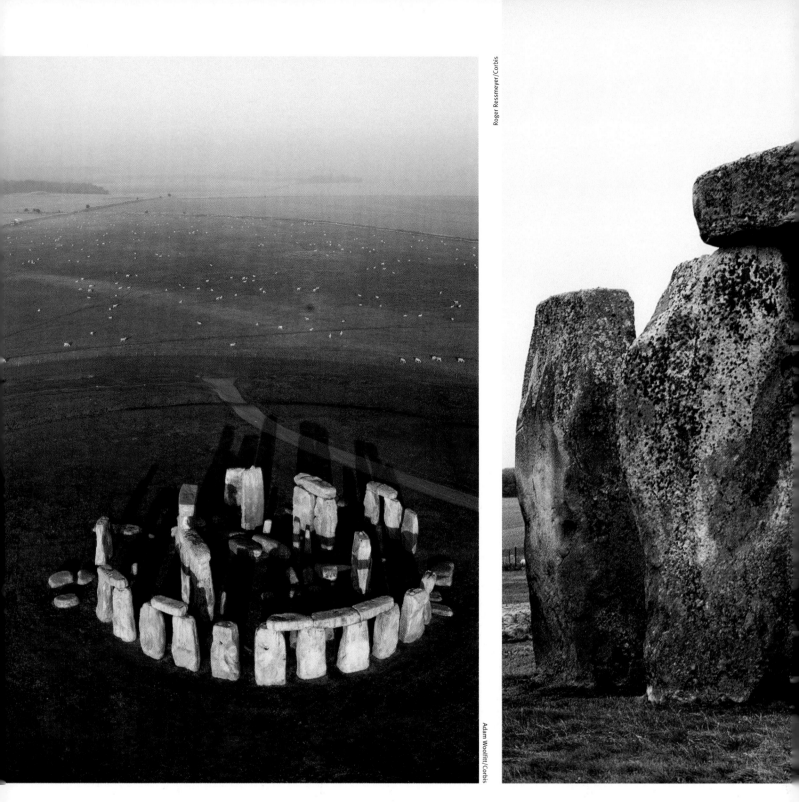

seli Hills in southwest Wales, 240 miles distant. That would be quite a schlep now with a heavy rock; then, it was truly grinding. And yet, it was clearly not dispiriting: Bluestone was the stone—the only stone—that would suffice for these people, so they went and got it.

About a century later, Stonehenge III presented a different transportation challenge, this one from a mere 20 miles away but even more daunting as it involved sarsen stones that were as long as 30 feet and weighed up to 50 tons. Not content with simply building yet another ring, 97 feet across with a horseshoe shape within, it was deemed necessary to top the circle with sarsen stones and then painstakingly pound the surfaces till they were wonderfully smooth. In subsequent years several other devilishly complicated structures were assembled. The purpose of each of them remains open to innumer-

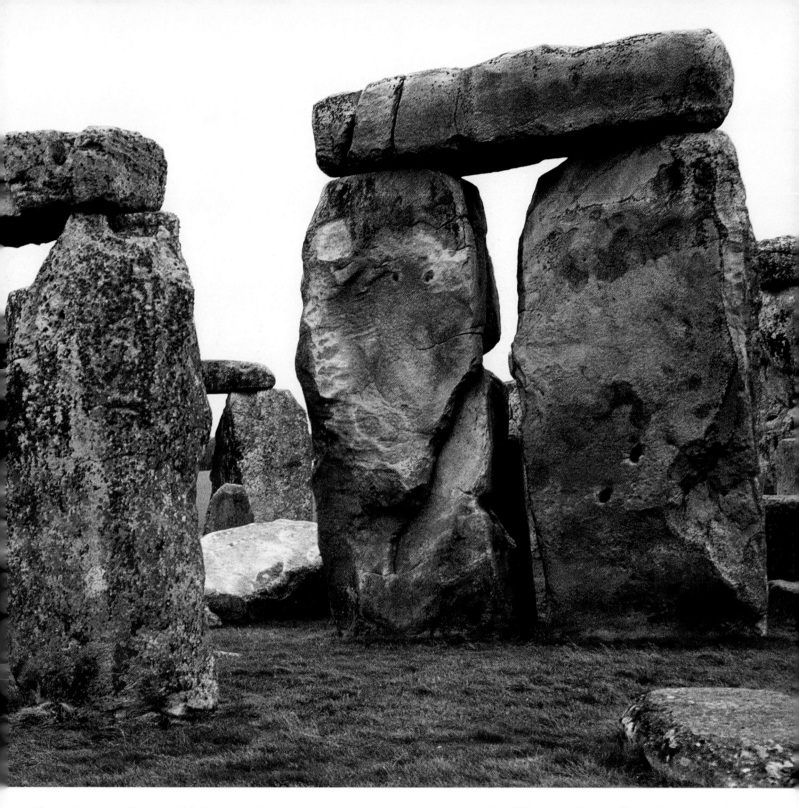

These stones speak clearly of another time, but what is the story they tell? Although an endless assortment of ideas has been proffered, many feel that we will never divine the truth.

able interpretations.

Whatever Stonehenge was devised for, it was still in use as late as 1100 B.C. Old notions that it was built by Druids or Romans have been discarded, as it had been made long before those groups visited the neighborhood. Most theories envision Stonehenge as a grounds where people worshiped in some manner, or perhaps as an astronomical computer of some sort.

Even if the stones have suffered the ravages of time and man, people are more than ever magnetically drawn here, especially during the summer solstice when the sun rises perfectly over the Heel Stone. In fact, Stonehenge is such an attraction that the attendant hordes of tourists would doubtless have sent the devout ancients scrambling wildly for the hills—there, perhaps, to create another grand mystery among mysteries.

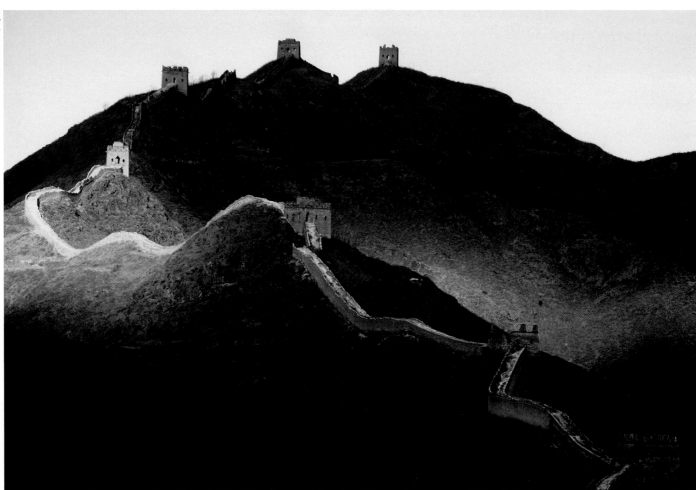

The Great Wall of China

The wall is composed of sundry elements, including brick, masonry, hardened earth, pebbles, palm fronds and tree trunks. In recent centuries, many of these materials have been purloined by local peoples needing supplies for their villages.

In a book bearing a considerable cargo of superlatives, let's briefly lighten the load by noting that, while the Great Wall of China is indeed the largest man-made thing on our planet, it is not visible from the moon, as so many believed for so long. NASA points out explicitly that the wall is hard to see from the space shuttle, let alone from the lunar satellite.

Having said that, this huge barrier boasts some serious statistics. It extends for 1,678 miles from east to west, but if early sections are included, the total length—owing to loops at various points, and segments where there are double, triple and even quadruple walls—amounts to some 6,214 miles, or more than a fifth of the earth's circumference.

Shi Huangdi, first ruler of a unified China, conceived some 22 centuries ago the notion of connecting existing ramparts into a monolith that would allow the vigilance necessary to comfort an emperor. Smoke signals by day and fires by night would announce intruders. The backbreaking labor was carried out by captured foes—China's main enemies of the time were nomadic tribes of the northern steppes—plus any peasants who were not vital to agricultural needs. Soldiers stationed along the wall performed the double function of guarding against belligerents and keeping the workers busy at their posts. It is said that for every new yard of construction, there was a corresponding fatality. During the Ming Dynasty (1368–1644) an epic renovation was performed, leaving the wall in a state similar to its present form.

The rest of the tale of the tape is as follows: The wall is 19 feet wide at its base and 15 feet at its top. It stands nearly 30 feet high, and there are gatehouses at varying intervals and watchtowers about 230 feet apart. The wall has long served its purpose by frustrating countless potential attackers from the north. Along the way, it has further contributed to the nation as an important icon in popular Chinese culture, the stuff of myth, poem and even opera.

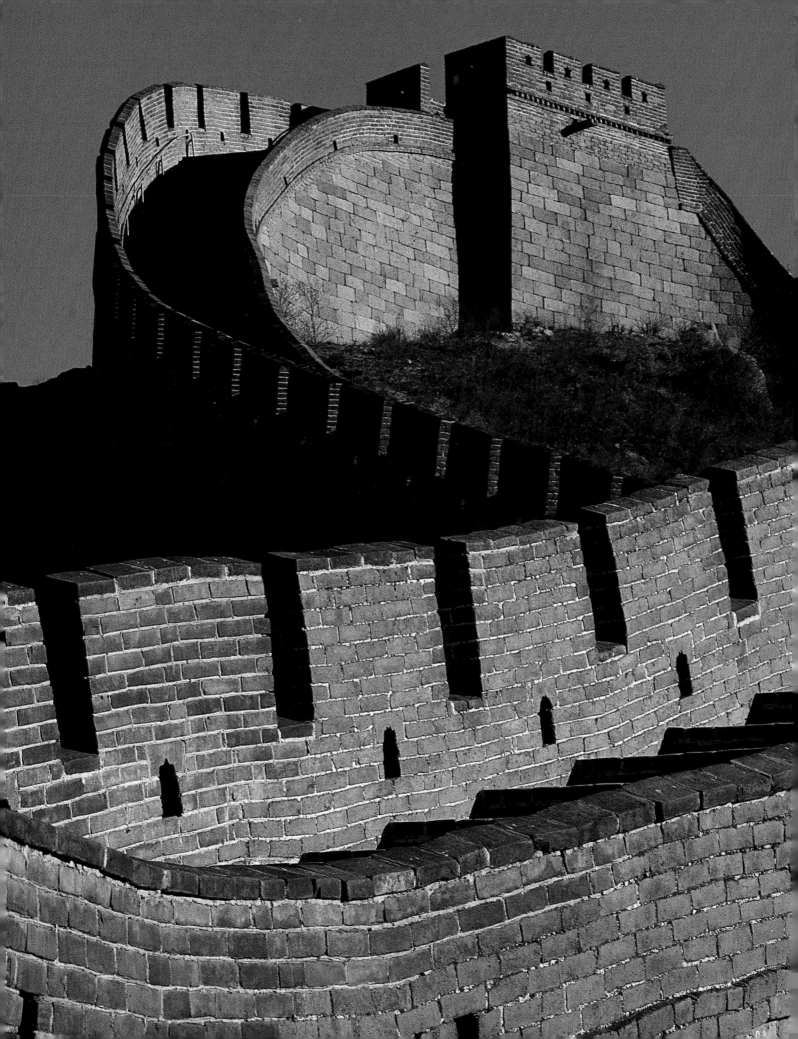

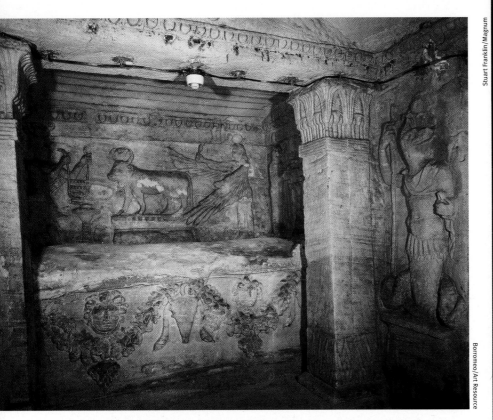

Stuart Franklin/Magnum

Borromeo/Art Resource

The Catacombs of Kom el-Shoqafa

E.M. Forster once remarked of Alexandria, "the best way to see the city is to walk about quite aimlessly." In 1900, to the everlasting benefit of humanity, a donkey out for a leisurely stroll in the Egyptian port city fell through a hole in the ground and into the access well of a culture nearly two millennia old. The poor beast's misfortune led to the discovery of the Catacombs of Kom el-Shoqafa, a unique netherworld that is noteworthy on several different fronts.

Catacombs are underground cemeteries in which recessed areas serve as tombs. The origin of the term is unclear, but it may first have been applied to the cemetery below Rome's Basilica of San Sebastiano. Catacombs became relatively common for Christian communities in the Roman Empire, but have also been found in Malta, Sicily, Lebanon and many other locales.

What sets the Kom el-Shoqafa site apart is a highly unusual and entirely fortunate blending of traditions and styles. In the 2nd century A.D., a single family, still practicing the ancient religion of Egypt, financed the tunneling 100 feet down through bedrock. While paying obeisance to Egypt-

Above, the interior of a tomb with a sarcophagus, or stone coffin, in the style of the Roman period. Catacombs had a very intricate layout, and there were secret passageways that led out of the building. It was an ideal place to take refuge during times of upheaval.

ian gods and motifs—a solar disk carved below a frieze of serpents; pillars topped by papyrus, lotus and acanthus leaves—the architects and artists who created the rotunda, vestibule, benches and so on had been schooled in the Greco-Roman style. Thus

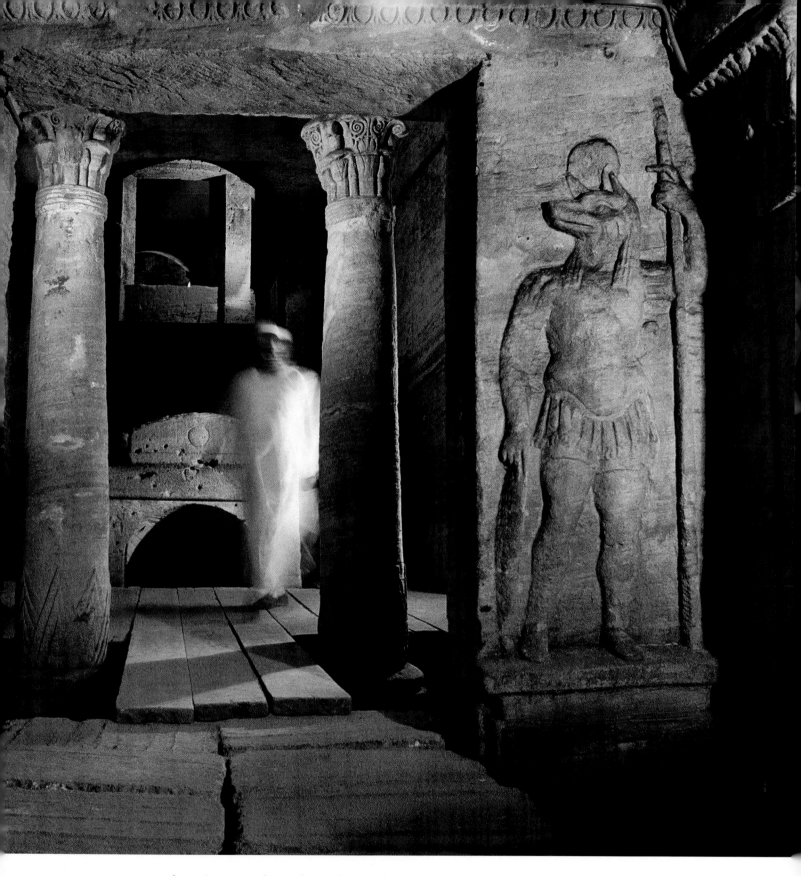

the entire necropolis is a divine olio, a hodgepodge, a pastiche even, whose animus defies translation. As one descends the circular staircase through three levels—the middle level is startlingly eerie—and enters the eccentric warrens within, one is trans-ported to a singular, surreal world. It was perhaps an earthquake long ago that hid this Wonder from view, but the misstep of a donkey led to one of the world's great archaeological finds: a one-of-a-kind portal to the realm of the dead.

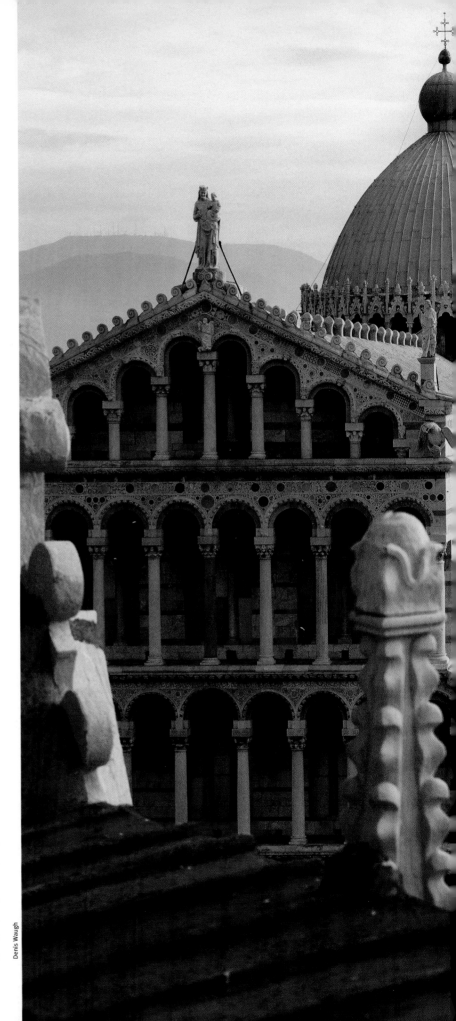

This photograph was taken in 1990, the year the tower finally had to be closed to the public. Taken from the Baptistery, it shows the tower listing dramatically behind the Cathedral.

Denis Waugh

The Leaning Tower of Pisa

Even if it had endured just as it was drawn up in the blueprints, this Wonder in the western Italian province of Tuscany would have been a marvel. It was to be a campanile, or bell tower, the third and final component of a spectacular cathedral complex built in the city of Pisa to advertise the wealth of its citizenry. On August 9, 1173, the first stone was laid for the edifice, which was intended to stand 185 feet high. Ongoing conflicts with rival Florence hampered construction, and then, after 11 years, with three stories of the white-marble edifice completed, its chief architect, Bonanno Pisano, noticed that the foundation was settling unevenly in the soft ground, composed of clay, fine sand and shells.

It had been slated for eight stories, so Pisano decided to compensate by making the next levels somewhat taller on the foreshortened side. Regrettably, the additional stone served only to make the foundation sink still deeper.

Yet another scuffle between Pisa and Florence, in 1185, halted work, this time for decades, and then Pisa got into a brouhaha with Genoa that once more suspended operations. Ironically, however, had all these stoppages not occurred, the campanile would have toppled long ago. The interruptions permitted the underlying soil to consolidate and gather resilience.

Initially the tower leaned only slightly, 0.2 degrees. A century later the tilt had reached one full degree, and by the time the structure was officially completed, in 1370, it listed 1.6 degrees. But the

48 **LIFE** THE MEDIEVAL WONDERS

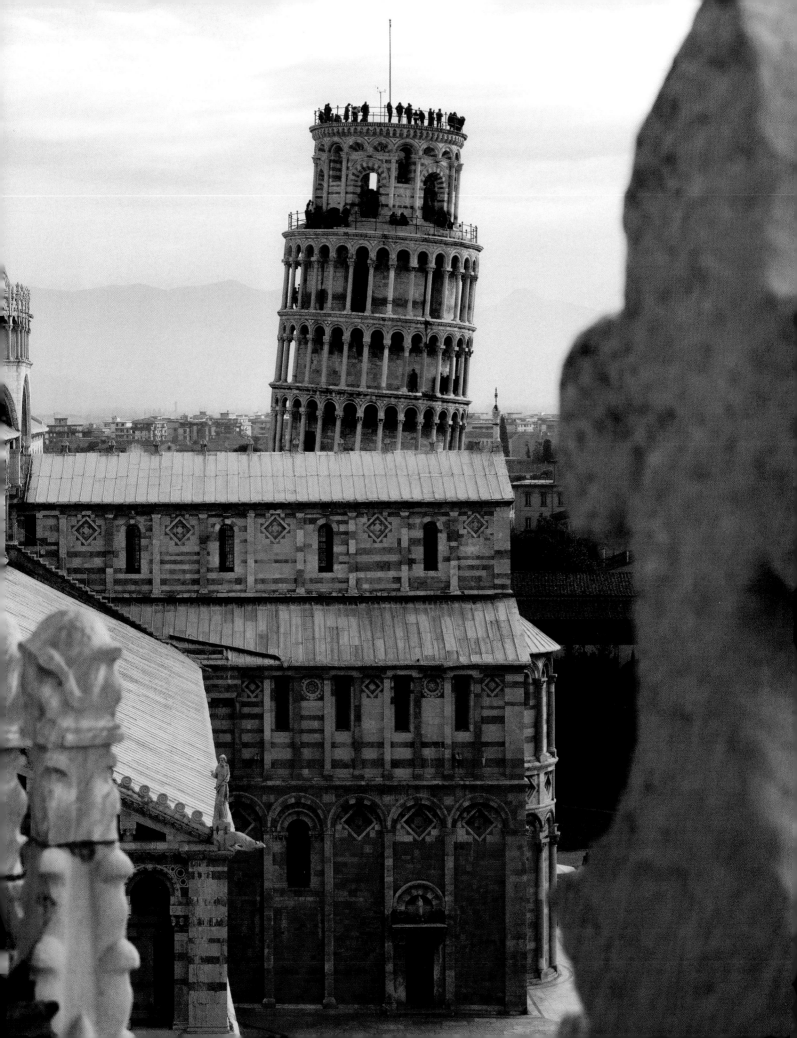

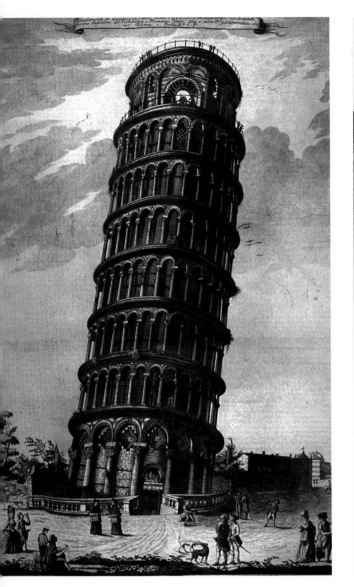

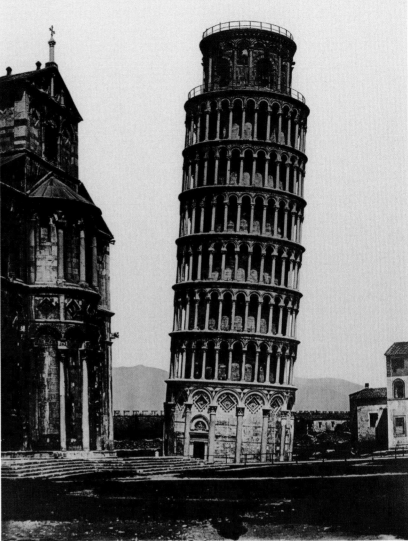

The illustration above was made in 1782. The artist has taken liberties with the tower's angle of incline, perhaps to attract tourists. At top right, a view circa 1880. Opposite: During the Festa Della Luminara, 70,000 candles enhance the leaning Wonder.

tower was now up, and by and large things were good, except that, as a bell tower, Pisa's lacked the sine qua non: bells. Three centuries passed before it acquired its seventh, and final, bell; at a weight of 3.5 tons, it no doubt played havoc with the ever-faltering structure. By 1817, it had achieved a five-degree slant.

For years to come, a veritable bedlam of methods was prescribed but invariably with the result that a bad situation was made worse.

By 1990, matters were such that people could no longer be permitted to climb the tower steps, and the Italian government, determined to save Pisa's most famous landmark, bit the bullet and sought outside counsel. It turned to John Burland of London's renowned Imperial College. The experienced Burland deemed the tower's salvation "the ultimate civil engineering challenge," and later

revealed that the building was in such dire straits that "we actually couldn't get it to stand up in our computer model." He likened the ground beneath the tower to "jelly or foam rubber." However, it was that very softness that allowed Burland to remove earth from beneath the taller side as a corrective to centuries of tilting. On June 16, 2001, his work completed, Burland proudly predicted that "it will take 300 years for the lean to be back to where it was in 1990." The Pisa tower, ballasted by lead counterweights at the base, now leans as it did in 1838—5.5 degrees to the south.

At one time, long ago, many people actually believed that the structure tilted by design, that it was yet one more beguiling aspect to an edifice already thrillingly beautiful. The truth is, this tower in the churchyard had always been intended to reach straight for the heavens.

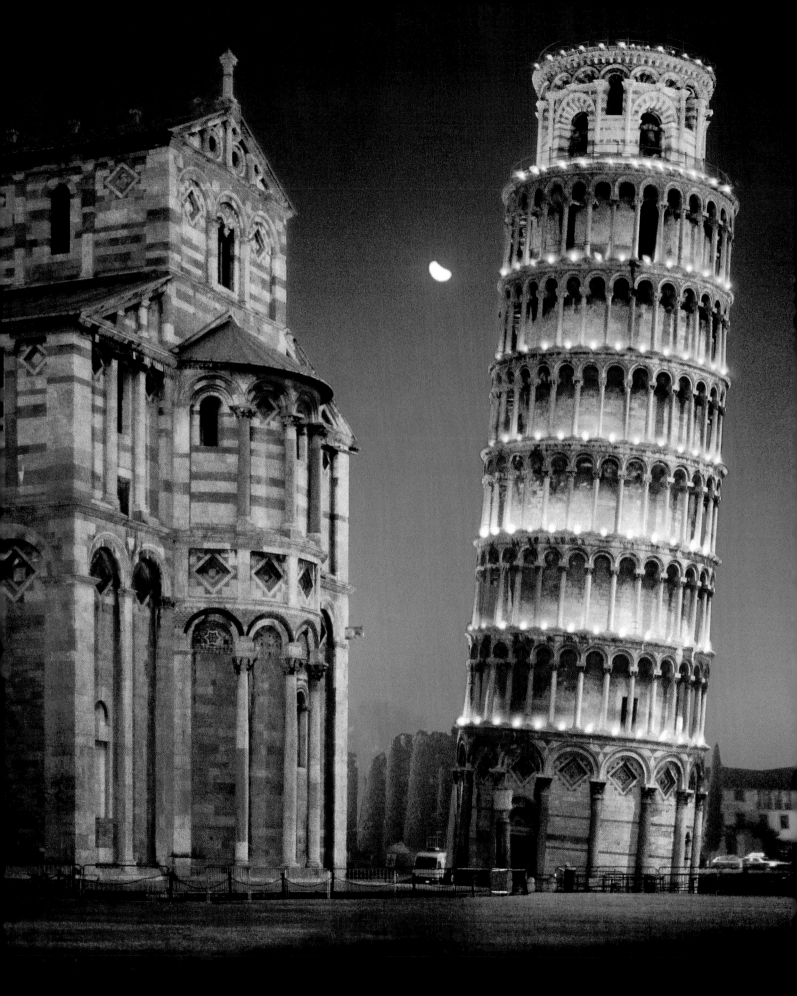

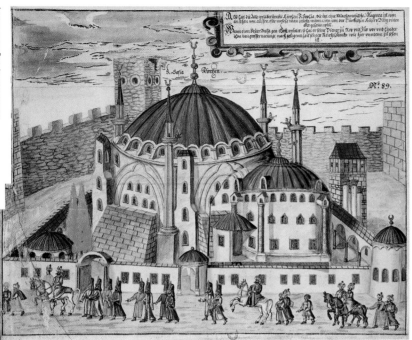

Hagia Sophia

T he crowning glory of the Byzantine era and arguably the paragon of all Middle Ages accomplishments, the cathedral that is known as Hagia Sophia was erected in Constantinople in the 6th century by the emperor Justinian the Builder. It was placed on the site where Constantine had created a church of the same name nearly two centuries earlier, a building later burned by rioting sports enthusiasts.

From the moment that Justinian began his Hagia Sophia (the name may be translated as "Holy Wisdom"; this was, after all, Justinian's bequeathal to Christianity), absolutely nothing—nothing—would be spared.

Selected as architects were the esteemed Isidorus of Miletus and Anthemius of Tralles (legend has it that Anthemius was the sort of fellow who liked to bedevil a neighbor by reflecting sunlight into his home). The two men planned a glorious church that would rise from a main floor of 250 feet by 220. Their sanctuary was outfitted with 40,000 pounds of silver, and the altar was made of gold that was inlaid with precious stones. Four acres of gold mosaics glittered along the ceiling, while the floor, walls and columns incorporated black marble from the Bosporus region, green from Greece and pink from Phrygia.

At right, with the Bosporus Strait, which separates Europe and Asia, flowing in the background, Hagia Sophia drinks in the waning sunlight. The illustration above, a 16th century German watercolor on paper, shows the holy building after its conversion to a mosque.

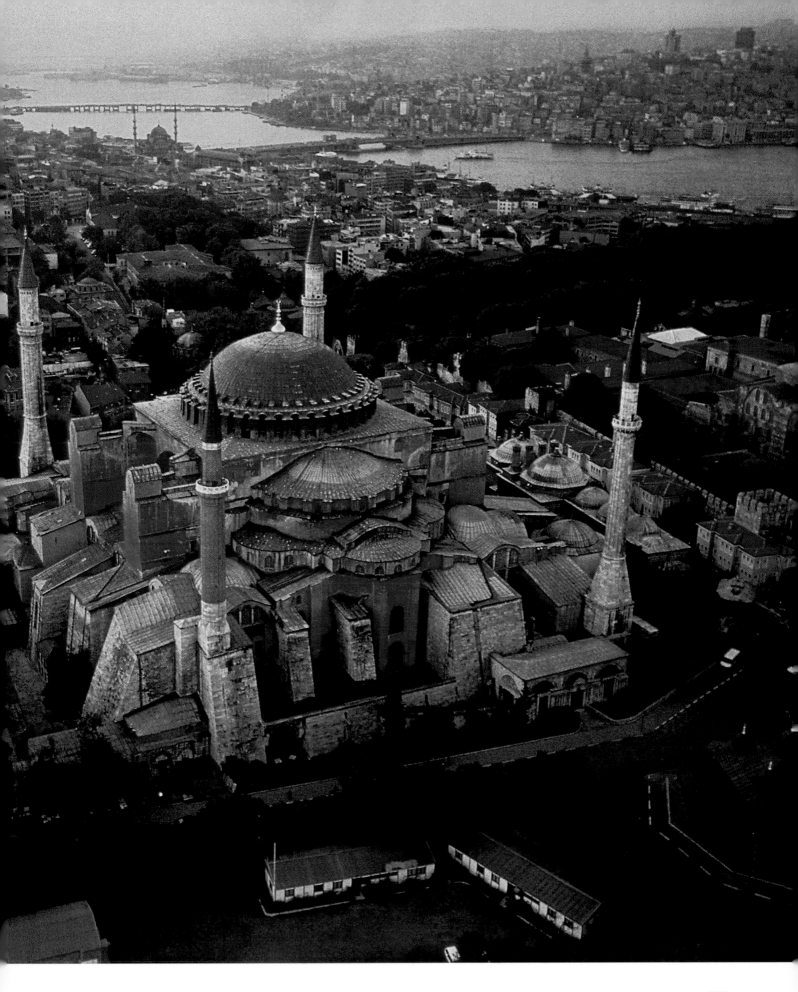

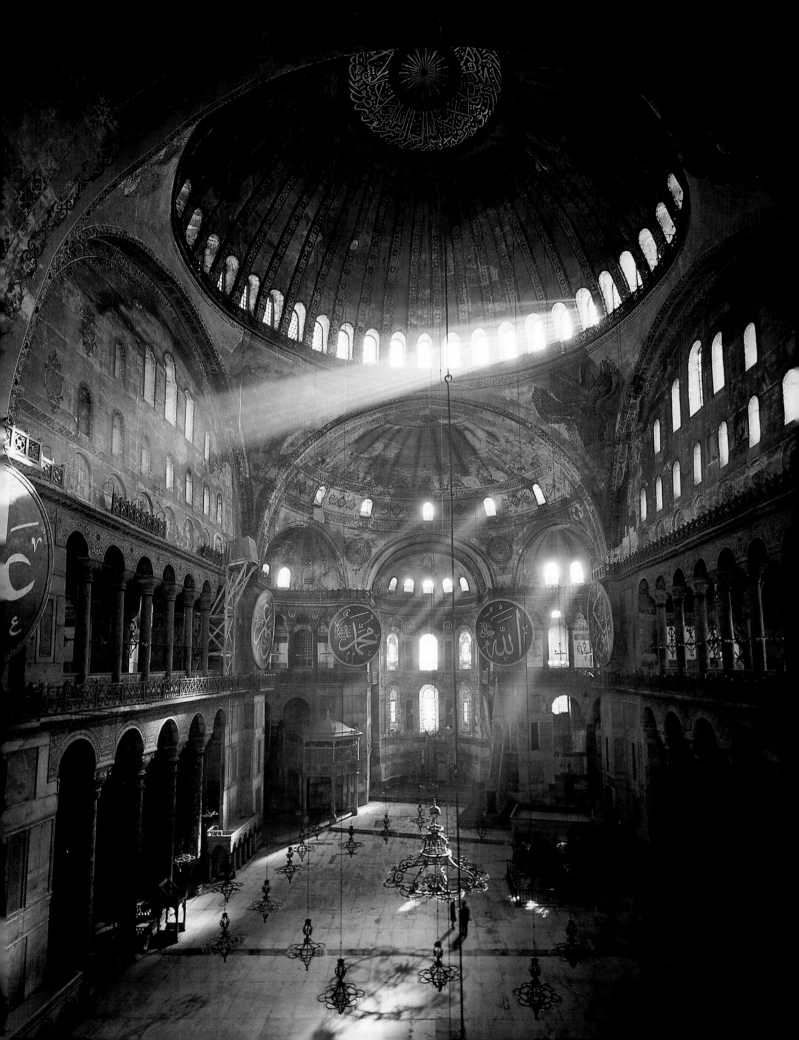

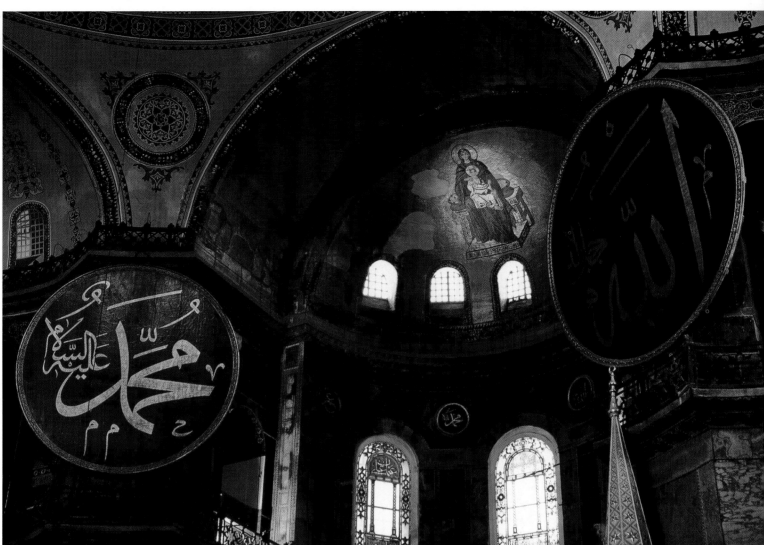

In the harmonious setting above, a mosaic of the Madonna and child is flanked by Islamic medallions boasting exquisite calligraphy. At left, the interior of a timeless masterpiece.

At the top of all this was the ne plus ultra, a ribbed dome that perched on 128-foot arches, thus giving the sense that the roof was afloat at its majestic height of 180 feet. As the historian Procopius noted, "a spectacle of marvelous beauty, overwhelming to those who know it by hearsay altogether incredible. For it soars to a height to match the sky . . ."

During the dedication ceremony, which was held with tremendous fanfare on December 27 in the year 537—the project had been completed in an astonishing five years, 10 months and four days—Justinian entered the church in a state of ecstasy, and vigorously echoed Procopius: "Glory be to God, who has thought me worthy to finish this work! Oh, Solomon, I have surpassed thee!" Two decades later, perhaps because of its unimaginably rapid construction (even by today's standards), Hagia Sophia suffered severe damage from earthquakes. As the

original designers were now deceased, a nephew of one, Isidorus the Younger, took on the task of rebuilding.

In 1204, Crusaders trampled Constantinople and, fueled by political passions, ransacked Hagia Sophia with such purpose that it was cited in a contemporaneous account as the worst such act "since the creation of the world." But repaired once more it would be, this time by the architect Ruchas. A couple of centuries further on, the building was converted to a mosque, and with appropriate adornments such as minarets it served in this capacity for nearly 500 years. In 1935 the Turkish leader Kemal Ataturk, recognizing that Hagia Sophia had served both Christians and Muslims, resolved with ecumenical wisdom that rather than stand as a source of inevitable dispute, Hagia Sophia would be turned into a museum. Today this brilliant diadem in the heart of Istanbul remains open to one and all.

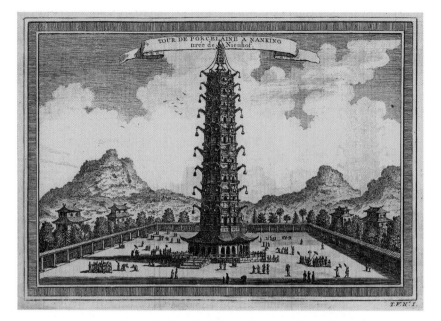

The Porcelain Tower of Nanjing

This is the sole Wonder of the Medieval Mind that is no longer in existence, a fact that in itself is quite remarkable when one considers the cataclysmic events that have befallen the planet in the intervening years. Nanjing, located on the Chang River in eastern China, lies midway between what were then Peking and Canton. At one time the seat of the imperial court, the city played host to several assaulting forces. It was one such attack, by Taiping rebels in 1853, that likely lay waste to the tower.

The building was begun in 1413 by the emperor Yung-lo to honor his mother. It was finished about two decades later. The Chinese called it Bao'ensi, or Temple of Gratitude.

The Porcelain Tower was, of course, a pagoda, and China is a land with plenty of pagodas. But what set this one apart was not its height (260 feet) but rather what it was made of. The walls of the octagonal pagoda were created from bricks of the finest white porcelain, which sparkled in the sun and at night were electrified by the light of 140 lanterns made of thin oyster shells and festooned along the tower's exterior. Within the porcelain were glazed stoneware tiles of green, brown and yellow, depicting animals and landscapes. The pagoda's nine stories were set off by overhanging eaves covered with glazed green tiles.

If one climbed the 184 steps to the top—all the

The walkway at right leads to a gate in the city wall of Nanjing to the site where the tower once stood. In the early 19th century, a French mathematician called the pagoda "the best contrived and noblest structure of all the East." Opposite, some examples of original tile are now housed in a Nanjing museum.

while passing 152 tiny bells that played gently in the breeze—one reached the golden dome, where there were hung five large pearls, whose power protected Nanjing from fires, floods, dust storms, tempests and disturbances. Or so it was believed, before the disturbance of 1853.

It was Europeans who created this Wonders of the Medieval Mind list, and it was they who dubbed this marvel the Porcelain Tower. But Longfellow,

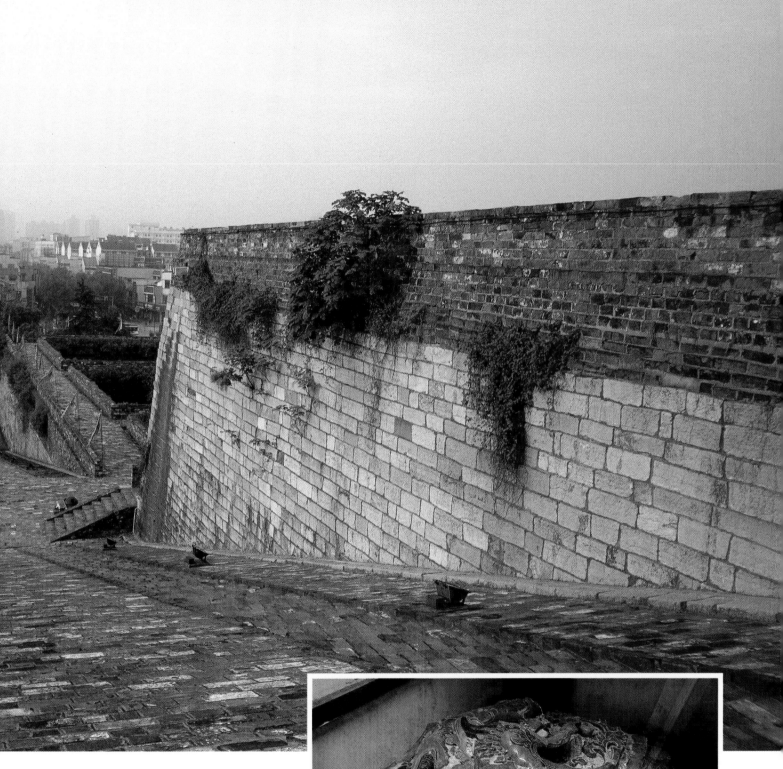

too, sang its praises in *Keramos:*

> And yonder by Nanking, behold
> The Tower of porcelain, strange and old,
> Uplifting to the astonished skies
> Its ninefold painted balconies,
> With balustrade of twining leaves,
> And roofs of tile beneath whose eaves
> Hang porcelain bells that all the time
> Ring with a soft melodious chime . . .

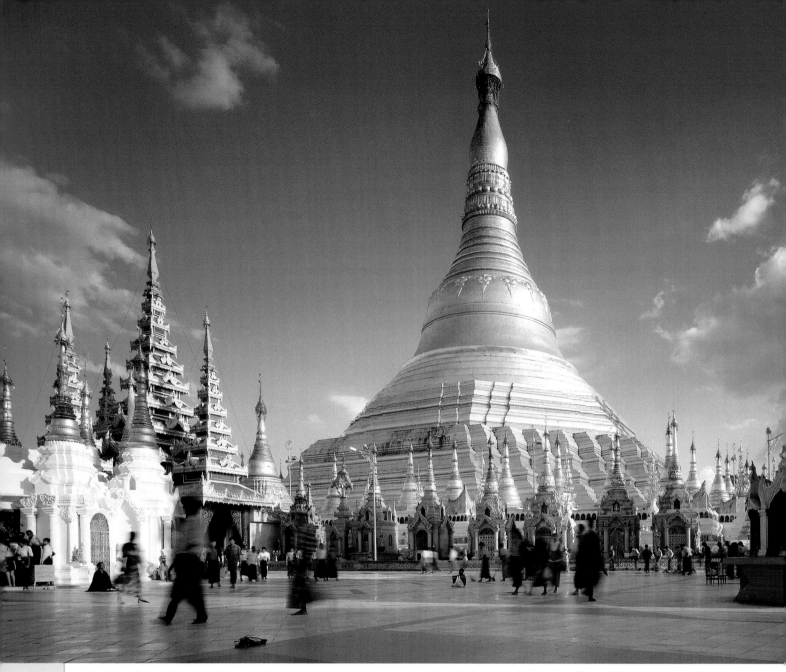

Yann Arthus-Bertrand/Altitude

Carmen Redondo/Corbis

The Shwedagon Pagoda Myanmar, the Golden Land, has many pagodas. Kipling called this one a "beautiful winking wonder."

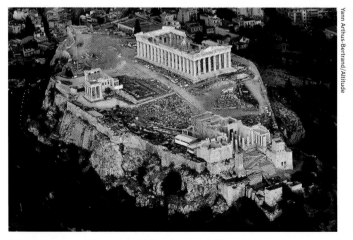

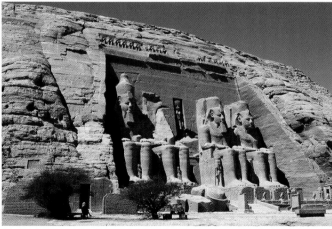

The Parthenon It rose on this Athenian hill in the 5th century B.C.

The Abu Simbel Temple Ramses II, times four—all in a row

The Seven Forgotten Wonders of the Medieval Mind

The Wonders of the World business has always been, on one level, a naming game, and critics have long been eager to point out what has been overlooked. A shadow list to the Medieval Minds collection has developed, and it includes the Abu Simbel Temple in Egypt and the spooky stonework on Easter Island (both of which will be treated in the Iconic Wonders chapter), the ruins of the ancient Cambodian temple Angkor Wat, France's Mont-Saint-Michel, India's Taj Mahal, Myanmar's Shwedagon Pagoda and (finally making a list!) the Parthenon in Greece.

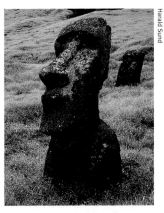

The Statues of Easter Island

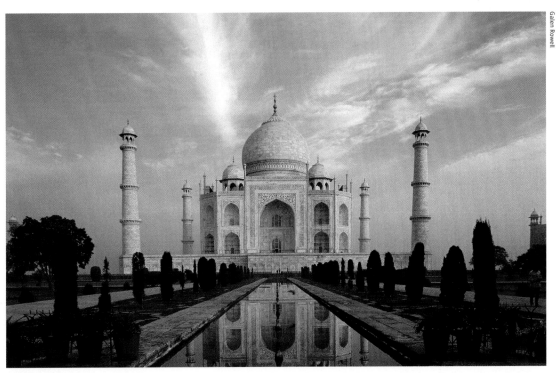

The Taj Mahal The mausoleum of the 17th century Mogul empress Mumtaz Mahal is grand beyond words.

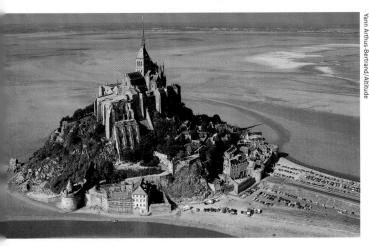

Mont-Saint-Michel The sea surrounds the abbey at high tide.

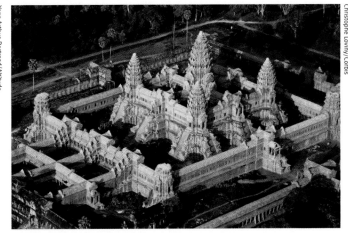

Angkor Wat It is the largest religious complex in the world.

The Seven
Natural Wonders of the World

The Great Barrier Reef off Australia's Queensland coast is teeming with animal life that is almost always beautiful, quite often benign and sometimes extremely dangerous.

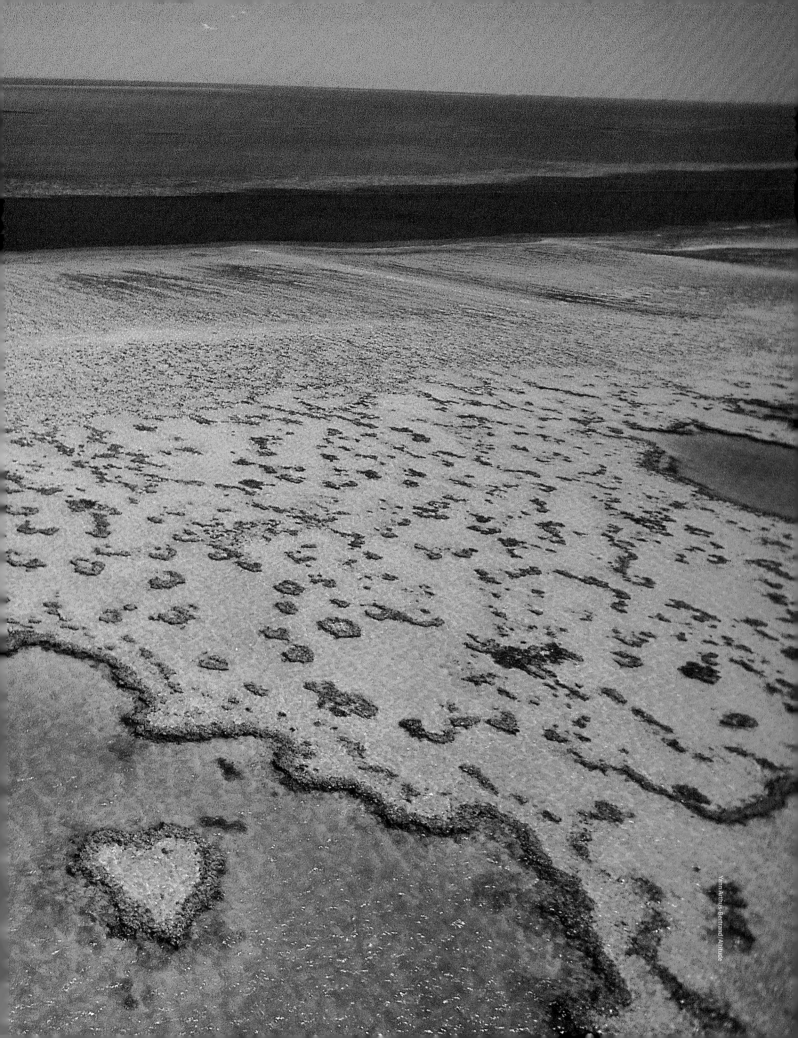

From the Sea to the Summit

You surely feel that you have visited one of the Natural Wonders. They're always at hand, or so it seems. You visit that rock bridge high above the stream bed in Virginia's Shenandoah Valley, then learn from the circular that you have just experienced one of the Seven Natural Wonders of the World. You vacation on England's southern, serene, certainly scenic Devon and Dorset coasts, and the locals tell you how lucky you are: You've just availed yourself of one of the world's Seven Natural Wonders.

They're not wrong—you're not wrong—but they're not right, either. While the famous list of Ancient Wonders underwent amendment in the final centuries B.C., and the Wonders of the Medieval Mind roster includes items that predate the Middle Ages, such flux and errata are as nothing compared with the uncertainty plaguing the Seven Natural Wonders. Depending on which list you sanction, you can add or subtract a desert or an island, trade one specular waterfall for another and, in the case of aurora borealis, nod to a phenomenon that is rare, fleeting and essentially out of thin air.

There are, perhaps, seven-times-seven Natural Wonders of the World; it is an all-comers club. Even a casual surfing of the Internet yields Seven Natural Wonders lists that include Mount Fuji in Japan, Mount Kilimanjaro in Tanzania, the Matterhorn in the European Alps, central Australia's Ayers Rock, Italy's Blue Grotto, Krakatoa Island in the Indian Ocean, Canada's Bay of Fundy, Argentina and Brazil's Iguaçu Falls, Africa's Sahara Desert and Nile River and, domestically, Yosemite Valley and its giant sequoias in California, the Petrified Forest and the Meteor Crater in Arizona, Niagara Falls, Alaska's Land of Ten Thousand Smokes, Rainbow Bridge National Monument in Utah, Red Rocks National Amphitheater in Colorado, Carlsbad Caverns in New Mexico and Stevie Wonder, citizen of the U.S. and, it can be argued, the wide, wide world.

Most if not all lists agree on a Big Three, as do we. These are the Great Barrier Reef, a glittering chain of coral reefs off Queensland, Australia; Mount Everest, the Himalayan peak in south-central Asia that is the world's highest; and the mile-deep Grand Canyon in Arizona. Many if not most lists include the fabulous harbor at Rio de Janeiro and the Paricutin volcano in Mexico, and we can see the wisdom of these nominations.

Now things get complicated. Do you go with the world's tallest waterfall, 3,212-foot-high Angel Falls in Venezuela, or that which is arguably the world's most awesome, Victoria Falls on the Zimbabwe-Zambia border? It's a tough call, but we finally side with those who side with Victoria, since this seems most in keeping with Herodotus's and Antipater's original thinking: A Wonder is not necessarily a record-holder, but rather a paradigmatic sight to behold.

The chief contenders for the seventh spot on the list, judging by the number of times each has been cited by some individual or organization—and these institutions include everything from the august National Geographic Society to CNN to *The Reader's Digest* to, now, LIFE—seem to be the Northern Lights and the prehistoric caves of France and Spain. The caves appear, to us, a direct response to the elusive nature of aurora borealis, a substitute nomination for a naturally occurring but not-really-of-this-earth atmospheric reaction.

We choose the Lights for two reasons. First, the caves' specialness rests largely on the ancient artwork therein, and so the caves are as much a man-made Wonder as they are natural. And second, the Northern Lights are a purposely provocative choice, and this, too, is in keeping with the thinking of the Greeks of old who first floated this Seven Wonders concept. By setting themselves up as authorities and then limiting their choices, they dared their audience to challenge them. They said: "Sure, of course there are eight. There are 800! But these are the seven." Herodotus and Antipater quite obviously solicited reader response, favorable and non—as do we.

So, then: On our list we have variety, what with a beautiful reef, a high mountain, a deep gorge, a dramatic bay, an angry volcano, a spectacular waterfall and a luminescent dance caused by solar wind particles trapped by Earth's magnetic field. We have geographical spread, with North America, South America, Africa, Eurasia, Australia and the skies above represented. We have beauty and glory to spare. Do we have consensus? With more than 100 countries throughout the world now bragging of national parkland, and with Natural Bridge, Va., and Great Britain's southern coast pressing their respective and very specific suits, it is clear that we do not. What we do have is seven, and that is all that we are allowed.

Get out your magnifying glass: A sense of perspective is attainable from this picture of Mount Everest's summit only if you find the three climbers who are making their way toward it. In the bottom third of this 1983 photo, they are the three aligned specks at 24,500 feet on the snow-covered West Ridge.

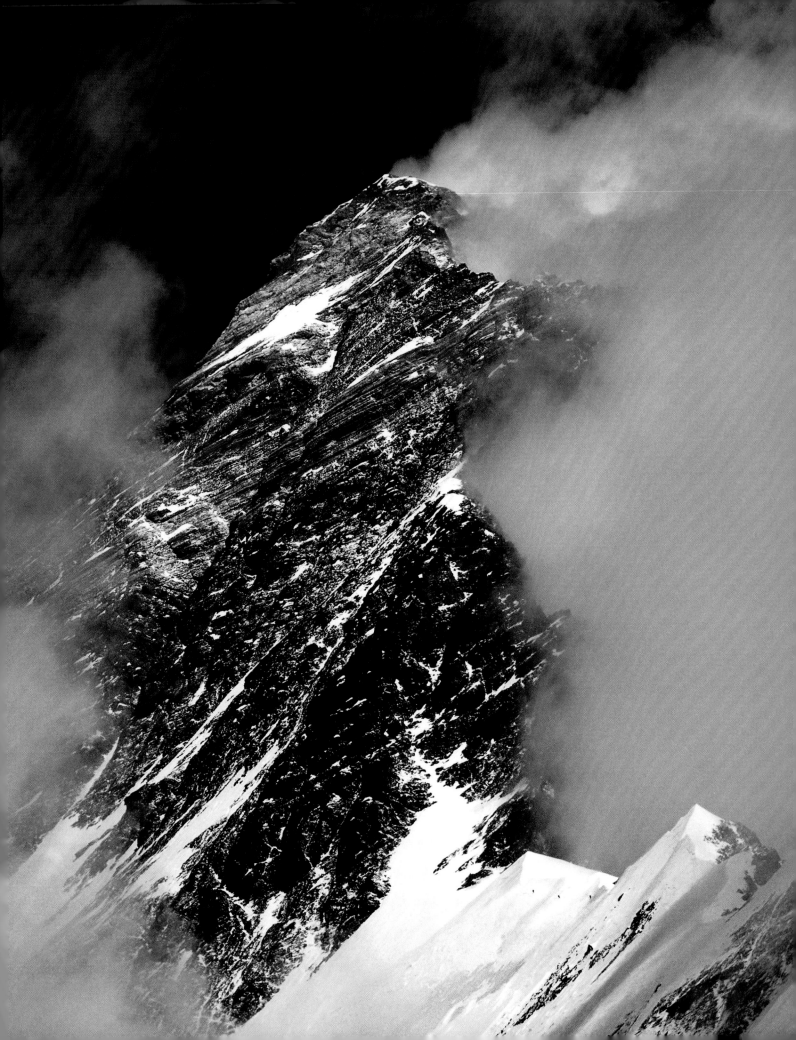

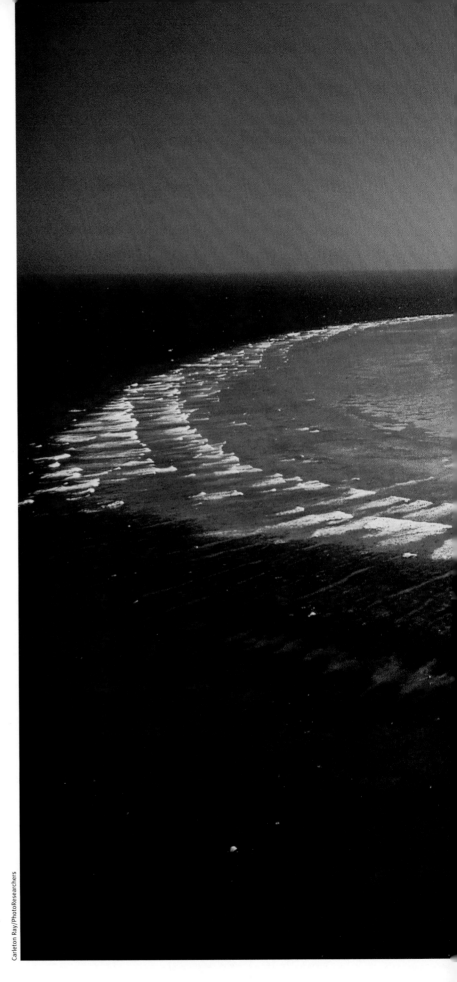

The islands in the Capricorn Group, lying along the Tropic of Capricorn some 60 miles off the Queensland coast, are cays made of coral.

The Great Barrier Reef

This, as opposed to the Great Wall of China, is the Wonder that is a cinch to see from deep space. At more than 1,200 miles in length and covering more than 100,000 square miles in all (it's about half the size of Texas), the Great Barrier Reef, off the northeastern Australia coast, is as glorious to behold from afar as it is up close. Save the aurora, it is by far the biggest of all the Natural Wonders.

The reef is an often misunderstood entity. For starters, it's not one coral reef but an interconnected series of perhaps 3,000, ranging in size from barely more than an acre to 25,000 acres. There are different kinds of reefs submerged at various, mostly shallow depths, some of them spreading out from the 300 islands within the Barrier Reef domain. It was long believed that the reef was as much as 20 million years old—not a far-fetched theory, given that relatives of modern corals developed as long ago as 230 million years—but a study published in *Geology* in the spring of 2001 said that new evidence from boreholes in the reef indicate a birth date of approximately 600,000 years ago. In fact, the structure of the reef as we know it today, built upon dead reefs below, dates back only 6,000 to 10,000 years.

Regarding its bounteous animal population, the Great Barrier Reef supports more than 1,500 species of fish, 4,000 species of mollusk and 400 species of coral. That's right: The tiny, colorful specimens that make up what has been called the world's largest living organism are not plant but animal. Coral polyps and hydrocorals are smaller relations of jellyfish and sea anemones, crowned with colorful tentacles. They exist in colonies and become fixed by remnant algae, sponges and other decayed creatures. (White coral is indicative of polyps that have died; the brilliant pastels that are the reef's hallmark show vibrant life.) Coral species are as different from one another as they are from much oth-

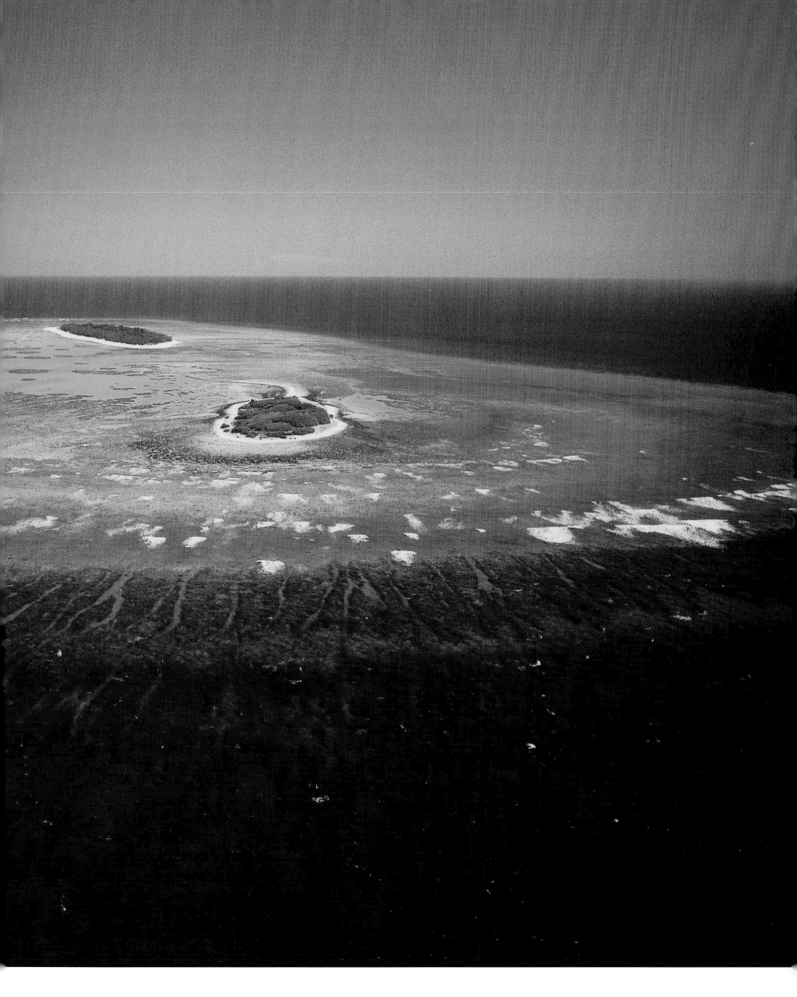

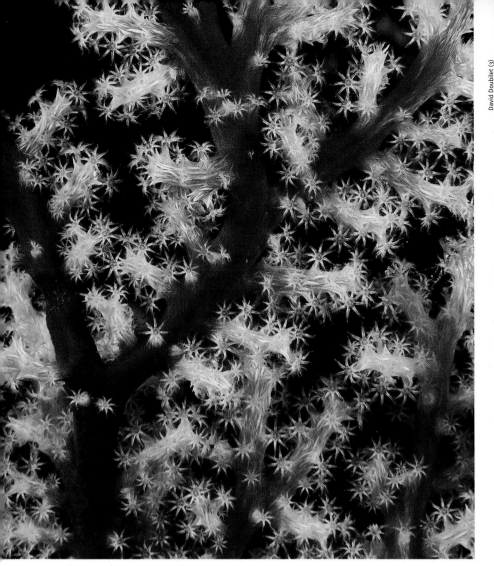

David Doublet (3)

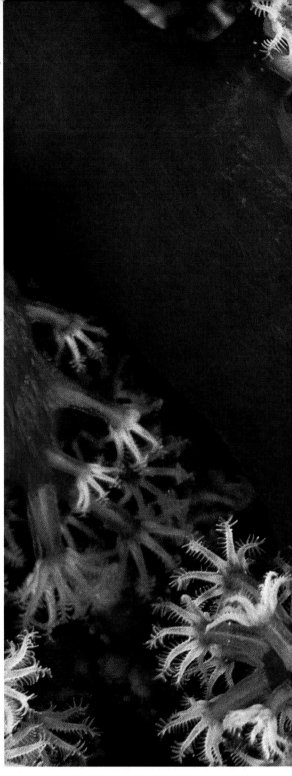

Above and right: soft coral polyps along the Great Barrier Reef. The reef hosts a multitude of life forms, including some that hide amidst their bright surroundings, and others that flaunt their colors. Below: A blue Christmas tree seaworm anchors itself to the coral. Opposite: The clown anemonefish, upon which Disney's intrepid Nemo is based, is a denizen of the reef.

Amos Nachoum/Corbis

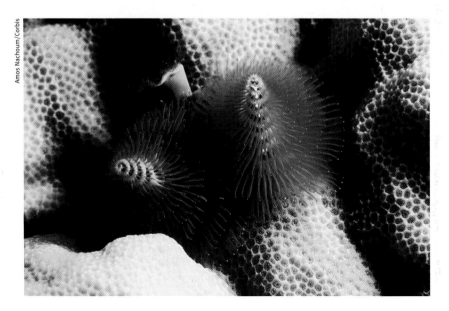

er sea life. Some reproduce asexually by splitting themselves, while others release sperm into the water to fertilize coral eggs. Corals employ poisonous barbs for defense, and use a store of potential energy to shoot them at an enemy at an acceleration rate of up to 40,000 G's, attaining a top speed of two yards per second.

Such rare talent has proved of little use against two fierce and tenacious predators: the crown of thorns seastar, and man. The former is a starfish

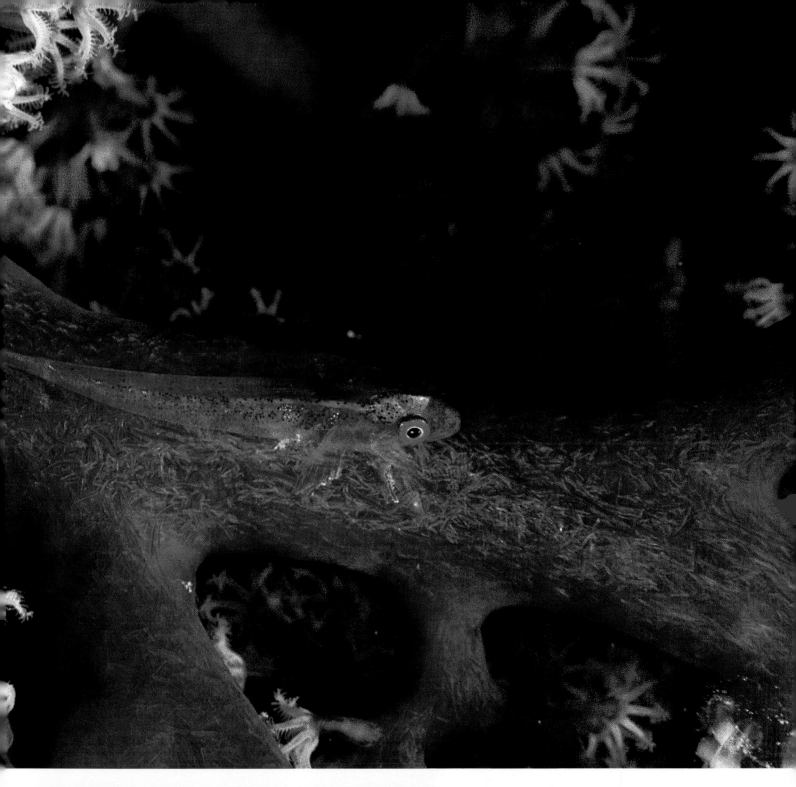

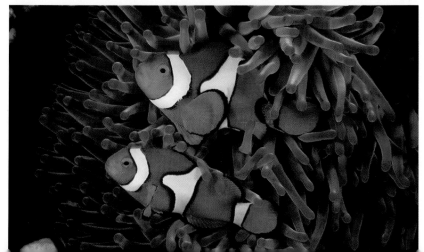

that can grow to nearly two feet in diameter and that has, since 1960, been eating away at parts of the Great Barrier Reef. The latter may be warming the oceans with his industrial ways, perhaps allowing the crown of thorns to proliferate, and is surely polluting the seas, where a most delicate life-death balance maintains. Even something as seemingly innocuous as sunscreen runoff can harm the fragile corals of the reef, and this venerable earthly Wonder now faces a perilous future.

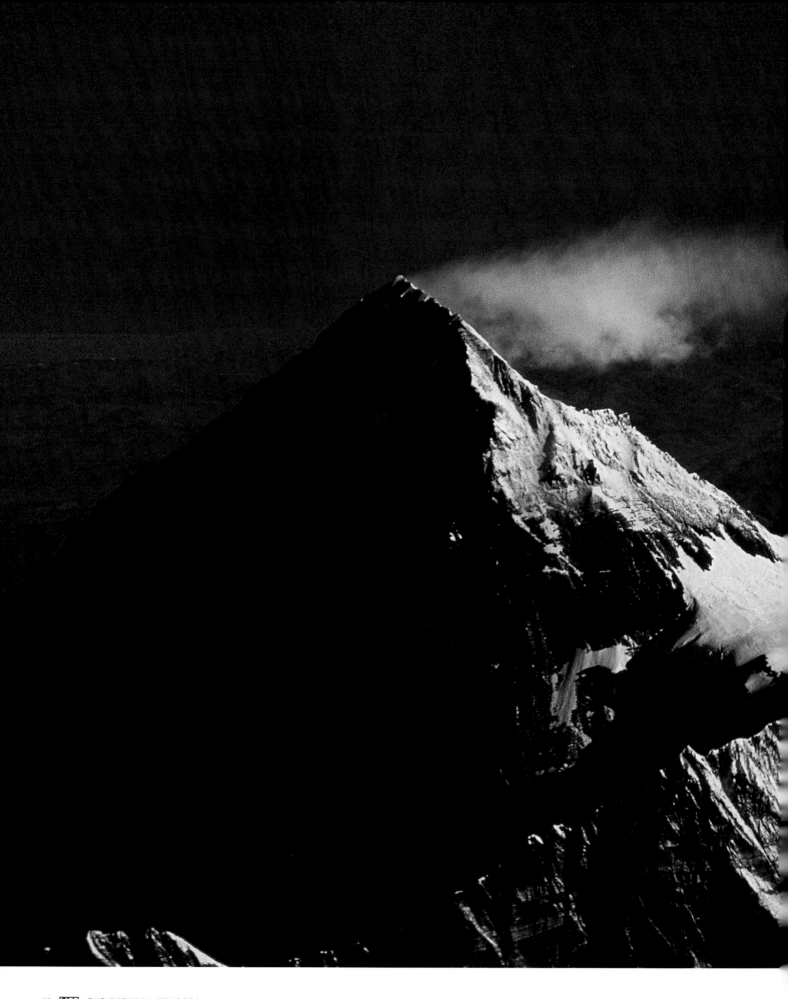

Mount Everest

The storied British mountaineer George
Mallory, who would die on the great
mountain's slopes in 1924, said that he
accepted Everest's challenge "because it
is there." His was a response at once elemental, ominous and thrilling—quite like the peak itself.

The story of the world's tallest mountain began
45 million years ago when the continent of India,
moving northward, collided with Asia. Among the
crash's ramifications was a mountain range that
would become the world's highest. As man eventually entered this history, he bestowed upon these
peaks the name Himalayas, Sanskrit for "abode of
snow." The attitude of that distant past held that
the very highest of these mountains ruled over a
mystical, spiritual realm. Chomolungma, the
Tibetans called it, Mother Goddess of the Earth.

Much of the world knows the 29,035-foot-high
mountain as Everest because in 1856, George Everest led a British mapping expedition to the region.
He called it Peak XV, but others later named it after
him. After the scouting came the climbing: By the
late 1800s, ascents were being made throughout
the Himalayas, and men began wondering how to
conquer Everest—how to overcome its avalanches,
crevasses, bitter cold and relentless wind.

By 1953, when Auckland beekeeper Edmund
Hillary and his Sherpa climbing partner Tenzing
Norgay were tapped by their British expedition to
make a summit assault, there had been decades of
failure and at least 13 lives lost on Everest. Hillary
and Tenzing succeeded, and in their footsteps have
trod hundreds of others. Today, guides lead tours
to the top, and there have been times when dozens
have reached the summit on the same day. For his
part, Hillary feels this World Wonder might be getting less wondrous. "I don't think a climber can get
the same joy out of it as we did," he told LIFE in an
interview. "Those sorts of challenges simply don't
exist anymore. We were born at the right time."

After six million years, the still-evolving gorge, a masterpiece of nature, is 277 miles long, a mile deep and, at its widest, 18 miles across.

The Grand Canyon

Two billion years ago events conspired to begin crafting the incomparable Grand Canyon. What is today magnificent was born in tectonic mayhem as water, erosion and deposition—the formation of rock from various materials—converged. Then, 60 million years ago, two geologic plates collided and a huge plateau built of many sedimentary layers was upthrust. Later still, the river that we now call the Colorado began carving into this block of sandstone, limestone and shale. The river was a sculptor's tool. "The Grand Canyon is carved deep by the master hand," wrote the 20th century botanist and author Donald Culross Peattie. "[I]t is all time inscribing the naked rock; it is the book of earth."

It has a place in natural history, and in the history of our nation. The first people to view the Grand Canyon were Native Americans who came to the region approximately 11,000 years ago. The first European to gaze upon the place, Garcia Lopez de Cardenas, who in 1540 was part of Francisco Vásquez de Coronado's explorations of the American Southwest, misunderstood what his eyes were telling him. Conditioned to the scale of European gorges, he was certain that the wee river below was no more than six feet wide, and that the rocks down there were man-size at best. The Native Americans told him the river was mighty and the boulders massive. Nonsense, said the conquistador, and he and his men spent days trying to reach the river. They never did, and finally admitted the locals were right.

In 1869, Civil War veteran Major John Wesley Powell led a boat trip the length of the canyon, one of the most intrepid explorations in history. Having braved rapids that constantly threatened his team with ruin, Powell exclaimed to his journal, "What a conflict of water and fire there must have been here! What a seething and boiling of the waters; what clouds of steam rolled into the heavens." He was more right than he ever could have known.

John Kieffer/Peter Arnold Inc.

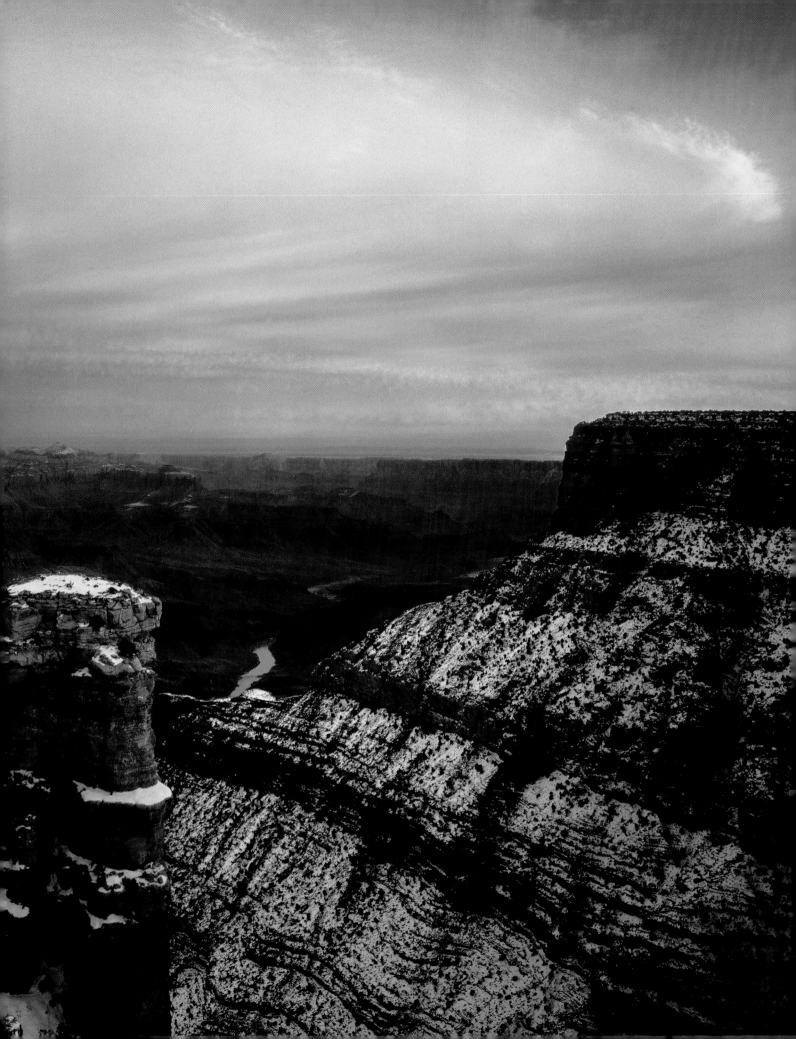

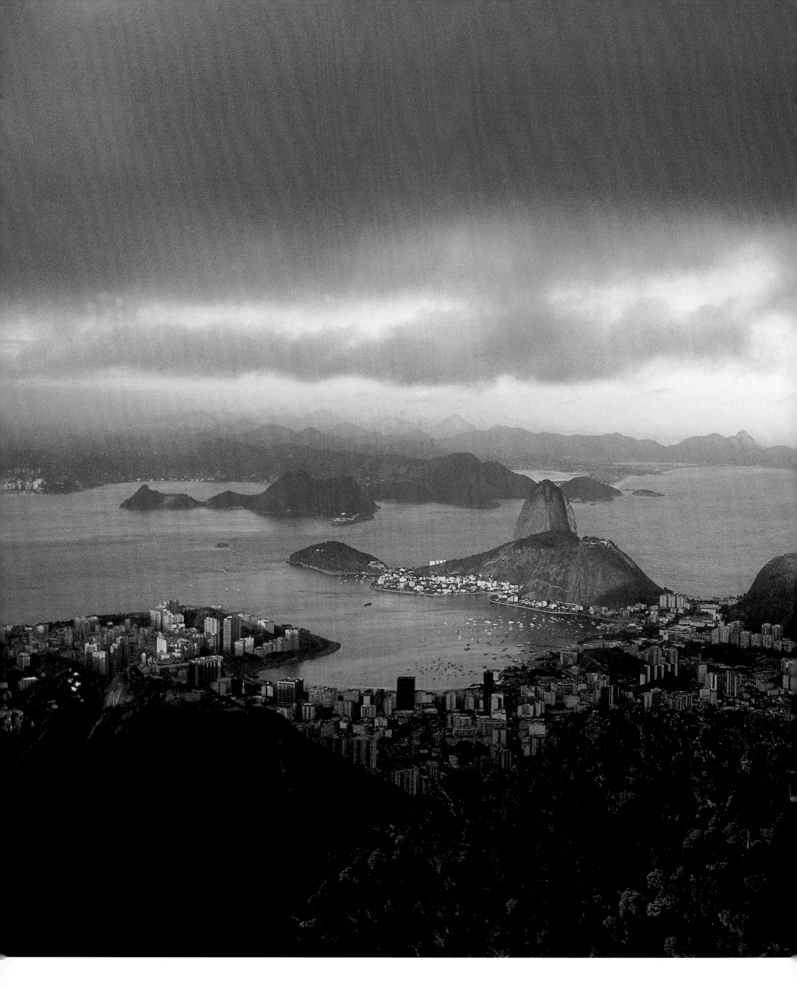

The Harbor at Rio

If there's a harbor anywhere in the world capable of stirring envy in Sydneysiders and San Franciscans, it is Rio de Janeiro's. Encircled by mountain ranges that sweep down to the shore, bespeckled with impressive rock domes, Guanabara Bay nestles behind a mile-wide entrance and extends inland 18 miles, while expanding to a breadth of 12 miles. It is deep, allowing the world's biggest ships access to the wharves; it's not only one of the world's most spacious natural harbors but also one of the safest. The confluence of rugged rock, lush rain forest, shimmering water and 45 miles of crescent-shaped sand beaches—Ipanema, Copacabana—make the setting seem something of a miracle. It is Shangri-La and Bali Hai in one.

Centerpiece landmarks of the harbor are two mountains, Pão de Açúcar (Sugar Loaf) and Corcovado (the Hunchback). The former is a 1,296-foot sentinel that bursts straight up from the water; in the modern day, it can be conquered by cable car. The nearby Corcovado has on its top, perched at the edge of the 2,310-foot-high cliff, what could reasonably qualify, in one of the man-made categories, as a Wonder in and of itself. The Christ the Redeemer statue, seeming to beckon all to overwhelmingly Roman Catholic Brazil, was finished in 1931 and stands a hundred feet tall.

When Portuguese explorers found this harbor in the early 1500s, they made a mistake. Thinking that Guanabara Bay represented the mouth of a river, they bestowed the name Rio de Janeiro—River of January, honoring the month of their arrival. Today's visitors to Rio know just what they're in for: a natural setting of incomparable beauty, backed by a sophisticated, cultured urban center that, even with its legendary crime rate, teems with a lusty love of life. (Rio's pre-Lenten Carnival each February makes New Orleans's Mardi Gras look like a parish social.) Rio has features that are mimicked in other ports-of-call, but nowhere else is like Rio.

Yann Arthus-Bertrand/Altitude

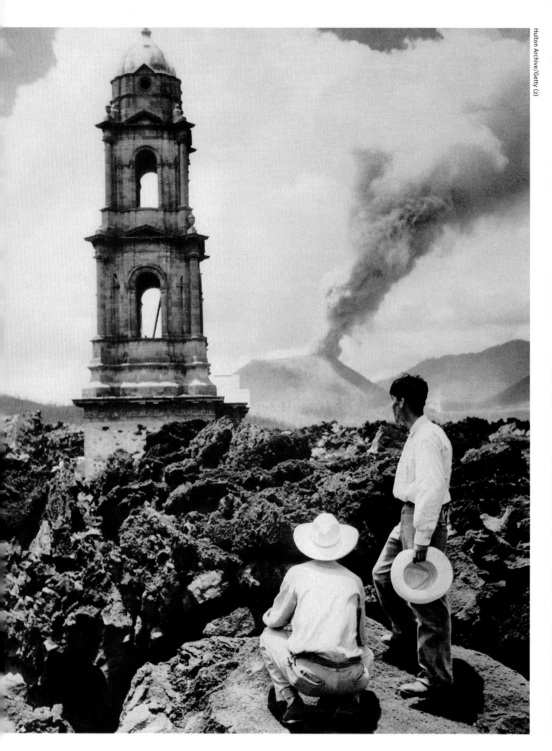

Hulton Archive/Getty (2)

The Paricutin Volcano

To say that the citizens of the Mexican town of Paricutin were surprised is to put it most mildly. One fine morning, you've got a cornfield, stalks waving placidly in the breeze. The next day you've got a nasty, snorting volcano—one growing by the minute.

The first day was February 20, 1943, and local farmers, who were used to seismic rumblings and grumblings in the area but nothing more, were still in the fields. Suddenly the earth shook violently and a vent opened. The farmers fled, some praying as they ran, thinking surely this was a sign from God.

"By the next morning, there was a pile of ashes, one hundred feet high," wrote Isaac Asimov in his account of the event. "By the end of the first year, the volcano . . . had spread out to cover the village of Paricutin, which was buried just as Pompeii had

Once it was a Wonder: For a decade, Paricutin was worth watching as its lava buried the village and most of neighboring San Juan Parangaricutiro save the church. Today, the 1,345-foot-tall volcano lies dormant.

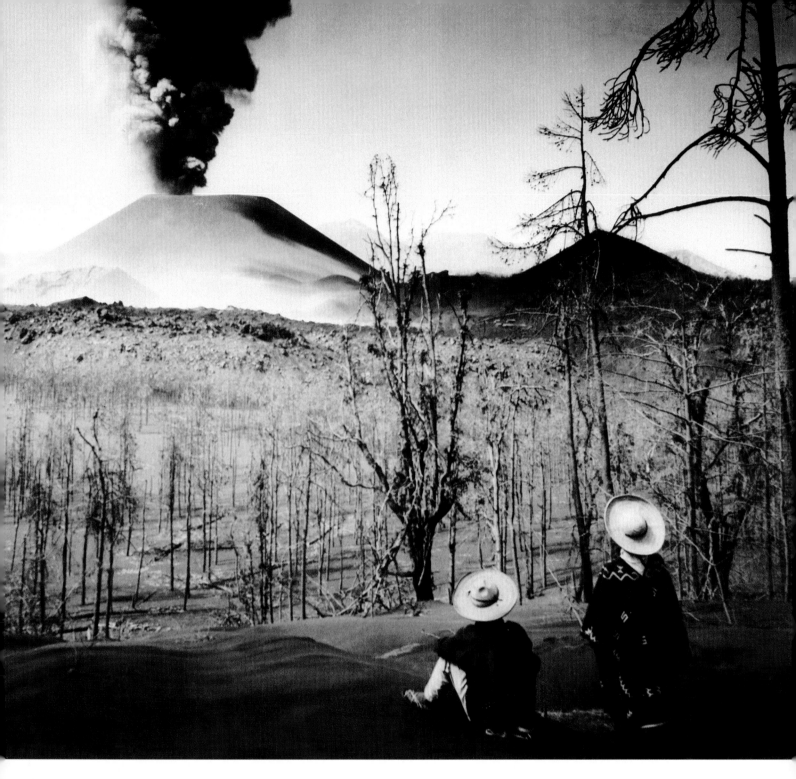

been but more slowly."

In contrast to Pompeii, none were killed by Paricutin's first eruption. But nine years of subsequent blasts, which annihilated not only all of Paricutin village but most of nearby San Juan Parangaricutiro, proved devastating. Paricutin quieted in 1952, and today, to wonder at its being a Wonder is understandable. But its dramatic birth only a short time ago, which offered the modern era an unprecedented look at a volcano's genesis, secures it fame.

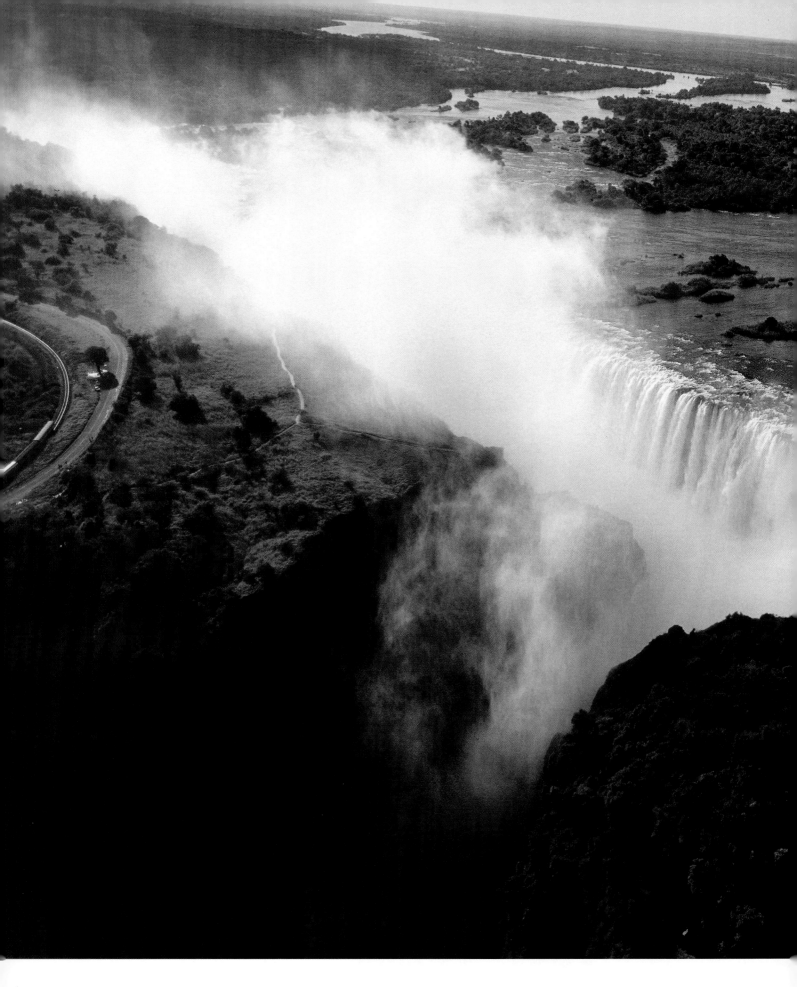

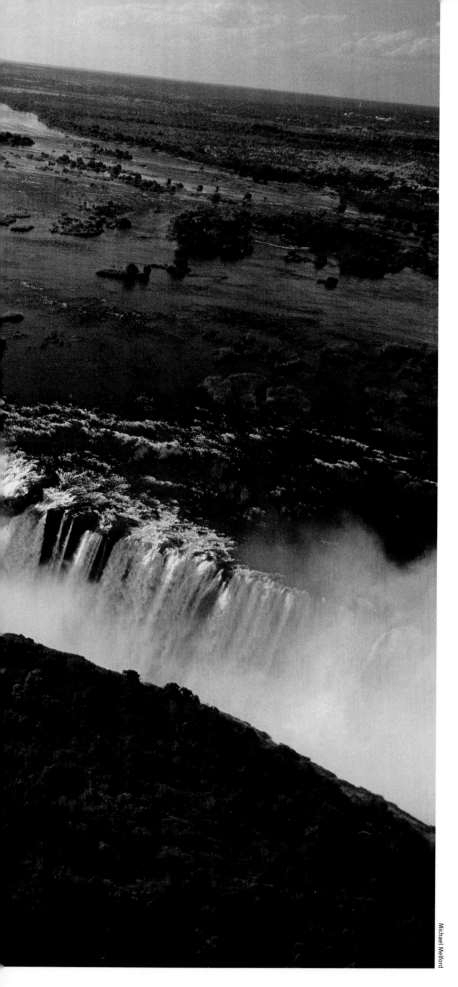

The cloud of water and vapor that is thrown off by the river's plunge can rise as much as a thousand feet in the air, occluding the Zambezi plain.

Victoria Falls

Large waterfalls are of such variety that they impress in different ways. There is the ethereal wispiness of a high falls viewed from afar, its spray drifting and the sound of the river barely discernible in the breeze: Angel Falls, Yosemite Falls. There is the dramatic tumult of long cascades over big rocks, such as those in raging rivers of the American West: the Tuolumne, the Snake. And then there is the sturm und drang of a wide and mighty stream finding itself, suddenly, at a precipice—with no option but to jump. The cauldron that is Niagara comes to mind. And even more—Victoria.

The Zambezi River has an easy time of it as it rolls Mississippi-like through south-central Africa. By the time it reaches the edge of a 350-foot-deep rift at the Zambia-Zimbabwe border, it is more than a mile wide, fat and carefree. Then its reverie is shattered. The Zambezi's waters are flung into the abyss and crash toward Batoka Gorge, furious and frothing now, redirected to Mozambique Channel, thence to the sea. As the river tumbles, it throws off spray, and Victoria Falls's hallmark characteristic forms above the cliffs. *Mosi oa Tunya,* the locals called this phenomenon for centuries before the white man arrived: The Smoke that Thunders.

That white man was none other than David Livingstone, the famous Scottish missionary and physician tracked down, in 1871, by Henry Stanley ("Dr. Livingstone, I presume?"). Earlier, in 1855, Livingstone was exploring the Zambezi when natives took him to the falls. He wrote for the folks back home an effective metaphor, suggesting that if one imagines "the Thames leaping bodily into the gulf, and forced there to change its direction, and flow from the right to the left bank, and then rush boiling and roaring through the hills, he may have some idea of what takes place at this, the most wonderful sight I had witnessed in Africa." Livingstone, dutiful son of the Empire, named that sight for Queen Victoria.

The Aurora Borealis

They are otherworldly Wonders, of neither the earth nor the sea, animated in the extreme but without animal spirit, a sensory experience beyond just the visual. They have been seen through the ages as omens, portents, signs and symbols: In the event, they are an interaction of particles, forces and gases that produces images of poetic beauty. They seem miracles of nature, though they are, in fact, rational, scientific, pure, even clinical.

The Northern Lights are as natural as air. Massive discharges of hydrogen from the sun transform into a gas of energized electrons and protons, and this "plasma" travels through space on the solar wind. Within five days of departing the sun's realm, some of the plasma reaches Earth. Grabbed by the planet's magnetic field and pulled downward toward the north and south magnetic poles, the charged particles from the sun interact with atoms of oxygen and nitrogen, and juiced-up ions are produced. Energy is thrown off, and on the planet's nightside, the various wavelengths show themselves in patches, arcs and draperies of green, white, yellow, red and turquoise light. (Interestingly, every aurora borealis has a southern parallel visible primarily over Antarctica. The aurora australis gets short shrift, however; only the Northern Lights, viewable by more people, are judged a Wonder.)

The science is interesting, the mythology more so. Canadian Inuit legend held that a heavenly light was emitted via holes through which the dead could pass. Alaska's Point Barrow natives considered the lights evil, while East Greenland Eskimos thought they were the spirits of children who died at birth. Some medievals felt that the glow reflected deceased warriors, while others read ominous warnings of plague or conflict. Many cultures have theorized that the lights were some sort of game being played by the dead. The aurora borealis has long been a powerful force—in fact, and in fancy.

Fred Hirschmann

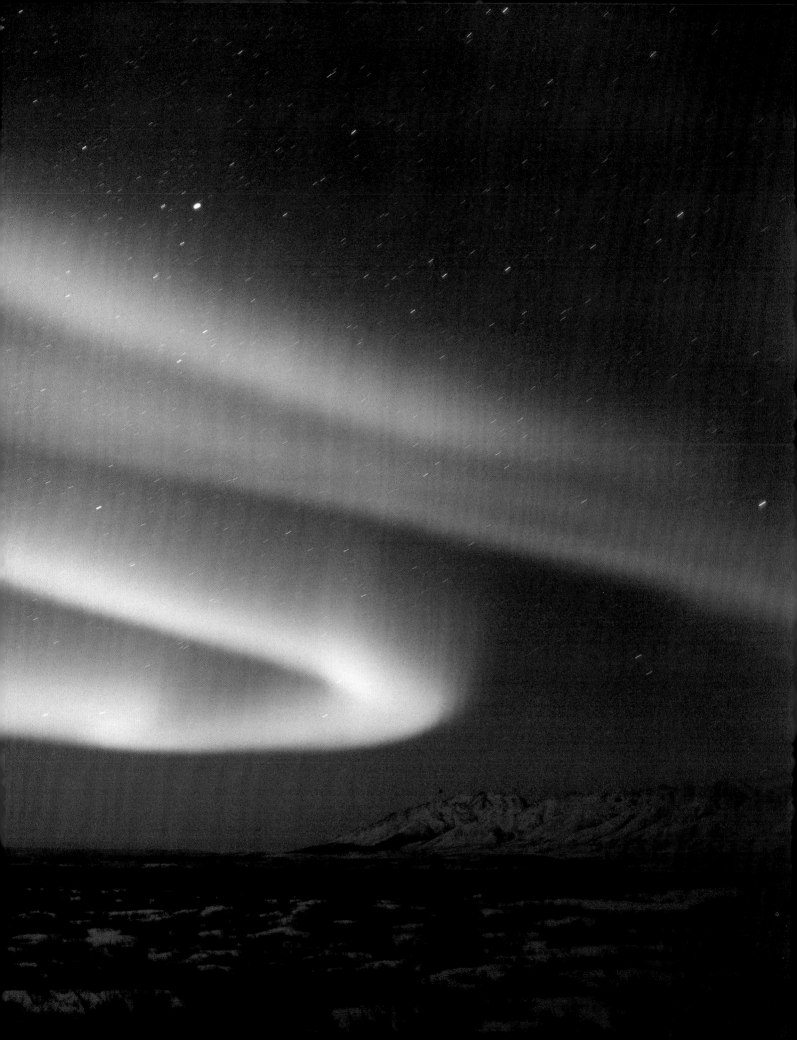

The Seven Forgotten Natural Wonders of the World

A problem with these Forgotten Wonders lineups is that, inevitably, the members take on a second-string aspect. This is, of course, unfair. As we have noted, it's a ludicrous judgment to say Angel Falls or Niagara Falls is somehow less wondrous than Victoria—but in a book such as this, that is our hard task. Those two waterfalls are cited on a Forgotten Natural Wonders of the World list that has emerged as authoritative, as is a third falls: Iguaçu, on the border of Brazil and Argentina. Mountains are big on the list too: Tanzania's Kilimanjaro, Japan's Fuji. Indonesia's volcanic island of Krakatoa and Canada's Bay of Fundy make seven.

Bay of Fundy The world's highest tides afflict Nova Scotia.

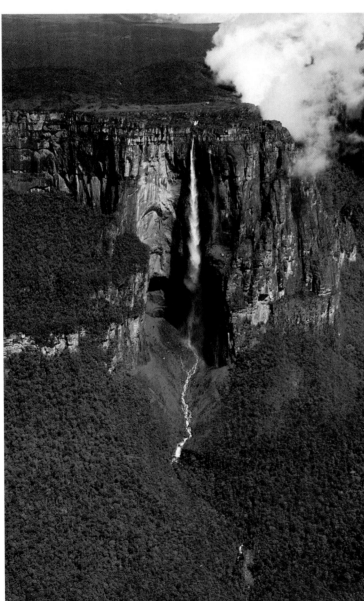

Angel Falls The world's tallest falls (3,212 feet) is in Venezuela's jungle.

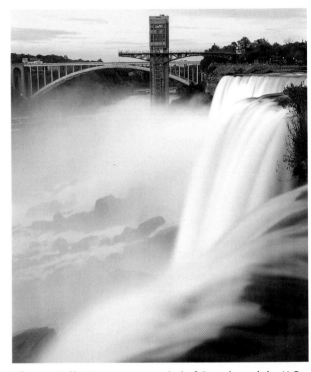

Niagara Falls Honeymoon capital of Canada and the U.S.

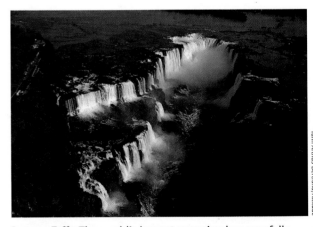

Iguaçu Falls The world's largest grouping has 275 falls.

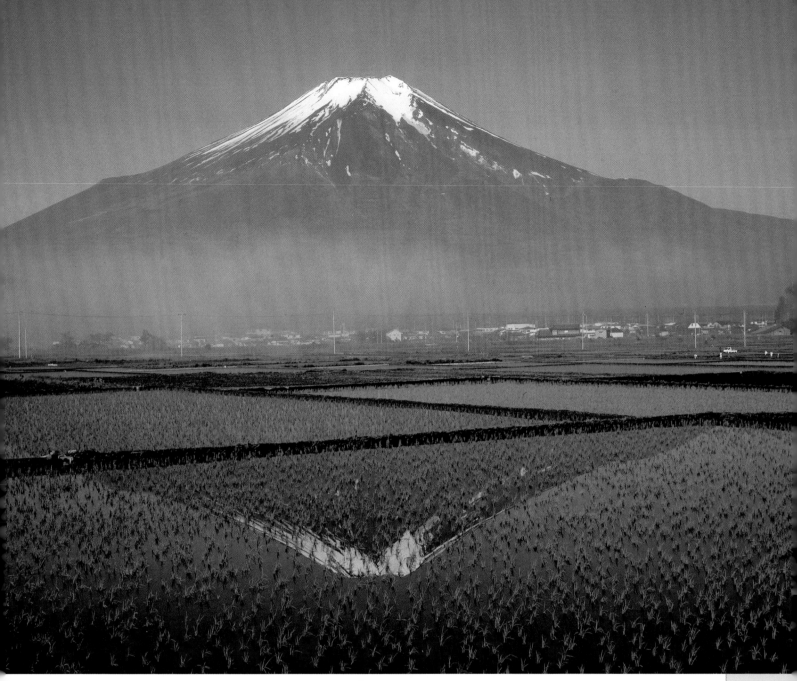

Mount Fuji At 12,388 feet, Japan's highest peak is a volcano that last blew in 1707. Some 12.5 million people live unsettlingly near it.

Charles O'Rear/Corbis

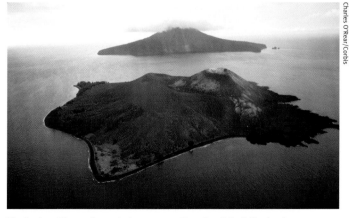

Krakatoa The volcano's huge eruption in 1883 killed 36,000.

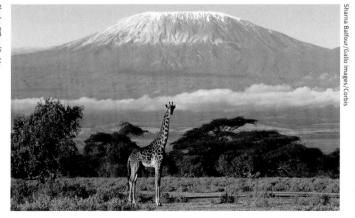

Sharna Balfour/Gallo Images/Corbis

Mount Kilimanjaro Its snows were immortalized by Hemingway.

The Seven Wonders of the
Modern World

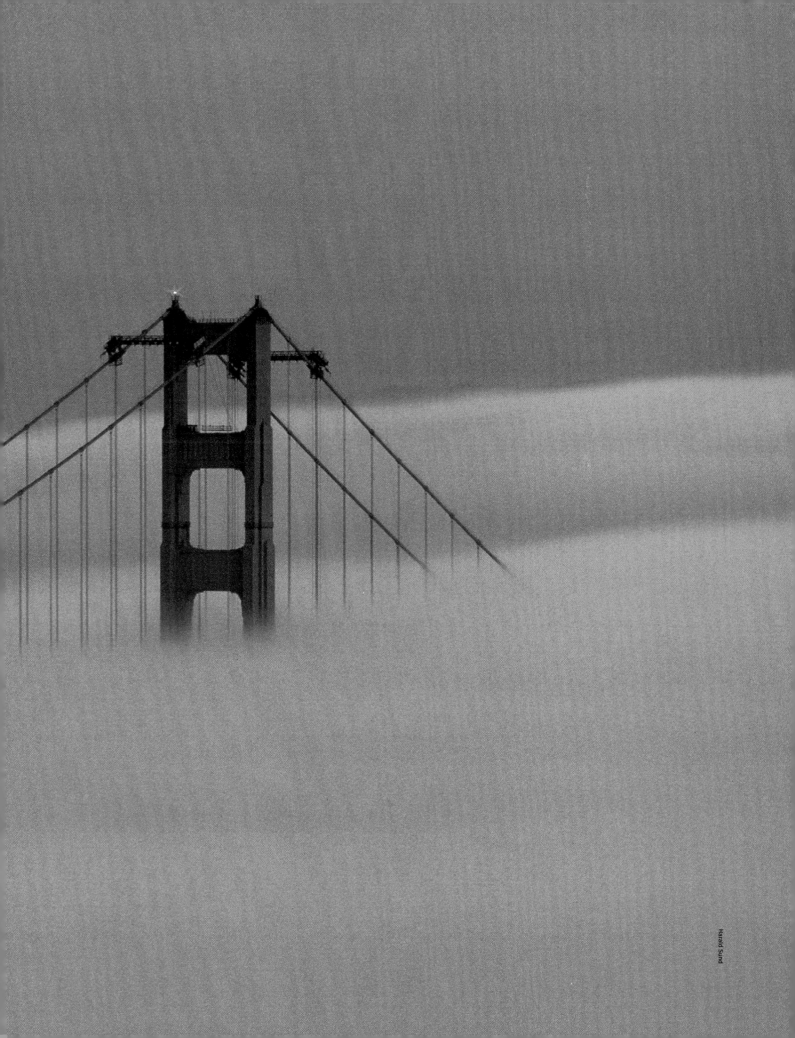

Wonders of **Today**...and **Tomorrow?**

As with the Natural Wonders, there is little consensus regarding the roll call of Modern Wonders. What is clear is that, in the 20th century, people who care about such things as World Wonders—people like us, people like you—felt it was high time for another list. The kind of technological derring-do behind the Pharos, or the architectural genius evident in Hagia Sofia, was at play in the world, and marvels being created in the here and now demanded attention. And so attention was paid, in one of the earlier Wonders of the Modern World lists, to the Eiffel Tower in Paris, the Empire State Building in New York City, Egypt's Suez Canal, San Francisco's Golden Gate Bridge, the dam on the Dnieper River in Russia, the Atomic Energy Research Establishment in Harwell, England, and Alaska's Alcan Highway.

The problem with an association having anything to do with "the modern day" is inherent: Mod-

The American Society of Civil Engineers named both Toronto's Canadian National Tower (above) and New York City's Empire State Building in its Modern Wonders list. But LIFE gives the nod to only one.

Through the years many other moderns have been nominated: the Akashi Kaikyo Bridge, a suspension span between Kobe and Awaji Island, Japan; Biosphere 2, the sealed environment in Arizona; the Aquarius underwater research lab in Florida; the Sydney Opera House in Australia; the Concorde supersonic airplane; the space shuttle; and a host of big buildings: Chicago's Sears Tower, Toronto's CN Tower, and Kuala Lampur's twin Petronas Towers, which are currently the world's tallest office buildings.

In 1996 the American Society of Civil Engineers, having conducted a worldwide survey, weighed in, and their list is compelling. A couple of the classics—the Empire State Building, the Golden Gate Bridge—were retained, for reasons that will be explained in the pages to follow. The Itaipu Dam in South America replaced the Dneproges, the Panama Canal was chosen instead of the Suez, the North Sea Protection Works, which is essential to the Netherlands' continued well-being, made the list as did the awesome Channel Tunnel linking England and France. While we found the society's reasoning for these inclusions persuasive, their seventh choice was the CN Tower,

ernity is ever-changing, and last week's cutting edge is tomorrow's rusty blade. How long it took for the 1940s-vintage Alcan Highway to look like just another road (albeit a really long one at more than 1,500 miles) may be open to debate, but it is certain that no self-respecting 21st century Modern Wonders list could include the facility at Harwell. Yes, it was state-of-the-art when it opened in 1947, but it is in the process of being decommissioned. There's still an archive at Harwell, but an archive is something less than a Wonder.

and we were reluctant to have two skyscrapers. So we replaced the Toronto landmark with a different animal altogether: the enormous CERN facility in Switzerland. Our rationale follows; see what you think.

A postscript: Since evolutionary principles are written in stone and the future draws closer each day, it's probable that one of our seven Moderns will soon be replaced. In 2006, if things progress according to plan, the International Space Station, the orbital outpost currently under construction on high, will be completed.

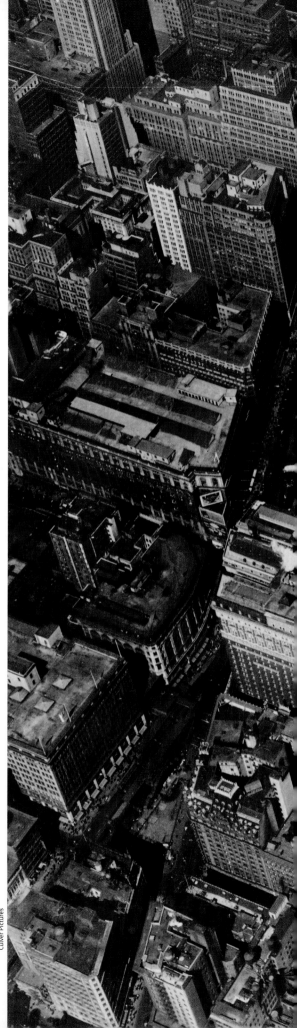

The Empire State Building

Among skyscrapers, the Empire State Building stands tall, even if, at 1,454 feet high, it is no longer the tallest. Malaysia's Petronas Towers became the world champ office buildings in 1998, measuring 1,483 feet apiece; the CN Tower in Toronto, built in 1976 to support an antenna, is the world's tallest freestanding structure at 1,815 feet, five inches. In any event, the Empire State is still the world's iconic big building, a skyscraper's skyscraper.

Its stature as a world Wonder is secure for all time not simply because of what it is, but also for how it came to be. In assessing the building's merits for its list of seven, the ASCE rightly acknowledged that it remained "the best-known skyscraper in the world, and was by far the tallest building in the world for more than 40 years," then added pointedly: "The building's most astonishing feat, however, was the speed in which it rose into the New York City skyline. Construction was completed in only one year and 45 days, without requiring

Modern lighting schemes honor everything from America (red, white, blue) to Bastille Day (blue, white, red), from St. Valentine's Day (red) to the Big Apple Circus (also red). A dark tower might nod to AIDS Awareness Day, or to an avian migration (the lights attract—and imperil—birds). In the background above, the twin towers.

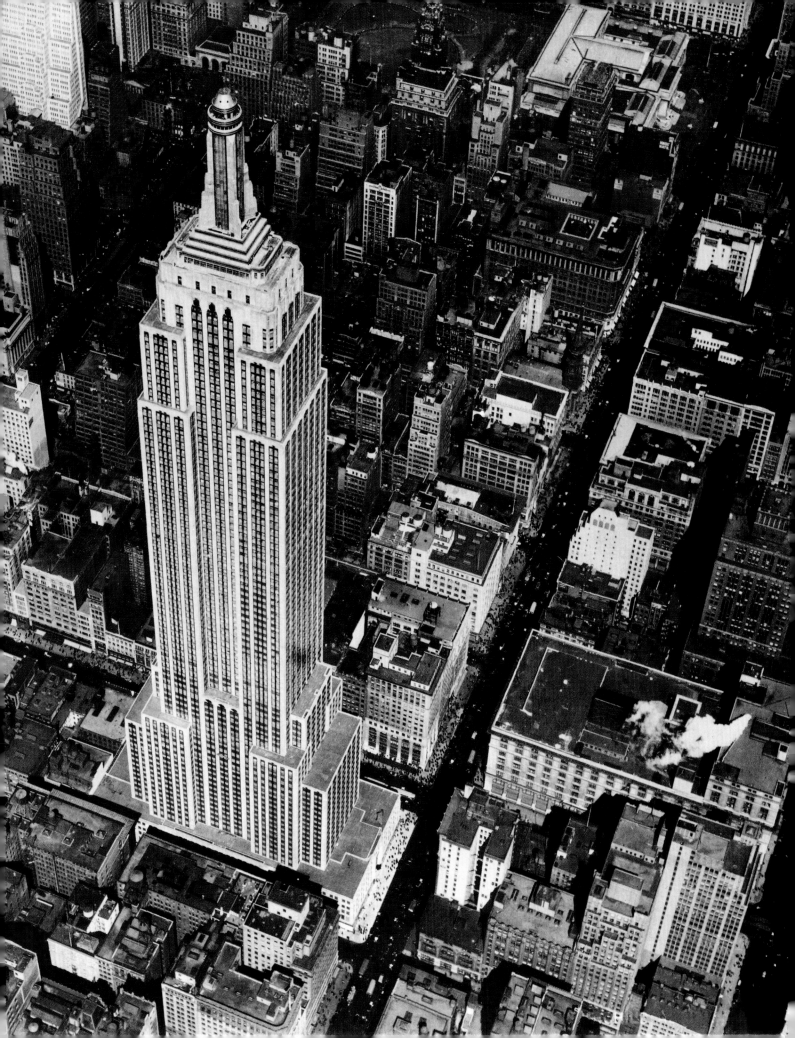

The building was named for New York, the Empire State. The men who built it on 34th Street and Fifth Avenue knew their tower would overtake the nearby Chrysler Building (faintly visible behind this steelworker), which briefly was the world's tallest.

overtime. Ironworkers set a torrid pace, riveting the 58,000-ton frame together in 23 weeks. While just below them, masons finished the exterior in eight months, as plumbers laid 51 miles of pipe and electricians installed 17 million feet of telephone wire. The building was so well engineered that it was easily repaired after a bomber crashed into it in 1945. The precise choreography of the operation revolutionized the tall building construction industry."

Civil engineers are wont to gush over 58,000-ton frames and 17 million feet of wire, but a factor equal to the technological achievement in the Empire State's fame has been its aesthetic. At its 1931 dedication, Depression-era masses cheered (and were cheered), and nothing in the intervening decades served to diminish the tower's particularly American luster. "The Empire State Building,

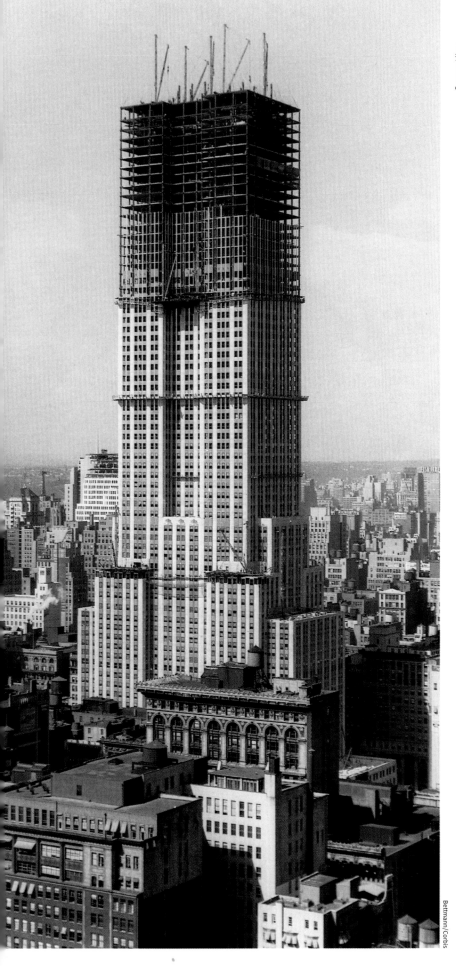

Paramount News

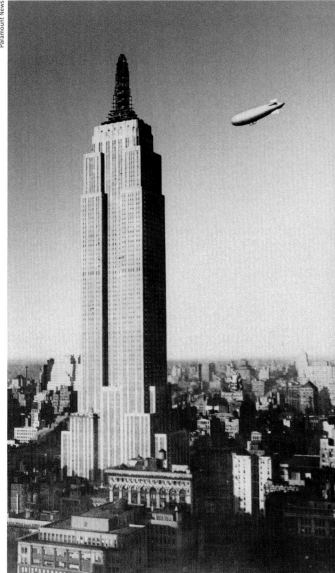

As the building rises in 1930, an exciting prospect is that its mast might be used to moor dirigibles. On December 16, however, high winds prevent this U.S. Navy airship from docking.

like most art deco skyscrapers, was modernistic, not modernist," wrote Edward W. Wolner in the *International Dictionary of Architects and Architecture.* "It was deliberately less pure, more flamboyant and populist than European theory allowed. It appeared to be a sculpted or modeled mass, giving to business imagery a substantial character."

The Empire State's success had much to do with ingenuity, frightfully hard work and even genius—but nothing to do with luck. It is one of the few skyscrapers in New York that confidently, even brazenly, gave its 13th floor the appropriate number.

Bettmann/Corbis

Below: In 1913, workers dig by hand through the Cucaracha Slide during construction of the canal's Galliard Cut. Today, passage through the cut for a cargo ship is serenity itself (right).

The Panama Canal

This famed channel through the Panamanian isthmus afforded the world not only convenient passage from Atlantic to Pacific but also, thanks to master palindromist Leigh Mercer, a most clever phrase: "A man, a plan, a canal—Panama!" Mercer issued his bon mots in 1914, the very year the canal opened. Make that: *finally* opened. It had been either a decade or 34 years in the building, depending on how you reckon it, and far longer in the dreaming.

In the 16th century, Spanish conquistadors in Central America foresaw an oceanic shortcut that would shave weeks off trade routes around South America. But the strong spine of the Continental Divide ran right down the isthmus, and in those days there was no technology to break that Panamanian back. It wasn't until the 19th century that a man, the legendary French canalmaker Ferdinand de Lesseps, felt sure he could succeed in the task.

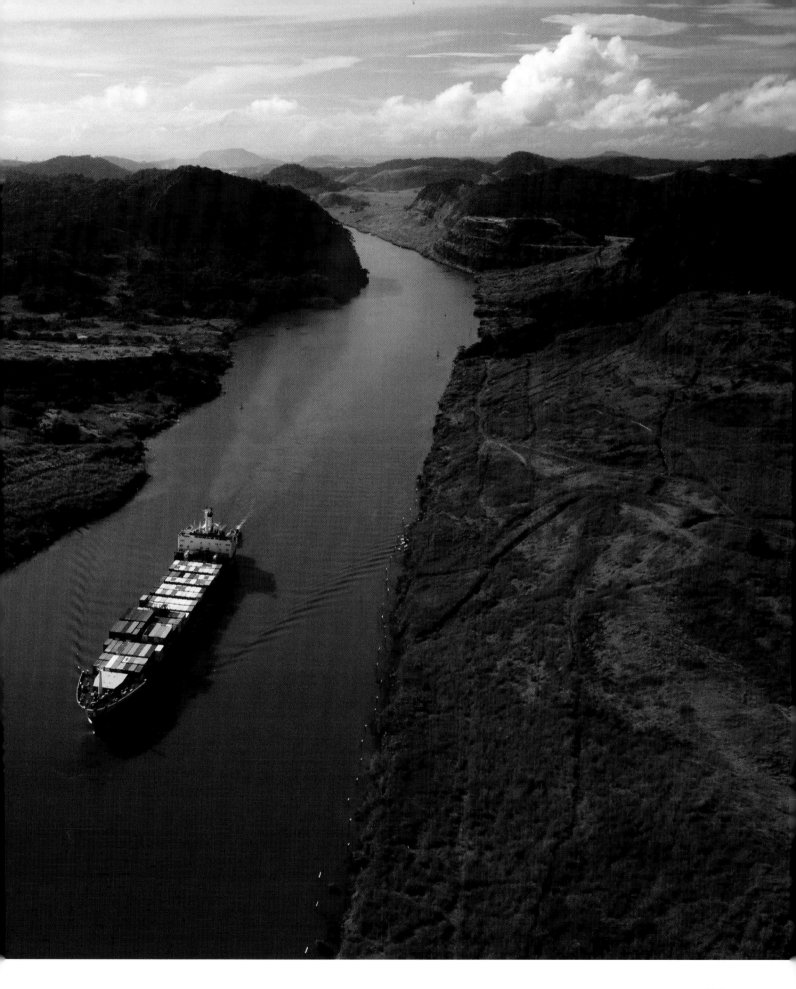

Top: Two men stand on rail tracks used to transport materials to the canal locks behind them, which would swing into action a year later.

De Lesseps' confidence was merited, even if the arc of his life stands as evidence that the Panama Canal—and not the Suez—is the Wonder. From 1859 to '69, he oversaw the carving of the Suez between the Mediterranean and Red seas, roughly following a canal route dug by the earlier Greeks and Romans (whose decline allowed the passage to fill back in). Now, on the first day of 1880, de Lesseps' daughter Fernanda scooped a symbolic first shovel of sand to launch the Panama project.

French engineering was at the time regarded as the best in the world, but Panama beat it back. Years of ferocious work under horrendous conditions (tropical storms, hellish heat, malaria) left de

Lesseps' operation bankrupt in 1889, the canal a third finished. De Lesseps died in 1894, and that year a second French effort was begun. More than a decade later, success still uncertain, the U.S. rode to the rescue. In 1907, Col. George Washington Goethals marshaled more than 42,000 men, who eventually moved enough dirt to bury all of Man-hattan 12 feet under. They tamed the raging Cha-gres River with a dam that created what was then the world's biggest man-made lake, and built the largest gates ever swung—Ishtar's included. The cost to both the French and Americans by the time the canal opened for business on August 15, 1914, was $639 million, and more than 30,000 lives.

Taking shape: As the project nears completion, a ditch starts to resemble a canal (opposite, bottom and above, on March 18, 1914).

Some 160 tons of water pour onto each of the Itaipu's turbines every second. The dam's powerhouse itself is half a mile long.

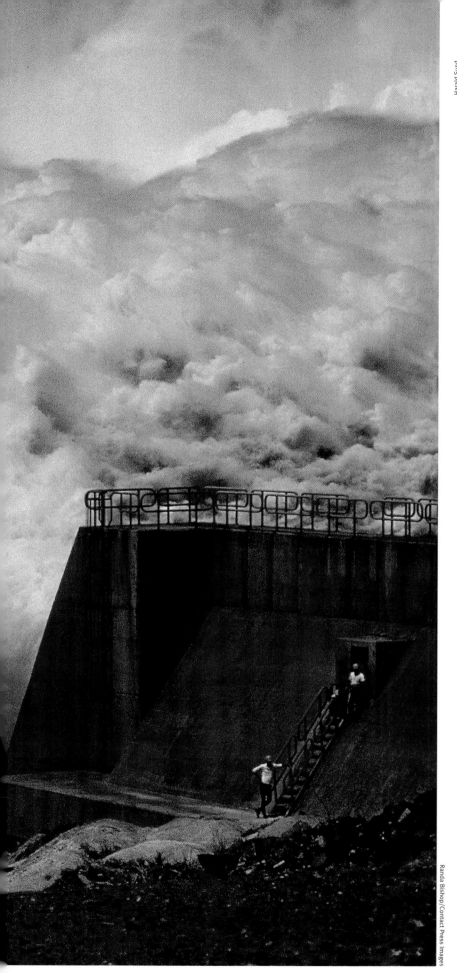

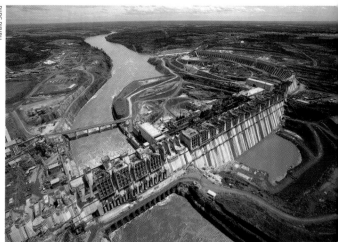

Itaipu Dam

When regarding such engineering marvels as the Panama Canal or the North Sea Protection Works, both of which utilize mighty dams in their myriad operations, it's tempting to say that the Itaipu hydroelectric plant on the Brazil-Paraguay border is just a dam. But then, the Pacific is just an ocean; Jupiter's just a big planet.

In several categories of colossalness, the Itaipu registers stats to shame other Wonders. Its volume of concrete is 15 times that used in the Channel Tunnel (or, vis-à-vis dams, five times Hoover's). It has an equivalent tonnage of iron and steel to 380 Eiffel Towers. It's a darned big dam and, ever since its completion in 1991, the most powerful anywhere.

Located 10 miles north of the International Bridge, which links the cities of Foz do Iguaçu, Brazil, and Ciudad del Este, Paraguay, the Itaipu is, actually, a series of dams on the seventh largest river in the world, the Paraná, whose course was shifted 1.3 miles during construction by the removal of 50 million tons of rock. That construction involved 16 hard years of labor and yielded walls as high as a 65-story building, 18 hydroelectric generators each 53 feet in diameter, and a constant generating capacity of 12,600 megawatts. That's an abstract figure that becomes real when you learn the Itaipu accounts for a quarter of Brazil's annual energy supply, and more than three quarters of Paraguay's. It alone could power nearly all of California—a prospect that would no doubt have Golden Staters, with all their energy woes, salivating.

Work on the $16 billion Chunnel was completed in 1994. It is multichambered, as pistons open and close ducts to relieve air pressure that builds ahead of an onrushing train. Below: Calais.

The Channel Tunnel

O f all the world's massive construction projects undertaken near the end of the previous millennium, one effort unquestionably qualified as a Wonder—not least, as it answered a centuries-old dream, that of uniting England with the European continent. We speak, of course, of the 31-mile Channel Tunnel, affectionately known in Britain, France and the wider world as "the Chunnel." In looking at a project that displaced three times more earth and rock than the building of Khufu's pyramid in Egypt, the folks at the American Society of Civil Engineers were breathless when citing the Chunnel as one of their Modern Wonders: "[I]t rolls infrastructure and immense machinery into an underwater tunnel system of unprecedented ambition." The ASCE went on to describe three concrete tubes *plunging* into the earth at Calais, France, then *burrowing* "through the chalky basement of the English Channel. They reemerge at Folkestone, behind the white cliffs of Dover. Through two of the tubes rush [trains] traveling close to 100 mph . . . Maintenance and emergency vehicles ply the third tunnel, between the rail tubes. Meanwhile, machines are always at work, turning the Channel Tunnel into a living, intelligent structure." All the while performing another sort of miracle by showing, on a daily basis, the British and the French in concert.

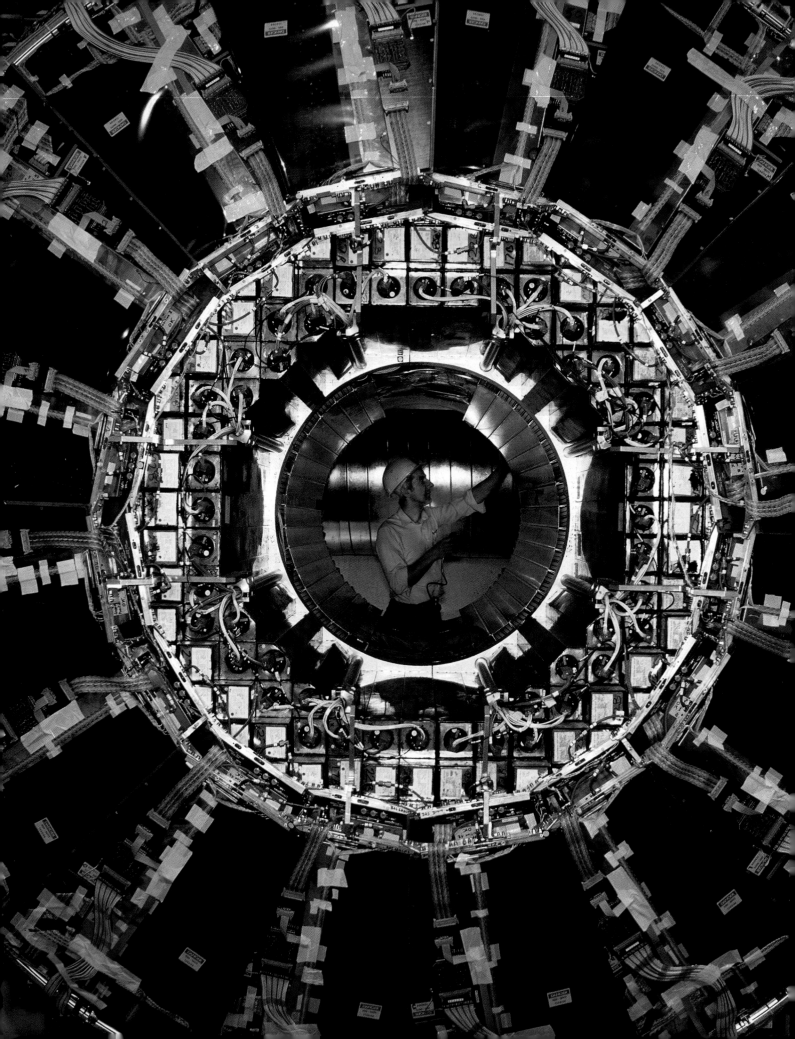

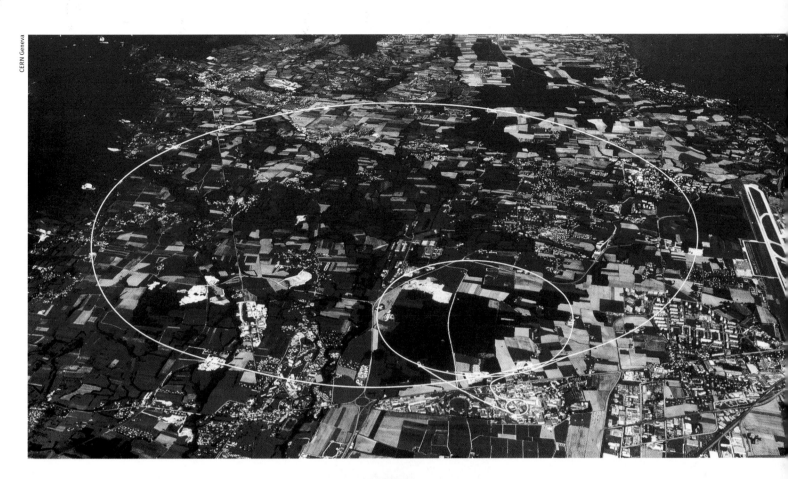

CERN

Considering that it is most famous for those awesome tools with the sci-fi nickname—"supercolliders"—CERN (Conseil Européen pour la Recherche Nucléaire) is subtle. Founded in 1954 near Geneva, it has grown to be the world's largest particle physics center. It has 20 member states now, and its doors are open to all: 40,000 visitors tour CERN annually, and 6,500 scientists from 500 universities in more than 80 countries come to do experiments. They are investigating, according to CERN's James Gillies, "what the universe and everything in it is made of, and why it behaves the way it does." Quite so, but you never know what CERN's 3,000 worker bees, several of whom have won Nobel Prizes, might come up with. In 1990, one of them invented the World Wide Web.

It is the supercolliders, however, that grab the attention, and this is inevitable as these are utterly fantastic research devices. Consider CERN's Large Electron Positron Collider, heretofore the world's biggest. Its 4,600 magnets and many boosters send electrons and positrons flying in opposite directions through a four-yard-wide aluminum tube, round and round a 17-mile loop. Every 22 millionths of a second, particles smash into one another, simulating ever closer the instant of the Big Bang. All along, the supercollider's detectors record vital data.

It's cosmic, and will soon be more so, as the even more powerful Large Hadron Collider, now being built at CERN, is due to come online in 2007.

A succession of CERN colliders have sent particles zooming through underground tunnels (outlined above), yielding info that could prove of use in outer space or in your local hospital.

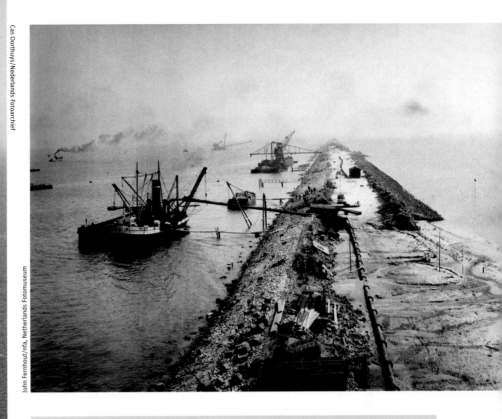

The North Sea Protection Works

As we know, Hans Brinker held back the North Sea by plugging a leak with his finger, and thus saved his country, the famously low-lying Holland. To keep the ocean at bay today requires an extravagant network of dikes, barriers, floodgates and other water-manipulating devices. Two conclusions: The North Sea Protection Works, which has bent but never broken, is a marvelous machine. And, that Hans must have been quite a lad.

Much of the Netherlands lies below sea level, and the Dutch have always used dams to protect fields and, indeed, themselves. (Were this not the case, half of Holland would be washed over daily by the tides.) By the 20th century, new technologies were becoming available to combat storm surges that overwhelmed existing structures; a devastating storm in 1916 was a catalyst for action.

The North Sea Protection Works is a system of structures and strategies put in place during the remainder of the century. It began with a 19-mile-long dike that closed the Zuider Zee, a tidal inlet that was subsequently drained, resulting in a half million acres of new farmland. In 1953 the "storm of the century" hit, but the dike, 100 yards thick at

The newer additions to the nationwide Protection Works, which include dams, supported dunes and giant protective gates that drop only in high weather, have sometimes required artificial islands to be built offshore, as well as the invention of new machinery for specific, never-before-encountered tasks.

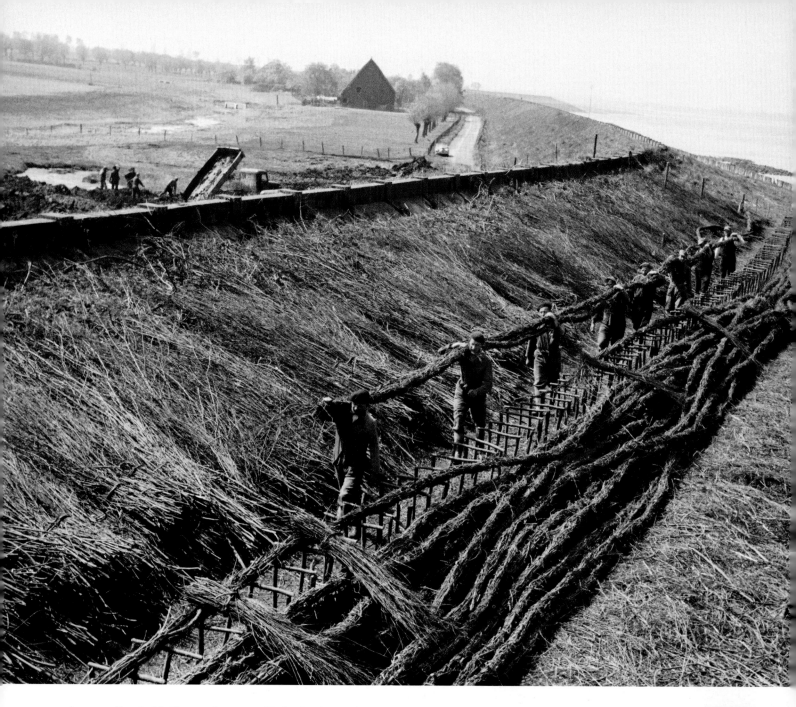

the waterline, held. The southwestern Netherlands was wrecked by the storm, however, and in the decades since, the Delta Project—dikes, dams, gates and channels—has been added, and in 1997, a barrier was built to protect Rotterdam.

The magnitude of the North Sea Protection Works has been compared to the Great Wall, and its technological sophistication to that of the first lunar landing. Metaphors are useful, but they obscure one point: The complex system is wholly unique, a testimony to its many designers and to the will of the Dutch people to dare a civil engineering project on the most monumental of scales. It is as daring and tenacious as . . . well, Hans Brinker.

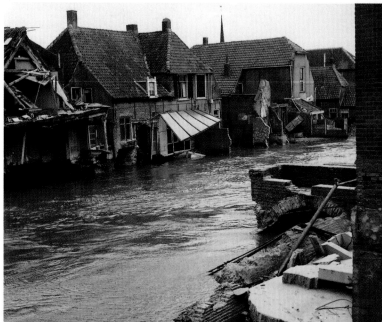

Georg Gerster/Rapho

W.F. Heemskerck-Düker/nfa, Netherlands Fotomuseum

Opposite: The 1953 storm wreaked such havoc, killing nearly 2,000 people and hundreds of thousands of animals, that action was demanded. The Works' original dam, badly damaged but intact, was soon joined by more sophisticated structures like these reinforced dunes.

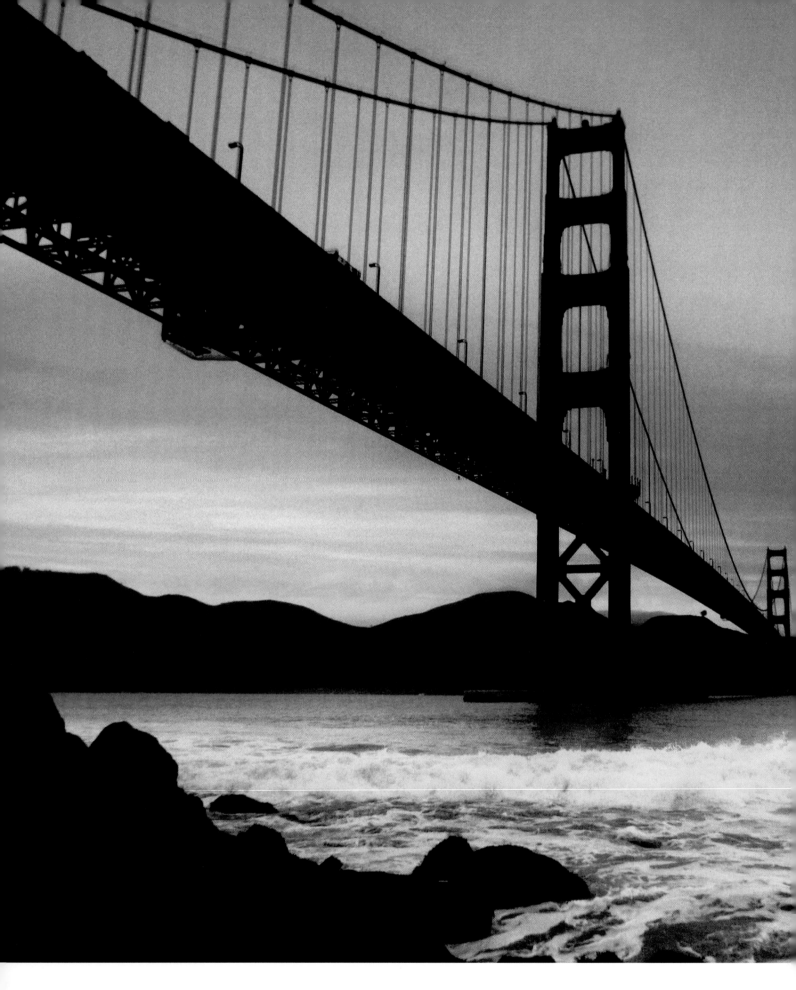

AP

Daniel Berehulak/Getty

The Golden Gate Bridge

The "bridge that couldn't be built," was an appellation bestowed, after its successful completion in 1937, upon a bridge that had in fact already been built. The product of Depression-era gutsiness and hope-against-hope, the Golden Gate Bridge was at once a marvel and a miracle. It was not only the longest suspension bridge in the world, it was also the first to span the mouth of an ocean harbor. And, to top it all, it was beautiful.

As opposed to many other outsize U.S. construction projects of the 1930s, the Golden Gate was not conceived as simply a means to utilize a dormant workforce or to energize a local citizenry. In fact, efforts to build the bridge began in the '20s, when things were still roaring and the world seemed to be the bee's knees. In 1928, six counties in northern California came up with a proposition and began floating it; in 1930, after the market had crashed but before the full ramifications set in, vot-

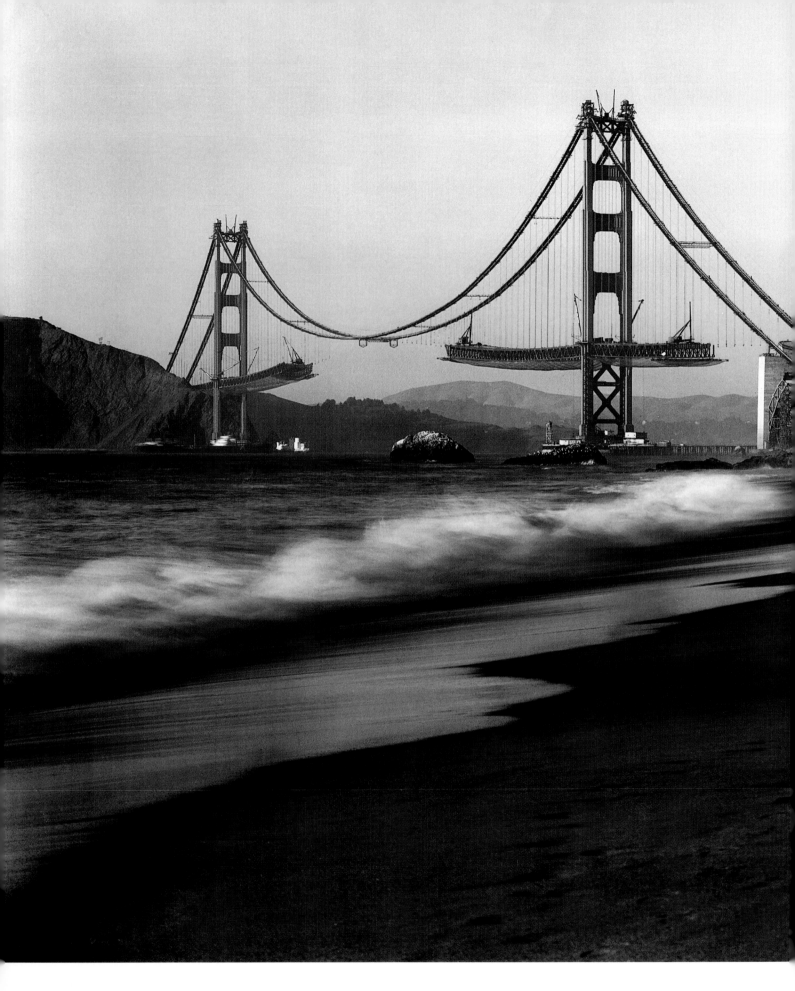

Above: Support cables came first, then a steel drapery was hung from them to hold the base upon which a road would be built. Today, the bridge is being retrofitted to withstand an 8.3-Richter-scale earthquake.

ers approved a $35 million bond to give the bridge a go. Engineer Joseph Baerman Strauss drew up a design that looked as improbable as it did fantastic, and with many doubters catcalling from the sidelines, work was begun on January 5, 1933.

The construction took only a tad longer than four years. The result was phenomenal. With twin towers rising 746 feet apiece and spans supported only by cables (the bridge's two principal cables contain 80,000 miles of steel wire, enough to circle the earth thrice), the bridge was built to sway as much as 27 feet in winds of up to 100 mph. The entire 1.7-mile length was painted International Orange to blend with the surroundings of scenic San Francisco—yet one more serendipitous decision in a long series of them. Today, the Golden Gate is the signature landmark of the city by the bay.

The Aswan High Dam The first Aswan on the Nile was completed in 1902 and later made larger. The High Dam was built in the 1960s.

Marc Garanger/Corbis

The Hoover Dam Taming the Colorado River was an historic feat.

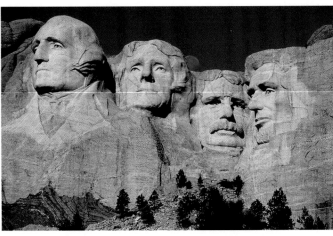

Paul Chesley/Network Aspen

Mount Rushmore Conceived in liberty, wrought in rock

The Seven Forgotten Wonders of the Modern World

Venerable and nouveau classics rub elbows on this list. It's good to see some recognition accrue to the London clock tower that houses the 13-ton bell known as Big Ben, which was first rung in 1859, as well as Gustave Eiffel's thousand-foot tower, which debuted in Paris in 1889. Joining them are such youngsters as Malaysia's Petronas Towers (1998) and the Gateway Arch, which was dedicated in St. Louis in 1966. Mount Rushmore, which we'll learn more about in the Iconic Wonders chapter, is cited, as are two dams: Egypt's Aswan High, and good old Hoover.

The Gateway Arch The spirit of St. Louis is McNificent.

The Petronas Towers Each is the world's tallest.

Big Ben It's not pictured; it's a bell, not a tower.

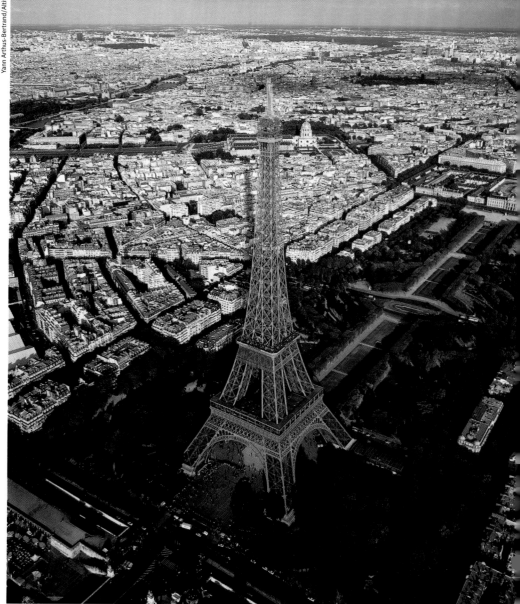

The Eiffel Tower The Paris landmark was for 40 years the world's tallest building.

The Seven Wonders of the
Underwater World

Scalefin anthias hug the surface
of a coral reef in the warm waters
of the Red Sea. The importance of
coral reefs cannot be overestimated.
They cover less than 0.2 percent of
the ocean floor but accommodate
a quarter of the ocean's species.

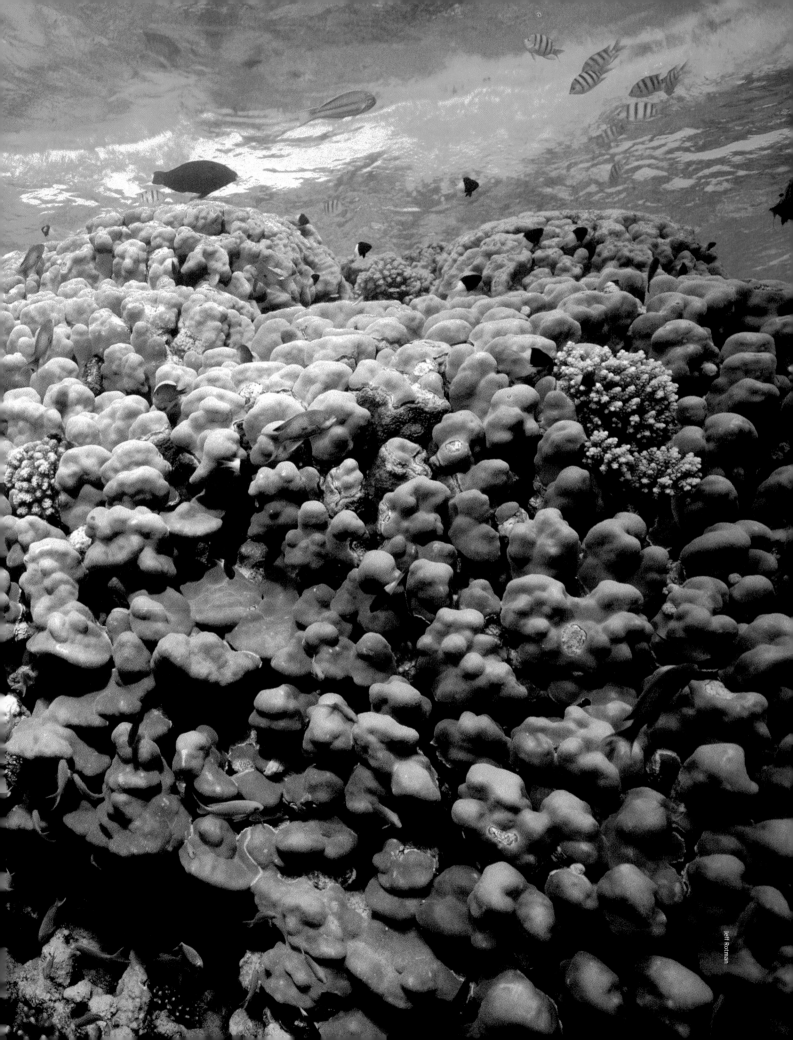

Treasures of **the Deep**

> *See how peaceful it is here. The sea is everything. An immense reservoir of nature where I roam at will . . . Here on the ocean floor is the only independence. Here I am free.*

— Jules Verne
Twenty Thousand Leagues Under the Sea

Long ago, long before there was a breaststroke or the Australian crawl, before swimming became a matter of sport and playtime rather than a desperate, flailing attempt to stay alive, most people steered clear of the sea unless they were in a boat of some sort. Even those who had carved out a way of life along the shore approached the water as a place to fish or to wash something. Many if not most of the old sailors and fishermen were, in fact, unable to swim at all. For certain, there were exceptions: the more adventurous island folk, and others who have always been as one with the water. But for most, the ocean was a cauldron brimming with frightful fiends. And if you got past the monsters, you fell off the end of the world.

Even as time went by, primitive boats, while suitable for fishing, were inadequate for those who were curious as to what was happening in the depths. It wasn't until the 1870s that the British vessel *Challenger* launched the first complex oceanic expeditions. Employing net tows and dredges to search for sea life, and wire soundings for depth measurements, *Challenger* roamed the seven seas, discovering submerged mountain ranges and hundreds of new animal species. Subsequent technology made exploration progressively more able, and diving bells, bathyspheres, scuba diving and snorkeling put human beings in situ. Photography and television shows from such pathfinders as Jacques Cousteau lured new generations of novitiates, and the once murky depths increasingly became a more immediate part of our world.

CEDAM International, founded in 1967, is devoted to conservation, education, diving, awareness and marine research, thus the acronym. In 1990, CEDAM president Rick Sammon was mulling over the fantastic things he had encountered as a diver and undersea photographer, and he fretted that because of habitat destruction his newborn son might never get to see these places in the same way. So Sammon conferred with qualified scientists, naturalists and others to create a list of Underwater Wonders. He confined his list to seven (that number had been magic in the past and he wanted to draw on that magic to preserve these gardens of Eden), although, says Sammon, it was difficult leaving off the likes of the Seychelles, Grand Cayman Island, the Florida Keys, the coast of Kenya and the cenotes and caves of the Yucatán Peninsula.

The CEDAM septet was a natural, and caught the attention of a lot of folks. Further, the list has been beneficial, especially in Palau. "It has really instilled a sense of pride in local governments and the people who live there," says Sammon.

The ocean floor provides something of a parallel with the rest of the planet. Mountains, seas, canyons, channels, rocks, sediment and so on describe the surface. But Underwater is also a completely different world, at times seemingly alien, as we see in the following pages.

Please note that the Great Barrier Reef is among the seven Underwater Wonders, but as it has already been treated in the Natural Wonders section, it is omitted here.

In the Galápagos Islands, a Pacific green sea turtle wends its way through a school of creolefish. With the exception of egg-laying and hatching, these turtles spend all their lives in ocean waters.

Marty Snyderman

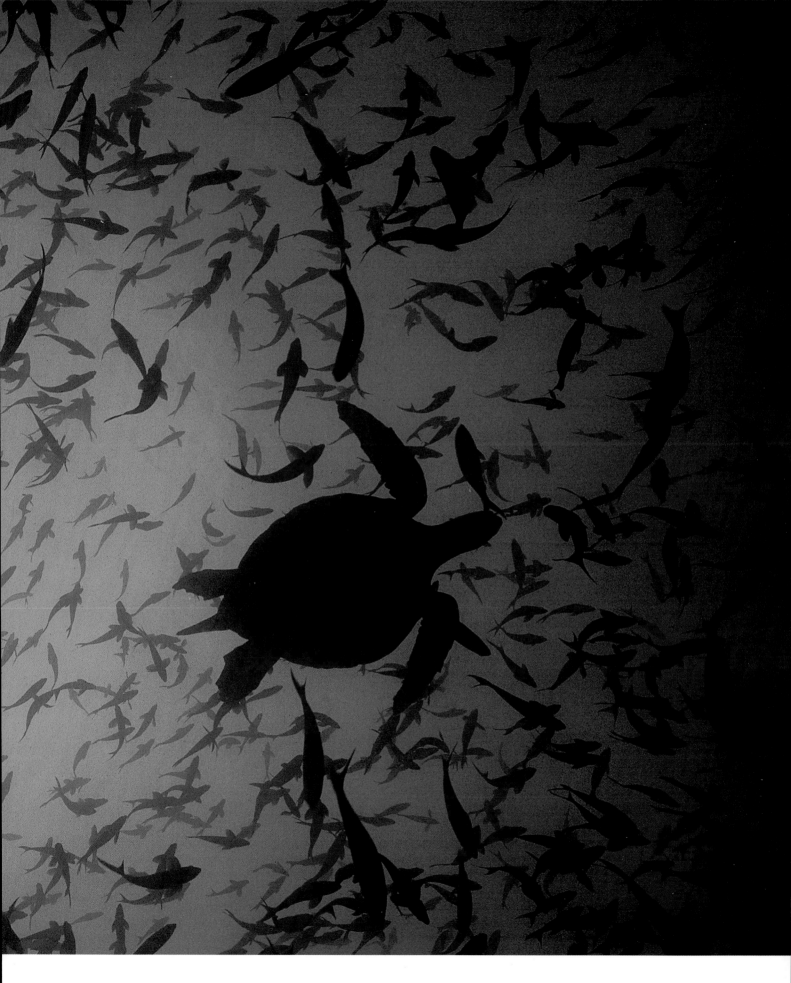

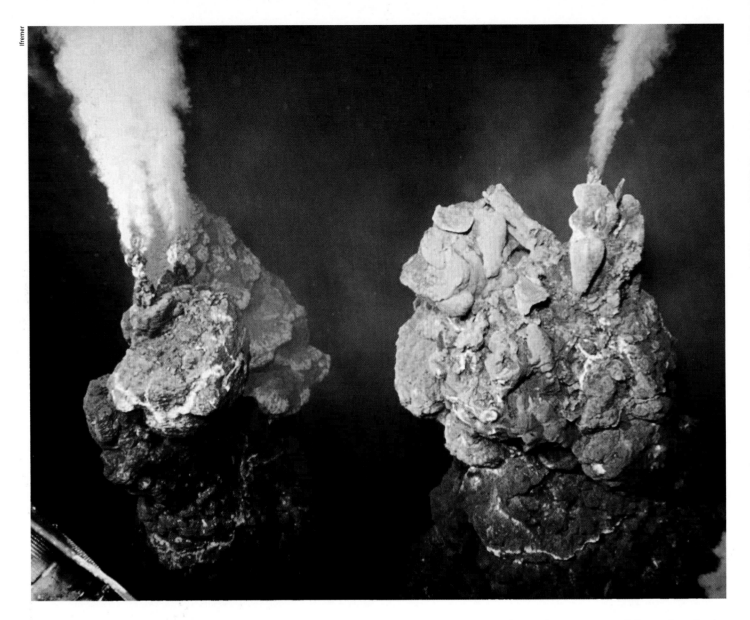

Deep-sea Vents

In 1977 the submersible *Alvin,* which can take three people nearly 15,000 feet below the sea, was engaged in one of its amazing ventures, this time to explore a volcanic rift in the Pacific. But as so often happens in the realm of science, a "routine" exploration opened the door to another world, one bursting with entirely new forms of life in an ecosystem that itself was a novelty.

Deep-sea vents, also known as hydrothermal vents, are, essentially, geysers on the ocean floor. They often form on oceanic mountain ridges. Cold seawater slips beneath the ocean floor, is heated by volcanic rock and thrust upward through cracks, where it collides with cold water, forming a toxic,

superheated plume. In the land of the plumes, chimneylike structures composed of mineral deposits, primarily metal sulfides, arise. In this environment of extreme heat and bitterly cold temperatures, of powerful poisons and acute acidity—with intense underwater pressures that would crush most animals, and a total absence of sunlight—an eerie world thrives, one apart from all others.

There is no plant life, only animals and microscopic organisms, and no photosynthesis, which had previously been considered by biologists de rigueur for all living things. Vent life is sustained by a process called chemosynthesis, in which microbes combine vent chemicals with oxygen. The animals dependent upon chemosynthesis represent a truly different kettle of fish. Some 300 species live near the vents, each of them needing the vents' ghastly

At right, 12-foot-long tubeworms as seen from the submersible *Alvin,* 8,000 feet below the surface at a vent in the Galápagos. Above, smokers hard at work, at roughly the same depth, between the Pacific islands of Fiji and Tonga.

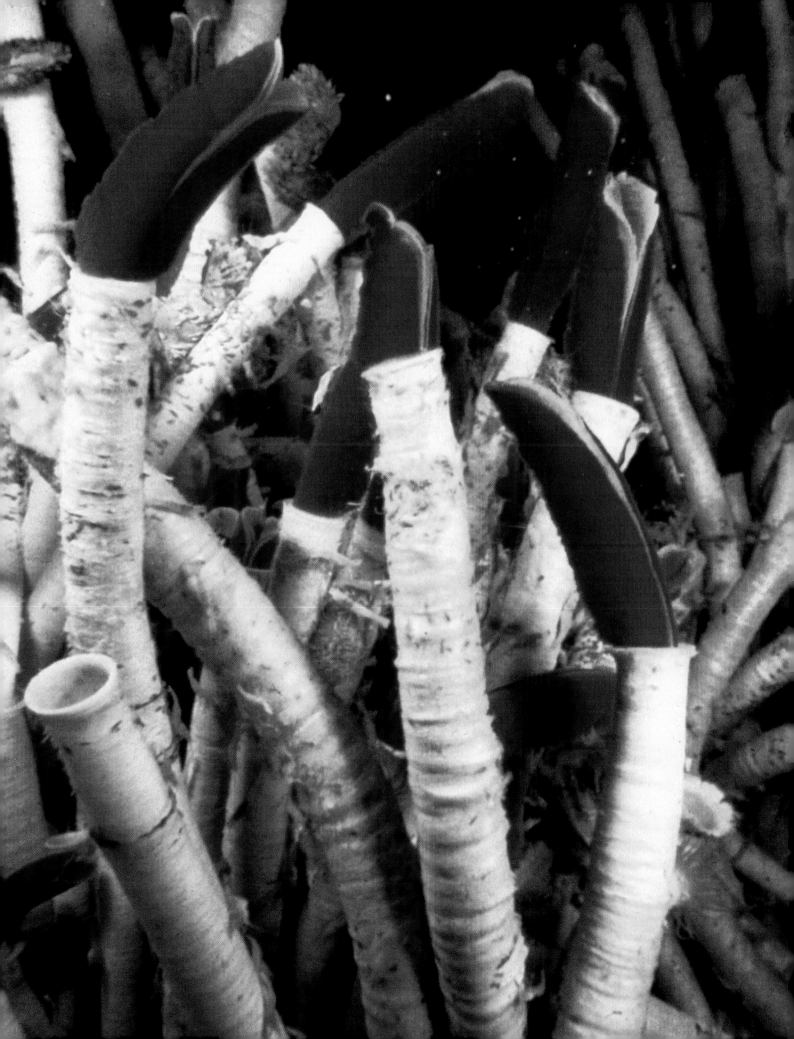

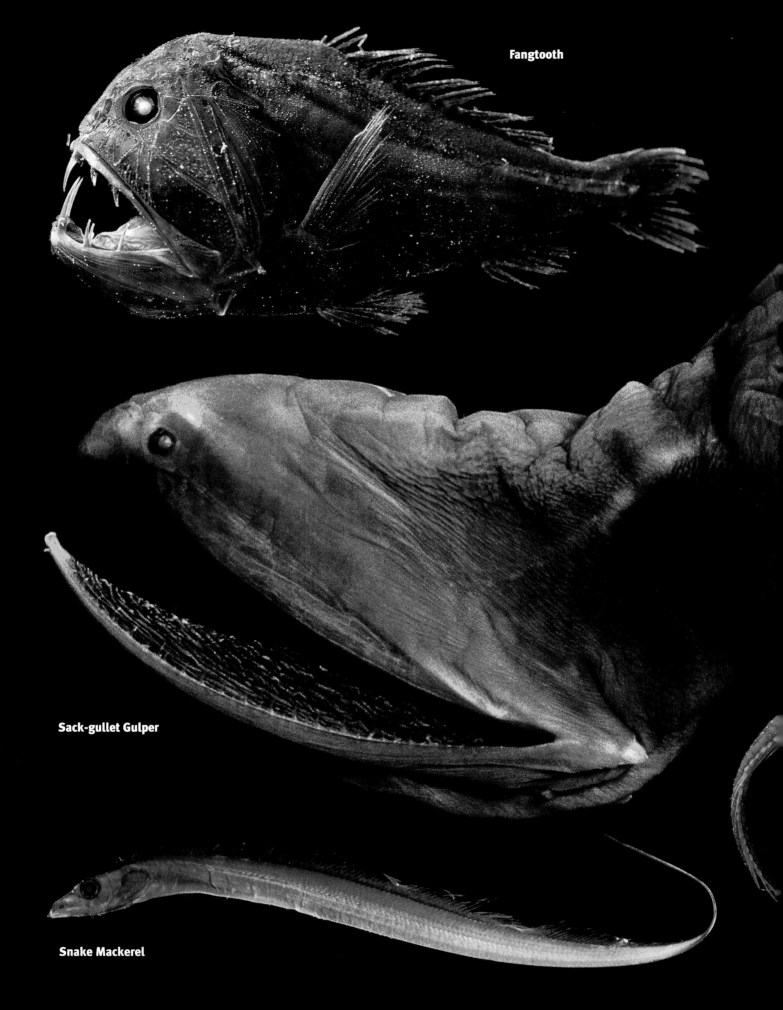

Fangtooth

Sack-gullet Gulper

Snake Mackerel

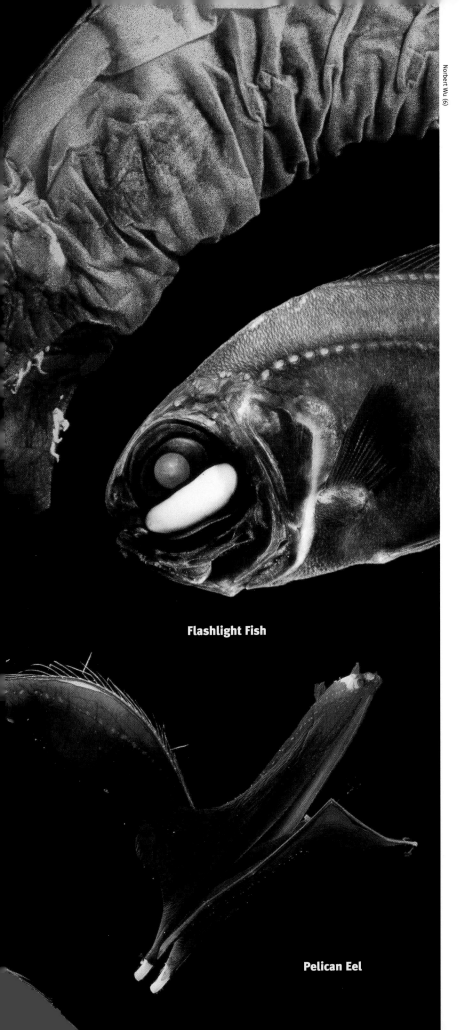

Norbert Wu (6)

ambience to survive. More than 95 percent of the known vent species are entirely new to science.

The vents and the animal life they nurture—snakelike creatures standing upright in long tubes, minute crabs, other crawly things—are classified as the Wonder, but there are deep-ocean fish below, above and in their midst that are, if anything, even more bizarre. Traveling in a dark world from 1,000 to 27,000 feet down are the mesopelagic species and the bottom-feeding benthic fishes—anglerfish, swallowers, eels and a species known in the oceanographic world as "the vampire squid from hell." These fish resemble ancient animals rather than anything alive today. They possess, variously, radar, ferocious dental work and a supernatural talent for bioluminescence. The members of this deepwater menagerie seem to have sprung full-blown from Hieronymus Bosch or Tim Burton, yet they are part of our world. Pleasant dreams . . .

Flashlight Fish

Pelican Eel

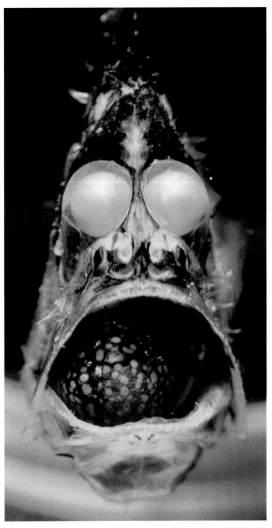

Hatchetfish

No, this isn't a scene from *Creature from the Black Lagoon*. It is a marine iguana grazing for seaweed in the shallows along Santa Cruz Island.

The Galápagos Islands

A visit to the Galápagos Islands calls to mind the power sweep of the old Green Bay Packers: You know what's coming, you try to brace yourself for it, but it overwhelms you. In these isles, you are as one with strange creatures who do not fear you and carry on with their daily affairs—forming an animate, dreamy patchwork quilt.

The 19 Galápagos islands lie 600 miles west of Ecuador. They are on the equator, yet are also in the way of cool, nutrient-rich currents; thus tropical forms coexist with cool-water species. Once known as the Enchanted Isles, their remoteness has, at least in part, served to create a world with 27 reptiles but only one amphibian, a frog that has recently become established. The land mammals are confined to rodents and a couple of bat species.

The islands take their name from their 500-pound giant tortoises (the Old Spanish word for tortoise is *galápago*). There are four-foot-long marine iguanas right off the set of a dinosaur movie, hundreds of them, that draw heat from the sun before disappearing into the water to munch on seaweed. Side by side with them are animals of Antarctic origin, like penguins and fur seals. Seabirds are represented by the delightful blue-footed booby and the world's only flightless cormorant.

Charles Darwin famously visited this land in 1835, and noted "several of the islands possess their own species of tortoise, mocking-thrush, finches, and numerous plants . . . that strikes me with wonder." This mutability of species helped the great man with his evolutionary theories. Ironically, however, there are scarlet crabs here identical to an Atlantic species from which they have been separated for perhaps 35 million years.

Clearly, the Galápagos are a one-of-a-kind place. With the careful management the islands have been receiving, they should remain for all time a Wonder among Wonders.

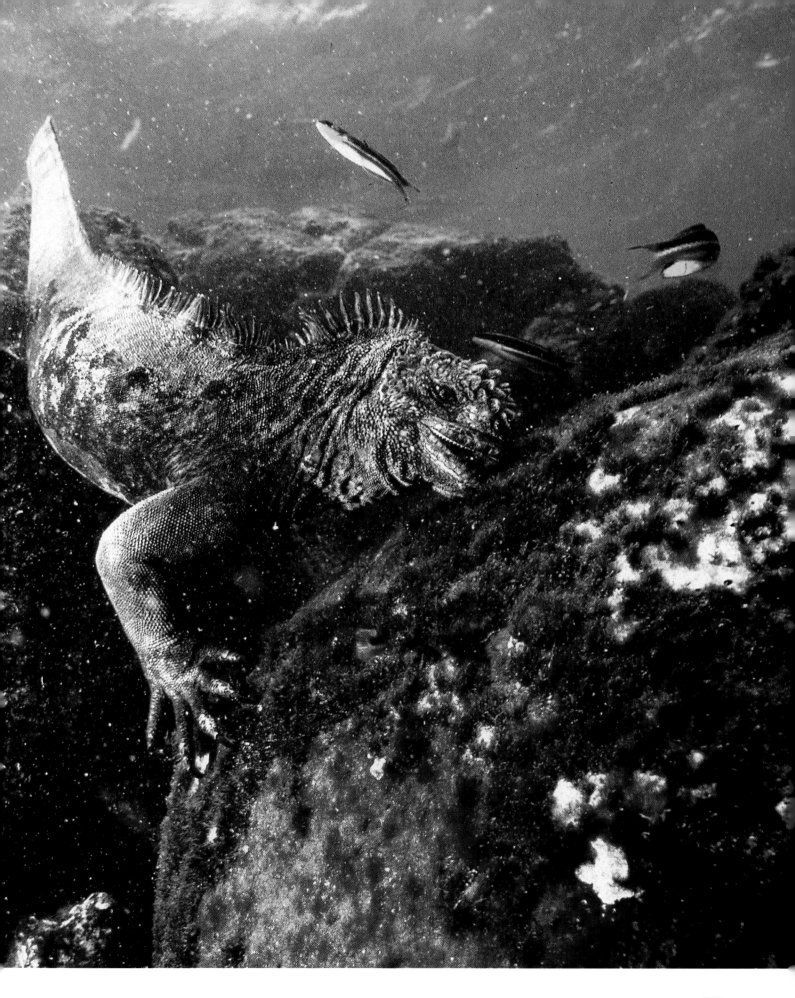

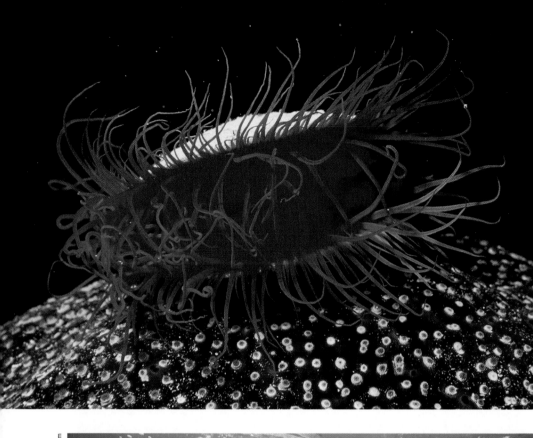

Greg Johnston (2)

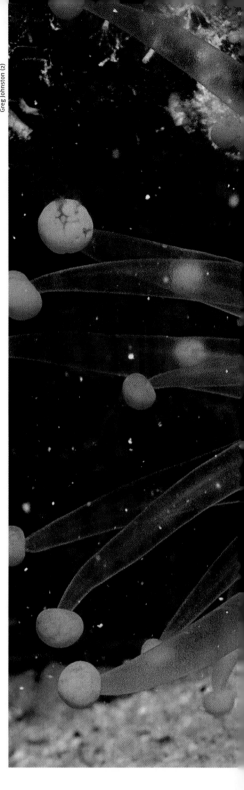

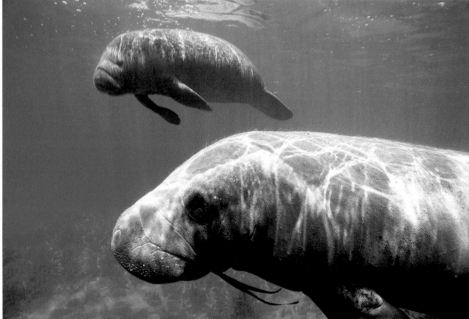

Doug Perrine/Seapics.com

The Belize Barrier Reef

Once the center of the Mayan civilization, the tiny nation of Belize, bordered by Mexico, Guatemala and the Caribbean, is now famed for its offshore atolls, mangrove forests, sand cays and coastal lagoons and estuaries. Belize is also home to the longest barrier reef in the Western Hemisphere. It runs for about 160 miles and typically hosts a multiformity of life. There are more than 500 types of fish, 350 mollusks and 65 corals. Belize provides sanctuary to threatened turtles like the hawksbill, and such birds as the brown pelican and the aptly named magnificent frigatebird, the male of which puffs up its throat in a huge red mating display.

There are two types of West Indian manatees, Florida and Antillean. Belize began to protect the latter back in the '30s, and today, it is home to more

Clockwise from above: an orange ball anemone along the shore off Ambergris Cay; Antillean manatees feeding on turtle grass; also at Ambergris, a rough file clam, which likes to hide in crevices.

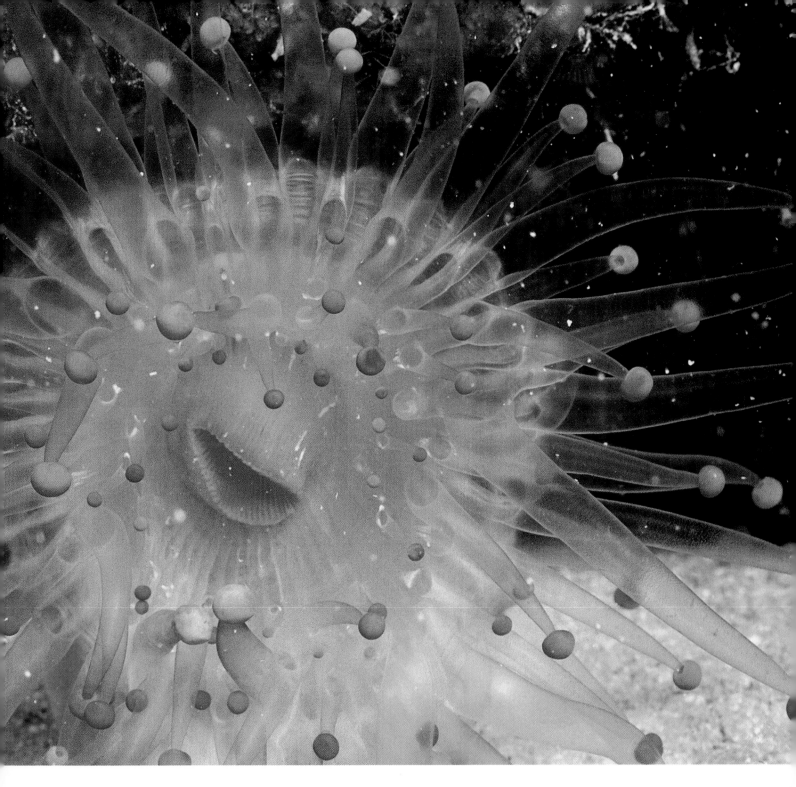

of the mammals—estimates vary from a few hundred to 800—than any other place. Although the manatees continue to be killed by hunters and boats, there is increasing hope for their survival.

One of the many intriguing fish in these waters is the cleaner wrasse, which sets up shop in a spot popular with other fish. This shop is a cleaning station at which fish line up, demonstrating their readiness by remaining stationary and opening their fins, gills and mouth. The cleaner wrasse then picks par-

asites and dead tissue from them, and itself benefits from the nutrients therein (coral reefs require nutrient-poor water). It even cleans the teeth of the other fish. To ensure that it doesn't get eaten while working, the cleaner wrasse vibrates its fins as a reminder that it is providing a service.

Given the locale's beauty and splendid inhabitants, it is no surprise that Darwin himself wrote in 1842 that Belize is "the most remarkable reef in the West Indies."

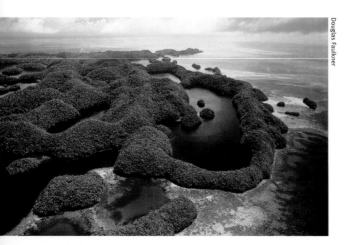

Palau

At the western end of the Caroline Islands in the Pacific Ocean lies a string of Micronesian pearls called Palau. An archipelago of some 340 islands, only nine of which are permanently inhabited, Palau has been called the cradle of diversity for its aggregation of aquatic plants and animals, unparalleled anywhere else. The 90-mile-long chain incorporates open atolls rimmed with coral reefs, lagoons, huge underwater caverns, mangrove swamps and especially diverse beds of sea grass with nine different varieties. There are also a few dozen marine lakes, like Jellyfish Lake, which is dark green and warm. Jellyfish is a harmonious place, and its sundry citizens have, over time, relinquished as unnecessary their stinging capability.

Palau's waters are a wonderland of sheer walls and blue holes, dramatic caves and locales like Blue Corner, with its swift currents racing through coral gardens. Adding to an already dramatic undersea environment, Palau was a Japanese stronghold during World War II, and many of the ships sunk there have become fabulous diving realms.

Palau's existence at the confluence of three of the world's major ocean currents nurtures a tremendous gathering of marine life. More than 1,500 types of fish swim the waters, and all seven known species of giant clams grace the sea bottom. And there are mammals galore, from finless porpoises to ginko-toothed beaked whales to the sea cows known as dugongs. Throw in manta rays, turtles, poisonous sea snakes and an underwater visibility that can exceed 200 feet, and Palau's Wonderness seems simply a given.

Clockwise from left: a view of the marine lake on Macharchar Island; the very poisonous black-spotted pufferfish; a diver in a school of jellyfish.

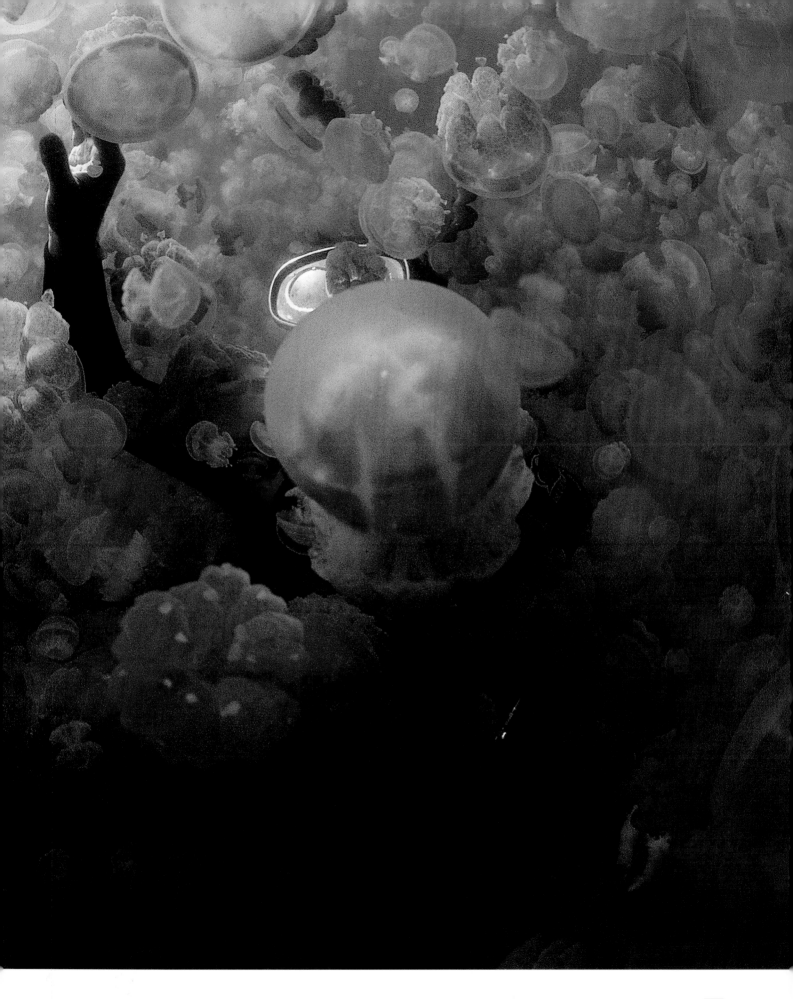

Galen Rowell

The spirit of Siberia is in the air in this lakeside shot. Scientists are still debating the origin of Baikal, the deepest lake in the world.

Lake Baikal

I f every one of the rivers on earth—the Nile, Amazon, Mississippi, Volga et al.—was funneled into the Lake Baikal basin, it would take the whole batch nearly a year to fill it. Baikal is immense. At about 30 million years, it is also the oldest lake, and at an average depth of nearly half a mile, it is the deepest. It is the only freshwater entry in our Underwater septet, but then, it accounts for one fifth of all the planet's fresh surface water. As a rule, lakes over time fill in with sediment, but Baikal is growing about four times faster than it is being silted up. The lake is surrounded by mountains from which winds, without any warning whatever, come howling down to churn up waves nearly 20 feet high. Because of Baikal's huge mass, its waters have a seaside effect on the surrounding shores. And yet, this is Siberia: The lake does freeze over in the dead of winter.

There are a thousand species of plants in Baikal's lagoons and bays, coves and deltas. Eighty percent of them exist only there. There are even more animals. The tiny epischura zooplankton feed on waterweeds and bacteria that otherwise would cloud the water, and contribute to Baikal's notable clarity. There are more than 100 types of mollusks. Worms occur in many varieties, including some along the lake's bottom that paralyze their victim and envelop it in mucus before slowly consuming it. Of the 56 types of fish, the enigmatic golomyanka is the most common. Less than a foot long and the color of mother-of-pearl, it has no scales. At night it moves along the surface, then in the daytime it removes to the bottom, where it somehow withstands the tremendous pressure.

There is no other place like Lake Baikal, whose name means Sacred Sea. As the Russian poet Mark Sergeev wrote, "If you are stopped suddenly by a penetrating blue and your heart stops, as sometimes happened only in childhood, from astonishment and delight . . . it means, this is Baikal."

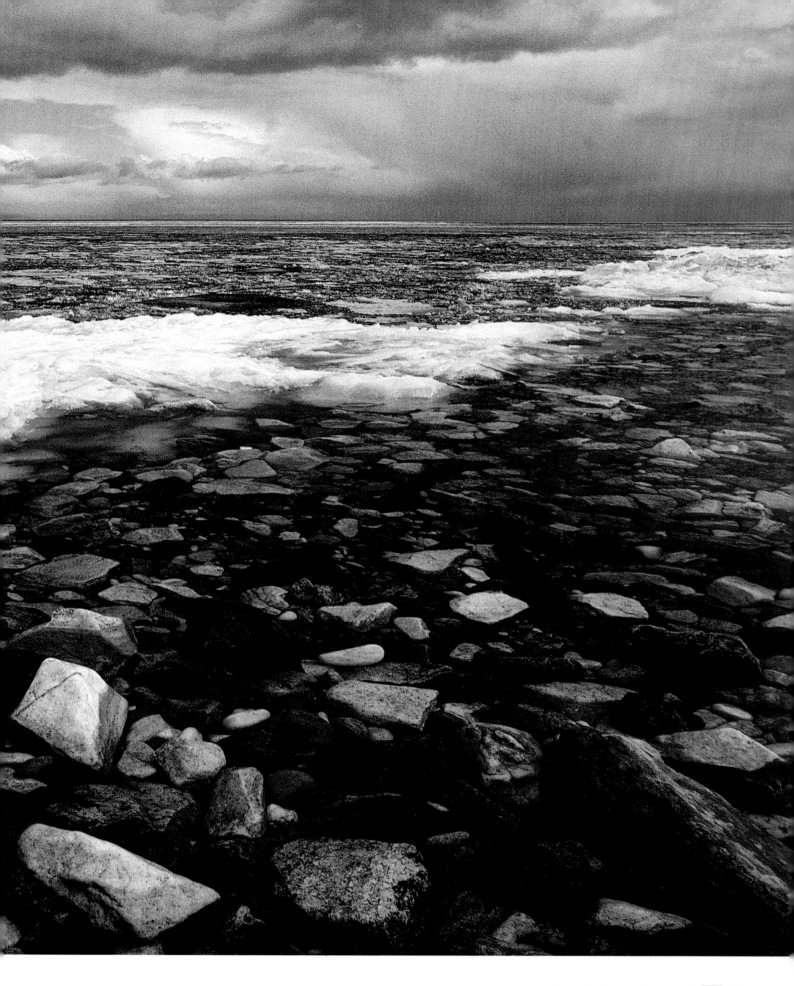

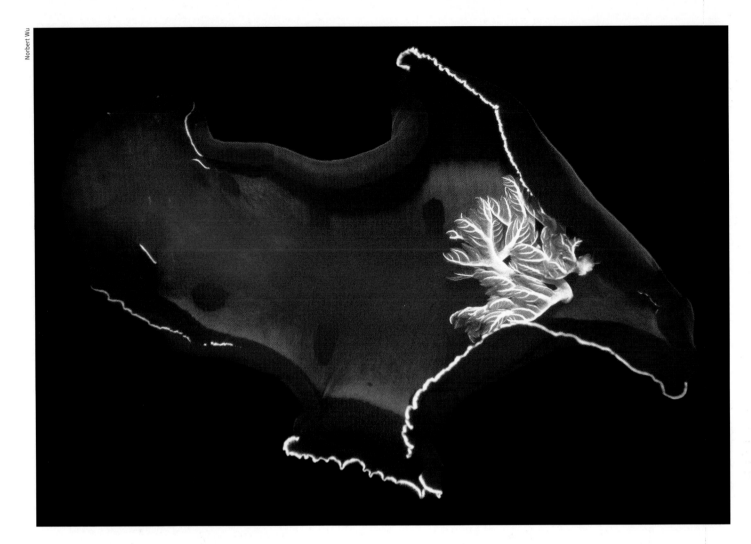

Norbert Wu

The Northern Red Sea

Thirty million years ago, the Mediterranean flowed into the northern end of the Red Sea, bringing life forms from the Atlantic to take root and breed. Millions of years later, tectonic shifts sealed off the northern tip while opening the southern end. This meant that there was now a portal to the Red Sea from the most diverse aquatic region on the planet, the Indo-Pacific. Today, although that influx exceeds the Mediterranean presence, this dual influence accounts for the Red Sea's remarkable diversity.

The waters of the sea run deep and are warmed by volcanic heat from the bottom. The Red Sea is home to more than a thousand species of invertebrates, vast numbers of anemones and a thousand kinds of fish. There are 200 different types of coral.

While the entire sea is fascinating, the northern tip is particularly renowned, featuring international attractions like Ras Muhammad, a deep-water coral plateau. There, in what has been called a quiet, churchlike setting, divers may encounter nearly anything, including the reef triggerfish, which charges with teeth bared only to halt just two feet away, or an intimidating yet friendly fish called the humphead wrasse. The coral reef is, of course, a dynamic unto itself. Corals are mainly nocturnal feeders, consuming tiny organisms snared on their complex surfaces. Other creatures also dine on this plankton and algae, and then are hunted by still other predators, who are themselves just one more link in a food chain ensuring a varied environment.

Another reason this sea boasts such an array of life is that the skies above are extremely clear, which permits sunlight to infuse the corals, thus making them grow faster, hence affecting everything else around them. For marine scientist Eugenie Clark, the waters of the northern Red Sea are heaven on earth: "If I could only dive in one place in the world, I would choose Ras Muhammad."

The Red Sea is home to a variety of life because it has been fed by both the Atlantic and Indo-Pacific oceans. It is justly famous for its limpid waters. Above: Nudibranchs are marine gastropod mollusks that have no shells or gills. *Hexabranchus sanguineus* swims by undulating its body.

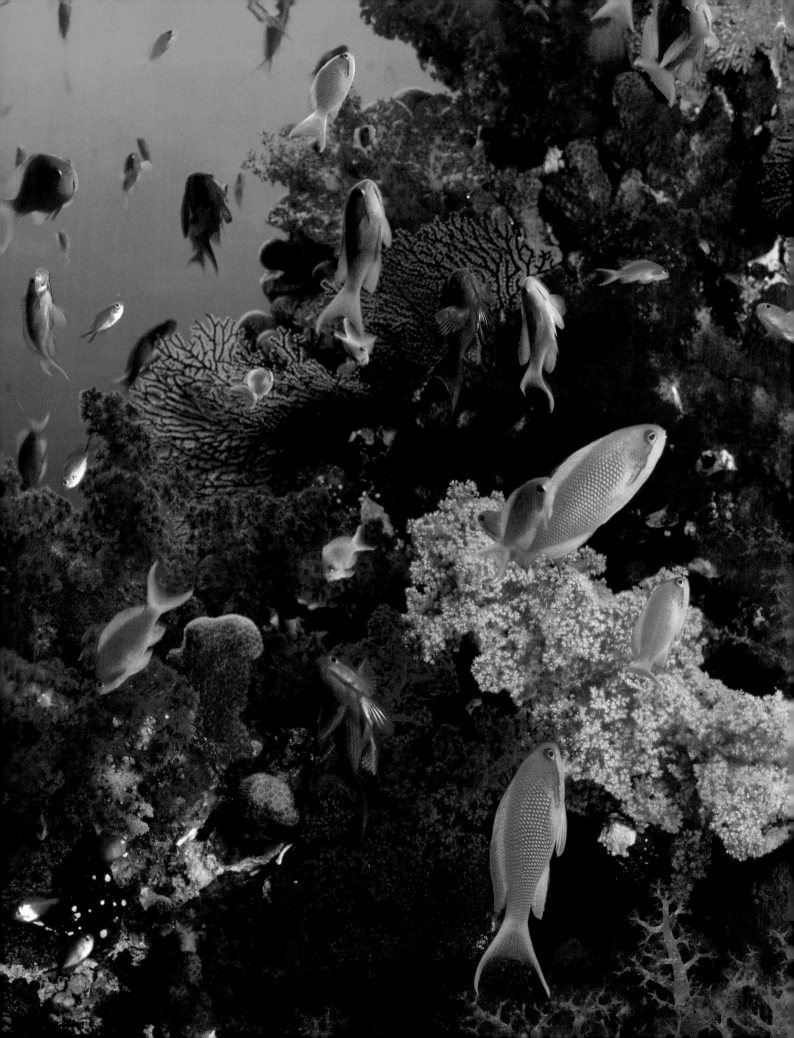

The Endless Wonders of Outer Space

There are more Underwater Wonders than have just been enumerated, and more in the heavens above than can be counted. Youngsters begin by wondering at the moon and the Big Dipper. Also visible to backyard stargazers on a crisp autumn night is the Milky Way. The fellow planets in our solar system, including the spectacular Jupiter, Saturn and Mars, can be seen with a store-bought telescope, and today we have the Hubble, peering deep into the void, showing us distant quasars in galaxies that were born near the beginning of time.

These faraway places have been brought closer mainly by the Hubble Telescope. Clockwise from left: a cluster of galaxies in the constellation Draco; an exploded star; a composite of the Whirlpool galaxy; spiral galaxies ("the Mice") that will collide and become a giant galaxy.

The Seven
Iconic Wonders of the World

The serenity of the giant
Buddha in Leshan, China, is as
profound as its size. Its head
is about 48 feet from hairline
to chin; its middle finger is
approximately 27 feet long.

Immortal Images

The way Voltaire put it, in a variation on the theme, has often been quoted: "If God did not exist, it would be necessary to invent him." In considering the words of Feuerbach and Voltaire, a question arises: Upon whom or what, then, do we gaze when we look at the stunning statuary and superhuman iconography that have been erected in various places at various times throughout history? When Buddhas are made to loom enormously over the countryside, do they honor the Indian philosopher, ascetic and founder of the faith, Siddhartha Gautama, whom they are said to depict? Or do they exalt the gods who influenced the Buddha? Or do they make manifest nirvana itself, a beatitude higher even than the gods? What is America saying about the four former Presidents who are immortalized in a redrawn mountain named Rushmore? Most inscrutably, what of the *moai* statues on Easter Island? Are they supposed to be man, martian or a heavenly deity whose devotees left no other record of their creed, which might have allowed us to decipher the statues?

The answers surely lie in humankind's aspirations. Ever since our species began contemplating God (or Yahweh or Allah or gods, plural—"God" herein standing for spirit), it has hoped to move in a more godlike direction. Man wants to please God, man wants to appease God, and, in an extreme presumption, man wants to be like God. (Some men of an imperial bent have gone much further, putting their laws above those of God, or even asserting themselves audaciously as gods on earth.)

This desire to get close to God, both now and in the future, is part of it, but also: Though human imagination is powerful, it is, by nature, limited. And so, man can see God only in himself. If Michelangelo's David was purposely godlike in its serenity and perfection, the artist's outstretched hand of God was overtly human in its exquisite and intricate detail.

The icons on the following pages are, unmistakably, spiritual (if not always specifically religious). Even those erected by a professedly secular or atheistic society—America's in the first case, the Soviet Union's in the second—speak of reverence for a superhuman ideal. When we render George Washington on a mountainside or the Buddha a hundred feet high, we are saying that these people who once walked among us somehow transcended the race. They were giants. And they were, in a way, members of a spiritual realm, even when they were of the flesh. The message of the thousands of terra-cotta soldiers found in China in 1974 might be multilayered—they are guarding the tomb of the emperor in this world, they are serving the emperor in the next—but part of it is evident: The men herein represented in clay are spiritual beings, they are larger than life, above life, immortal.

A way then to think about these symbolic statues and pictures is as elaborate tombstones. Even if they do not sit precisely above the graves, they are serving the same purpose. They are honoring the dead (the greatest of the dead with the greatest of tributes). They are building a bridge from here to the beyond. They are crying out to God—*this is us*—and they are imploring passersby to consider just how good we can be.

As the expression goes, Let the chips fall where they may. And it seems that at Mount Rushmore, the crew that blasted and chiseled the supreme American iconic sculpture hewed to the old saying.

Jeff Gnass

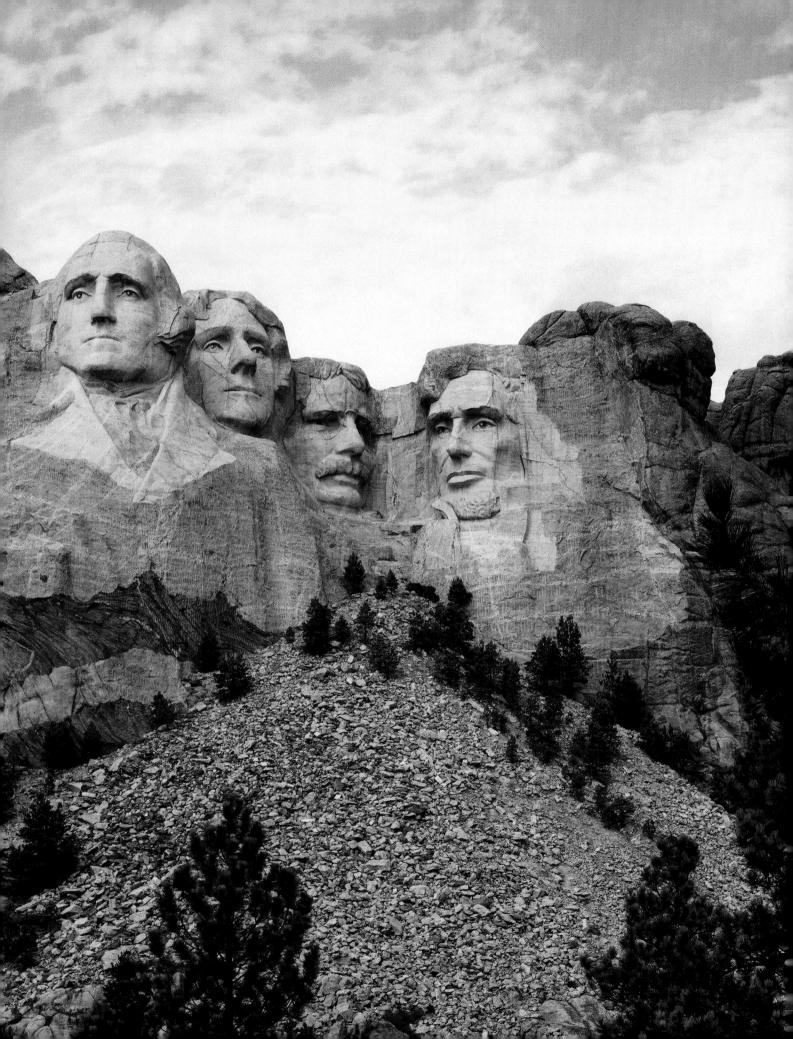

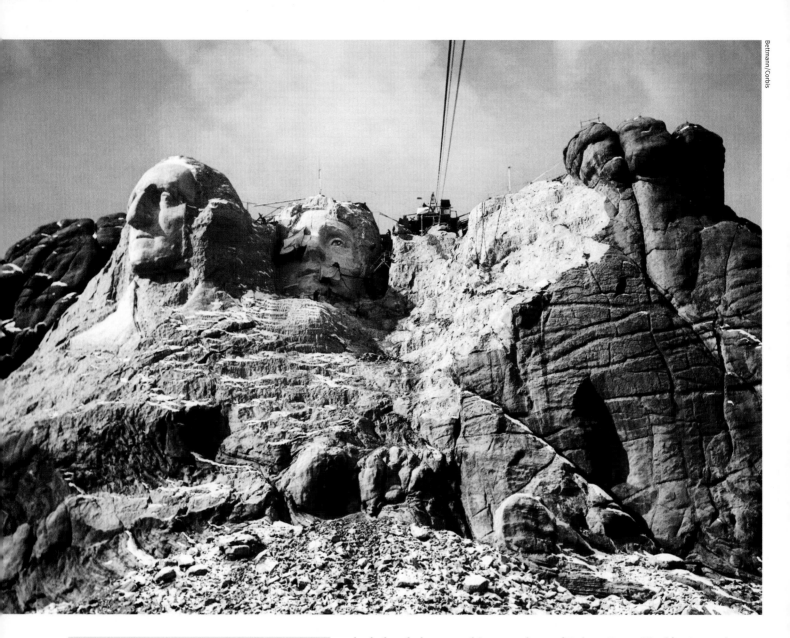

Mount Rushmore

This most American of Wonders might have been something quite different, or it might not have been at all. But in the Black Hills of South Dakota are carved the visages of four American Presidents: George Washington, Thomas Jefferson, Theodore Roosevelt and Abraham Lincoln.

The initial idea of having giant statues along his state's skyline came from Doane Robinson, the superintendent of South Dakota's Historical Society. He had in mind such western heroes as Buffalo Bill Cody, the Sioux chief Red Cloud and Lewis and Clark. In 1924, Robinson got in touch with Gutzon Borglum, a talented if enigmatic sculptor who

had already been working on a bust of Robert E. Lee on Georgia's Stone Mountain. That project had been plagued by funding problems, and Borglum became enchanted with the South Dakota prospect. But he quickly told Robinson that this needed to be on a national scale. It was decided to do the Presidents, who would represent the birth, growth, preservation and development of the United States.

On and off from 1927 to 1941, Borglum and 400 workers toiled on the craggy, pine-laden cliff known as Mount Rushmore, having selected a southeastern exposure to ensure direct sunlight for much of the day. And even though dynamite blasted away 90 percent of the 450,000 tons of granite removed from the mountain, not a single life was lost during the creation of the 60-foot visages. They are a Wonder the country can be justly proud of.

Washington and Jefferson are coming along nicely, but the other Presidents will have to bide their time. At right, Gutzon Borglum and his son, Lincoln, pass by Jefferson. When Gutzon died only months from the statue's completion, Lincoln took the reins.

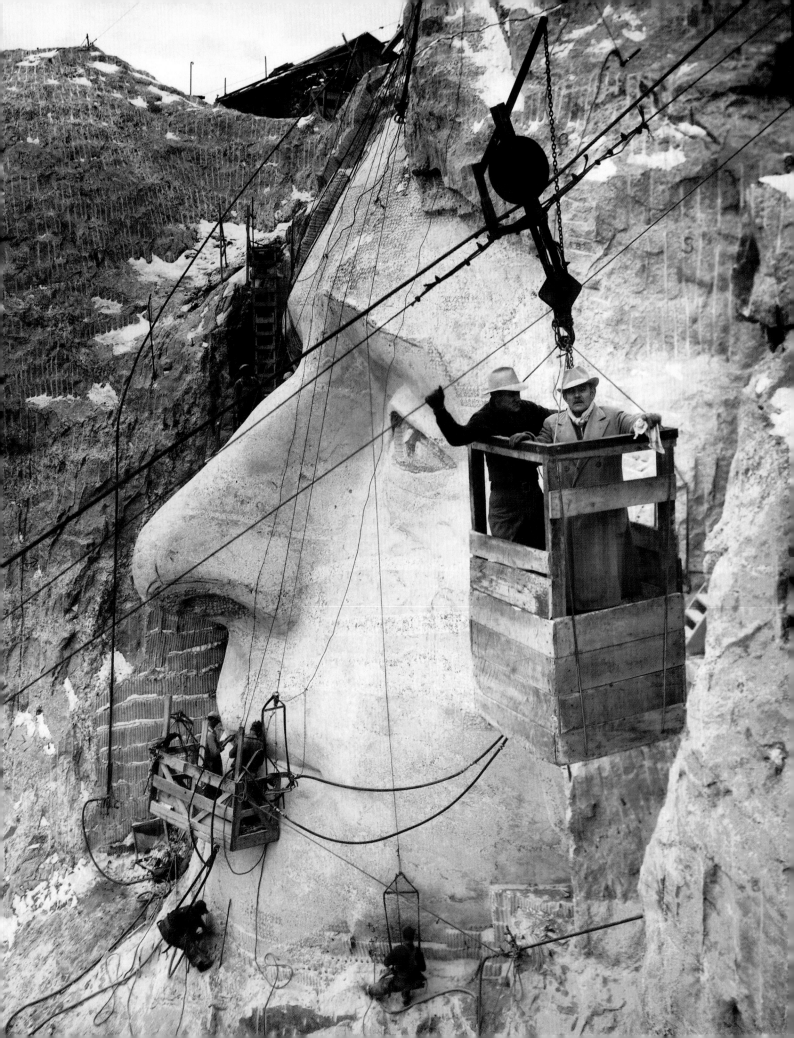

The enigmatic statues were placed mainly on the perimeter of the island, always facing inward. Here, a culture was lost to obsession.

The Statues of Easter Island

One of the most remote inhabited islands on earth, Easter Island lies more than 2,000 miles from the shores of both Chile and Tahiti. It was settled in about 400 A.D. by Polynesians who, legend has it, were led by a chief named Hotu Matua, the Great Parent. When these early people arrived, their new home was lush, with giant palms for boats and housing. By the time their descendants were through, Easter Island would be a hellhole.

For some reason, beginning in the year 1000 and increasingly till 1600, the islanders were engaged in the construction and siting of statues, seemingly to the exclusion of anything else. They used volcanic tuff to carve at least 887 statues called *moai,* the largest of which was nearly 72 feet long. These moai were human forms, with exaggerated noses and ears. Because the islanders left no written record and but a flimsy oral history, there is no way to hold an informed opinion as to their purpose. In any case, simply carving these moai was not enough: A third of them were transported around the island and placed on *ahu,* ceremonial platforms that stood at an average of four feet high. Moving the moai was a tremendous undertaking since the tallest that was erected stood 32.6 feet tall and weighed 82 tons.

Archaeologist Jo Anne Van Tilburg and others believe the islanders used palm trunks to move the statues. This deforestation became critical in the culture's decline and fall. With the disappearance of trees, topsoil was washed into the sea, leaving the islanders with no way to raise food, nor could they build boats to catch food. Inevitably, the social order collapsed; in its place came civil war and cannibalism. And in what must have been particularly frenzied activity, the moai were toppled by the Easter Islanders themselves. Those standing today are the product of recent archaeological enterprise.

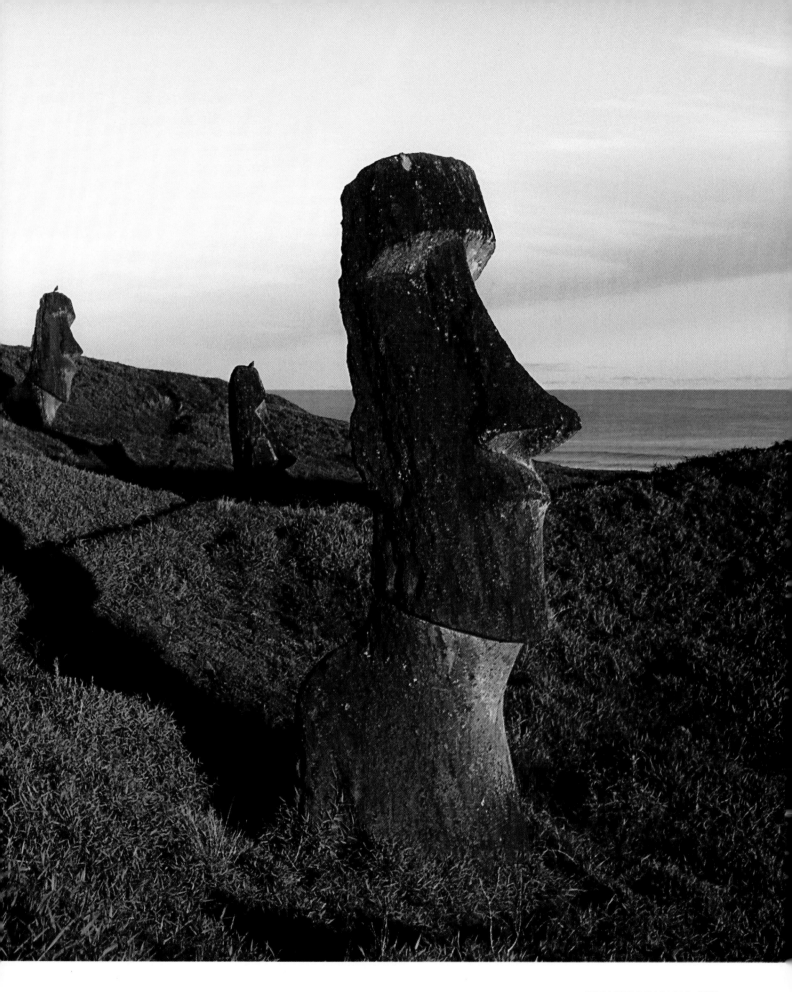

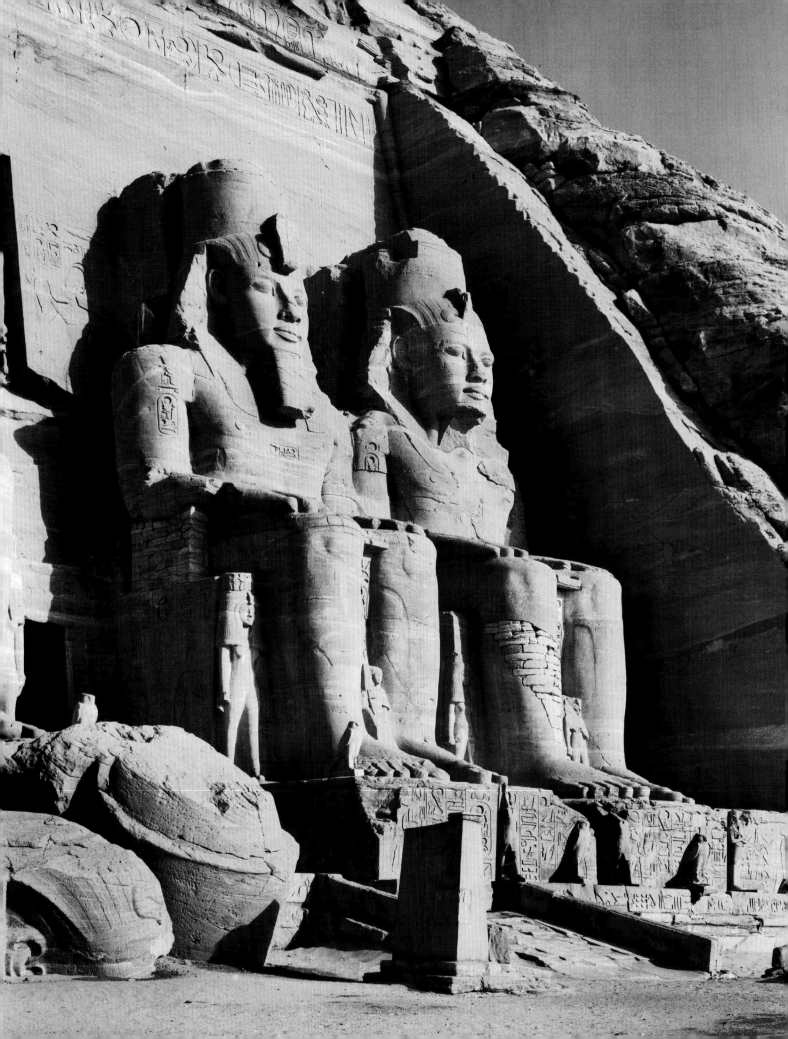

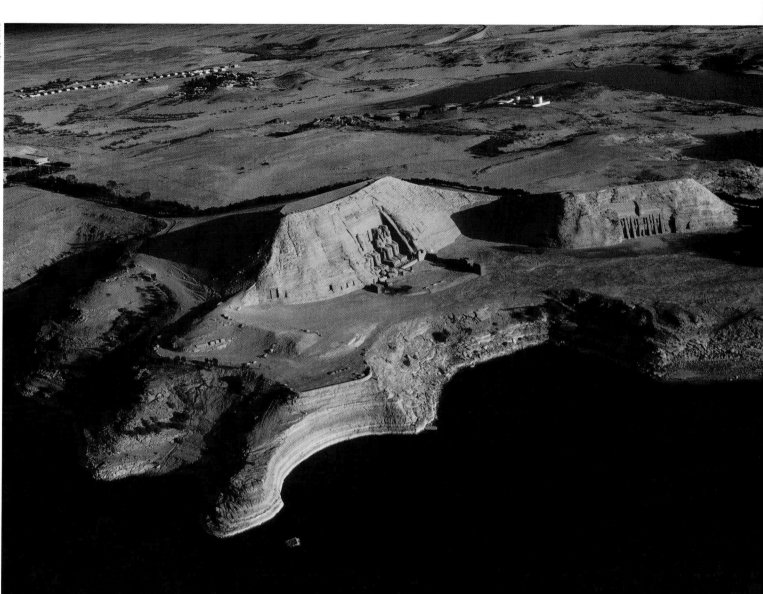

Abu Simbel

Although it was not unusual for an Egyptian pharaoh to be in possession of a majestic ego, Ramses II (c. 1279-1213 B.C.), who fancied himself divine as well as powerful, set a standard for self-regard that, many hall-of-fame despots later, remains impressive. As with many other pharaohs, he was also an inveterate tomb and temple builder—he would eventually order up seven temples—but it was his signature style to adorn the buildings with scads of statues of himself. A notion of Ramses' megalomaniacal personality can be gleaned when one considers his Temple of Hathor near the Sudanese border. Ramses had it built for

his favorite wife, Nefertari, and indeed there are two 33-foot-high statues of the deified queen flanking the entrance. But there are four equally tall statues of the pharaoh himself.

The Hathor temple, named after the goddess of love and music, is also called the Small Temple, for it stands near the Great Temple, the paragon of Ramses' magnificent seven. The Great also features four Ramses likenesses, each of them 66 feet high. (Abu Simbel refers to both temples and all the attendant statues.) It took Ramses' men two decades to build this temple and its seated colossi, and when they were done their boss pronounced it, "The House of Ramses, Beloved of Amun," Amun being a prominent god. Inside the temple is a statue of Amun seated alongside three other gods, one of whom is, yes, Ramses.

These two 67-foot Ramses statues seem quite immovable, but between 1964 and 1968 they and the rest of the Great Temple were relocated 200 feet up the sandstone cliff so as not to be submerged by the newly created Lake Nasser (above), a by-product of the Aswan High Dam.

The Buddha's spiral topknot is level with the summit of Lingyun, and he faces Mount Emeishan. Beneath the hills run the waters of the rivers.

The Leshan Buddha

In 2001, Afghanistan's ruling Taliban party notoriously and in defiance of an international outcry blew up two gigantic Buddhas that had, for more than 1,500 years, overlooked the Bamiyan Valley. The Talibans said the Buddhas had to go because they were "un-Islamic." But their drastic action did nothing, of course, to weaken Buddhism, nor did it do very much to deplete the world's supply of giant Buddhas. There is a huge Buddha statue in South Korea's Soraksan National Park; there is a colossal Buddha on the Hawaiian island of Maui; there are large Buddhas at points between. And then there is the Leshan Giant Buddha in China, which is, quite simply, the biggest stone Buddha in the world.

Statistics first, then some history: The Buddha is 233 feet tall and 92 feet broad at the shoulders. Each of his ears is 23 feet long, and his nose measures 18 feet. Each eye is 11 feet across, and each eyebrow 18 feet.

He was carved from the side of the Lingyun Hill over some 90 years in the Tang Period (618–907) with, it is suspected, a dual purpose. Certainly he was meant as a point of pilgrimage for Buddhists, but also: The spot at the confluence of the Minjiang, Dadu and Qingyi rivers was said to be plagued by a monster who regularly caused floods and swamped boats. If a tribute could help subdue the evil beast, thought Master Haitong of the nearby Lingyun Monastery, who headed the effort to build the Buddha, then it is for the good.

More than 100 people can sit between the Buddha's enormous bare feet—and often do, as they meditate or pay respects. And yet for all his enormousness, the stoic Buddha seems principally to be about serenity and a somber religiousness. A local saying that apprises the Buddha's position within the hill has it, "The mountain is a Buddha, the Buddha is a mountain." That seems quite to the point. This is an immense, strong, transcendent creation.

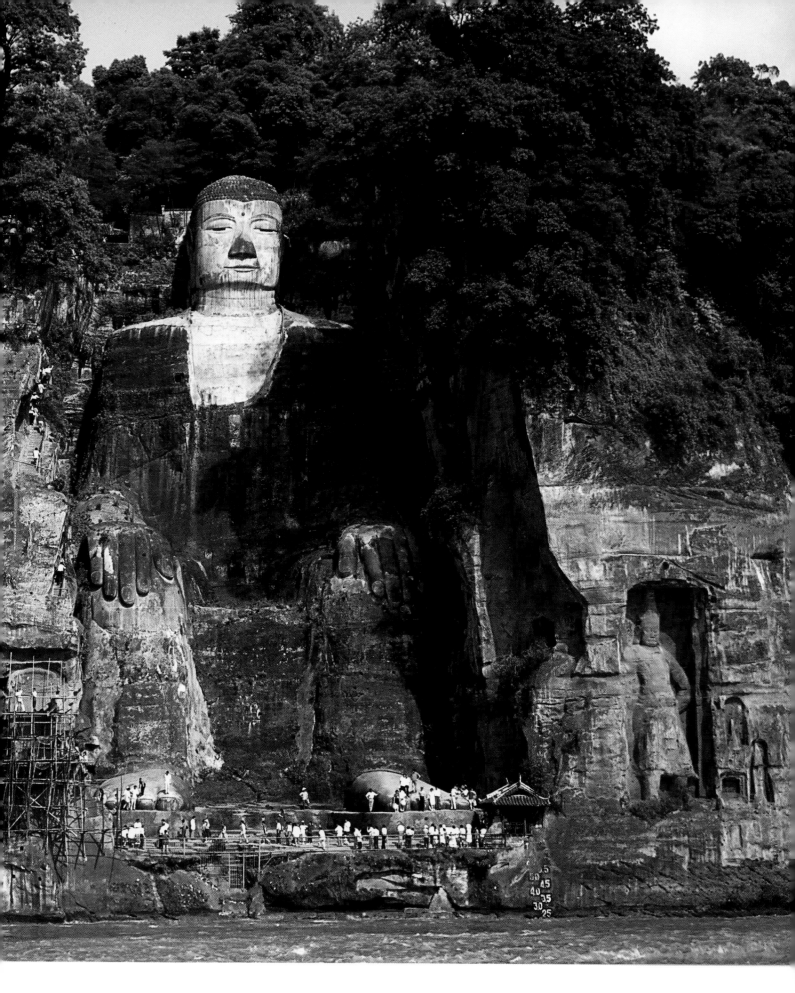

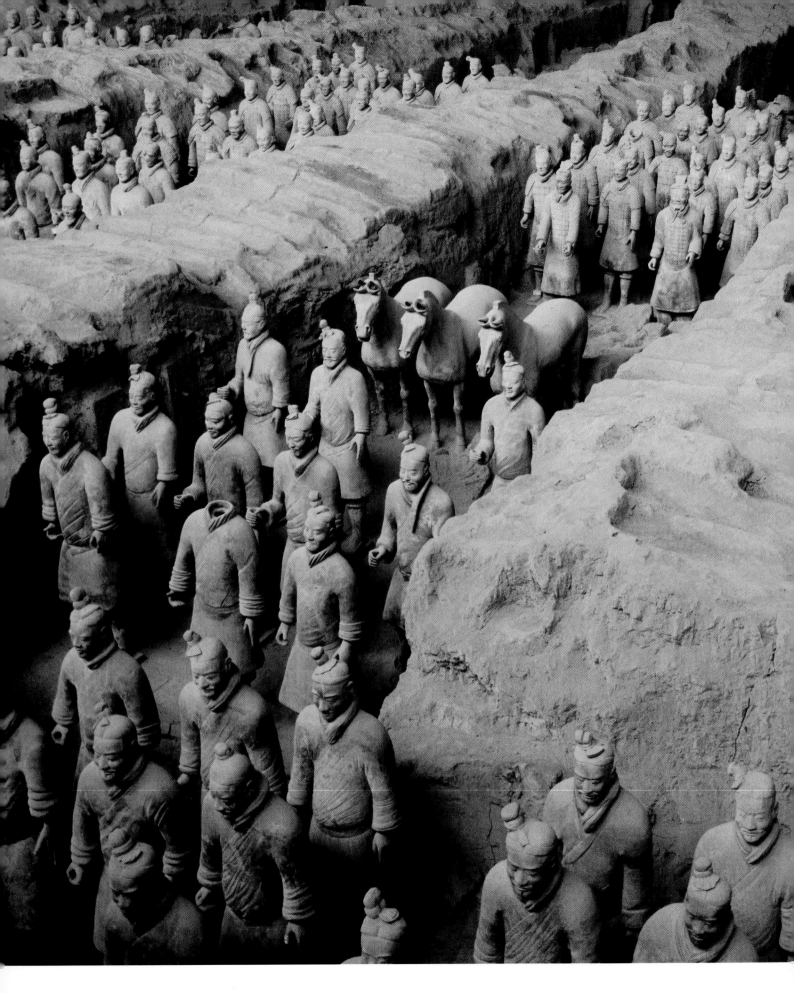

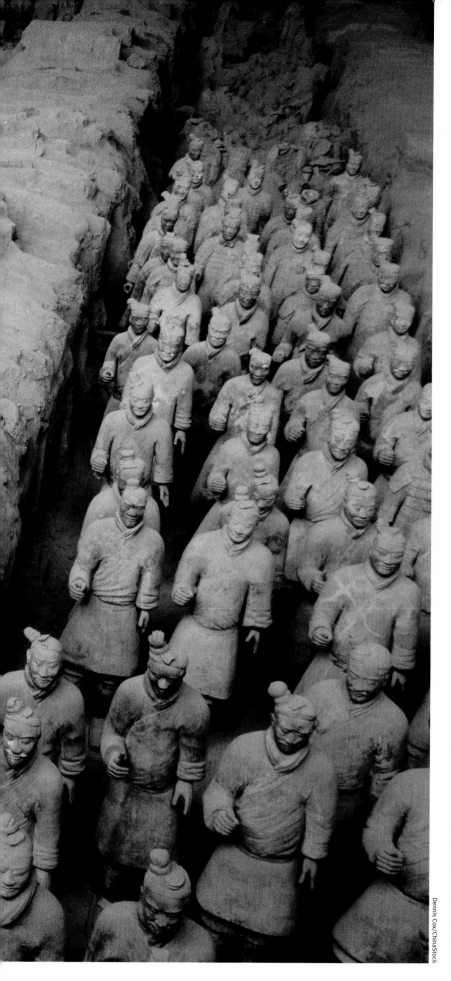

Dennis Cox/ChinaStock

The Terra-cotta Army

A group of farmers simply trying to sink a well in the northwest Chinese city of Xi'an in 1974 ended up making one of the premier archaeological discoveries of the 20th century. They were digging near the tomb of Shi Huangdi, China's first emperor (and, of particular note for this volume, the man who first conceived of the Great Wall of China). In those times, the Chinese believed in taking their earthly belongings with them to the next realm, and this great emperor so wanted to guard his many possessions that he cleverly created an army to guard them—an army unlike any other.

The force numbers more than 7,000 soldiers, horses and chariots, all of them fashioned out of terra-cotta. Some soldiers are standing, others are kneeling, shooting or yelling. They likely had been painted in yellows, purples and greens, although nothing but traces of the pigments remain. Also missing are weapons—bows, swords, spears—lost to vandals. Indeed, terra-cotta being what it is, many of the soldiers themselves were smashed when their wooden ceiling collapsed. Restoration efforts at the site, now a museum, are ongoing.

Some three quarters of a million people worked over 30 years to make the figures. Because they all have different faces and clothing, it was at first thought they were made individually. It has now become clear that the body parts were made in various molds. Craftsmen then covered them in clay, and added sculptural detail to give each a unique appearance. For historians, that these soldiers exist at all is a source of some wonderment, given that no mention is made of them in the ordinarily comprehensive Chinese books of history.

Incredibly, this army is facing yet a new foe. There are nine kinds of mold attacking the statues, a result of higher temperatures and humidity in the building housing them. The culprit? Breath from the many tourists who visit the soldiers.

The Ajanta Caves

There are, to be sure, other caves with remarkable iconographic imagery. In fact, some are named on certain lists of World Wonders. Those in Europe where prehistoric drawings have been discovered are vastly intriguing, their jewel being the ancient caves of Lascaux in France, whose walls boast not only 16,000-year-old pictures of animals but also the oldest known map of the night sky. However, the Ajanta Caves in India are special in so many ways: the narrative of their art, which comments on man's human and spiritual conditions; the beyond-belief excellence of that art; and the inherent ambition in the intricate system of caves itself. The Gupta Dynasty that reigned in northern India for much of the 4th, 5th and 6th centuries is storied for its sophistication and achievement, and nothing the Guptas left behind supports this reputation more strongly than the caves at Ajanta.

Work on what would become a labyrinthine network of monasteries was begun well before the rise of the Guptas. As early as the 2nd century B.C., laborers were digging into tall cliffs that formed a horseshoe at a bend in the Waghora River. The efforts of those ancients stand today as mere groundbreaking for what the Guptas would create on the site more than a half millennium later. Thirty caves were cut into the basalt; five were houses of worship, while the others were separate monasteries, each with a central courtyard surrounded by as many as two dozen small rooms for the monks. The imperial Guptas oversaw a flowering of northern India, with advances in mathematics, literature and other arts. In the caves, the art itself astonishes: colorful decorations in the monasteries, murals depicting historic scenes and local lore, painting and statuary honoring Buddha in the worship halls. Almost all paintings were created during a 20-year period in the 5th century, a fact nearly as breathtaking as the masterpieces themselves.

For a long time, no one knew. Then, in 1819, cavalry officers of the British Raj went tiger hunting near Ajanta. At one point they pushed through some brush and discovered a Buddha statue, beckoning. Then, there was a door in the cliffside. They entered, awestruck at what they had found.

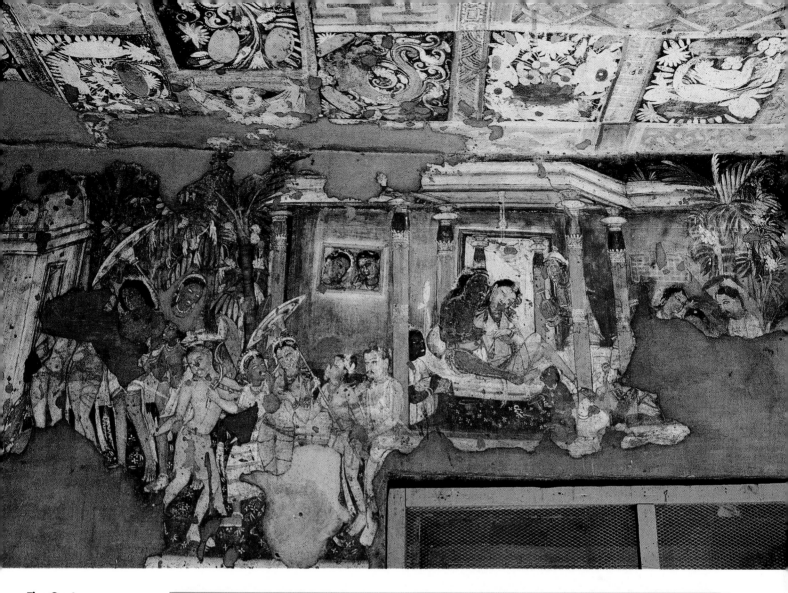

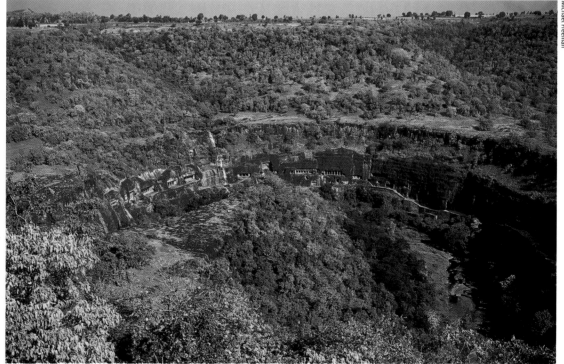

Five Gupta emperors ruled for some 250 years, then their dynasty fell apart internally and was finished off by invaders. With it went what some scholars call India's golden age. The caves and their treasures went into hiding behind the sheer cliffs rising over the Waghora River (right). Above: a palace scene in a monastery. Opposite: the Bodhisattva Vajrapani, outside the main shrine of Cave 1.

On February 2, 2003, the 60th
anniversary of the Stalingrad siege,
soldiers parade before the statue in
uniforms tailored like those of WWII.

Mother Russia

In yet another link among the Wonders of this book, the titanic statue known as Mother Russia, or by some Motherland Is Calling, is to Russia as the Statue of Liberty is to America. Both speak clearly to their country's sense of self. And, of course, the Statue of Liberty is herself a descendant of the Colossus of Rhodes.

Mother Russia is set on a hill in the center of Volgograd, previously known as Stalingrad. In 1942, the Soviet Union was on the ropes, as German armies were rolling across her steppes and through her towns, seemingly unstoppable despite heavy resistance. Then, at Stalingrad, the people gave entirely of themselves, women digging ditches, kids carrying loads, men arming themselves to the teeth. The Motherland had once more called on her children for the ultimate sacrifice. It proved to be a turning point in World War II as, at the end of a siege that lasted from July to February, the Nazis were stopped in their tracks—left to freeze in their summer uniforms during the brutally cold winter. They left behind a quarter million soldiers, huge amounts of matériel, and all their momentum. The Soviet casualties were immense.

The hill on which the statue sits was the scene of terrible fighting, thus it is an ideal if sobering site for a memorial to the battle. The statue, which was finished in 1967, is described as "a mother standing guard over her country, her raised sword threatening to destroy any who dare to invade her land, and calling on her sons to follow her example."

In such a vast land, it is appropriate that this icon is so large. Mother Russia stands 272 feet from her toes to the tip of her stainless steel sword, which is well over twice as long as the Statue of Liberty's arm. The body is made of reinforced concrete; the fluttering scarf alone weighs 250 tons. Despite this, and the subject's defiant mien, the statue today is under duress, as high winds are abrading the surface and water is seeping into the cracks.

Mikhail Metzel/AP

Borobudur Temple The island of Java is the site for this massive, pyramidal Buddhist monument.

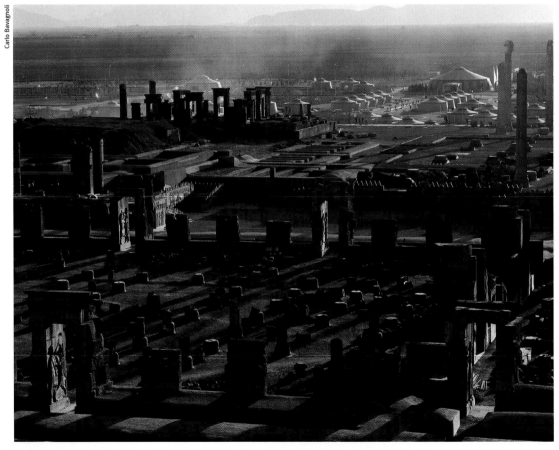

Persepolis These Persian palaces were looted and burned by Alexander the Great in 330 B.C.

Machu Picchu This abandoned, pre-Columbian fortress city of the Incas is a secret world in the Andes.

Mayan Temples The accomplishments of the Mayan civilization rank among the highest ever.

Lest We Forget...

We cannot know who first said of the ancient list, "Hogwash!"—but he was the first of many. While it is too late for a nominee to crack the hallowed seven, new evidence and excavations keep the debate lively. In the company of those who wonder about Wonders, the Mayan temples constructed in Guatemala beginning around 600 B.C. are often mentioned, as is the Throne Hall of Persepolis. The exquisitely preserved Borobudur Temple has its own adherents. And then there's everyone's favorite Forgotten, fabulous Machu Picchu, the Peruvian city that is mystical to the point of magical.

The Seven Wonders of the
Animal World

This giant Pacific octopus, having finished a swim, is settling to the bottom of the sea off Quadra Island in British Columbia. They are found from California to Alaska to Japan.

A Wondrous **Menagerie**

> *All animals, except man, know that
> the principal business of life is to enjoy it.*
>
> — **Samuel Butler** The Way of All Flesh

T here are three forms of complex life as we know it—animal, plant and fungus. And although agreement is all too rare when it comes to putting finite figures to these sorts of things, it would be reasonable to state that estimates of the total number of animal species can run to more than 10 million, and that these account for three quarters of all creatures on our planet.

Perhaps the salient characteristic of animals is mobility. Plants are able to survive simply by being there, by basking in the sunlight or idling while water plays over them. Thus are they provided with materials by which they produce glucose and other nutrients they require to function. Animals, however, by and large resort to mobility to secure their daily bread. When an animal is confronted by a particular stimulus, it responds by moving, and animals are capable of spontaneously generating this movement by themselves. What permits animals to go where they want when they want is their musculature. Leopards and gorillas have muscles, of course, but so do robins and ants—even spiders and clams. Every animal does, except the sponges.

This ability to "go" can be effected only by a sensory perception and an internal communication; the process is fascinating at the most mundane levels, and intoxicating in the dazzling range of sophistication to which it has evolved.

Animals see and hear and smell in very different ways. They have very different concerns, as well: What is important to one is likely "invisible" to another. Differences occur at every level, in eating (or being eaten), in aggression or self-defense, in sexual reproduction. It is all these differences that have led to the profound variety in the size, shape, behavior and so on that infiltrate the animal kingdom.

Clearly, this kingdom is a marvelous one. Yet even its very existence must not be taken for granted. The several billion years of cataclysm that have racked this little planet—and there is no proof of life anywhere else but on Earth— could easily have rendered living things a no-show, something that just didn't ever happen to happen, instead of yielding a cornucopia of excitement. All animals are wonderful, in their own way: worm and tiger, hummingbird and rhino, walking stick and fiddler crab. And, of course, the seven that follow, our selection for the Wonders among wonders. For as George Orwell noted in *Animal Farm,* with somewhat different intent, "All animals are equal but some animals are more equal than others."

Every year, millions of monarch butterflies take part in an amazing migration to warmer climes. These monarchs in Michoacán, Mexico, are nearing the end of their long journey. Some of them will head for the very same trees that their forebears roosted in during the previous winter.

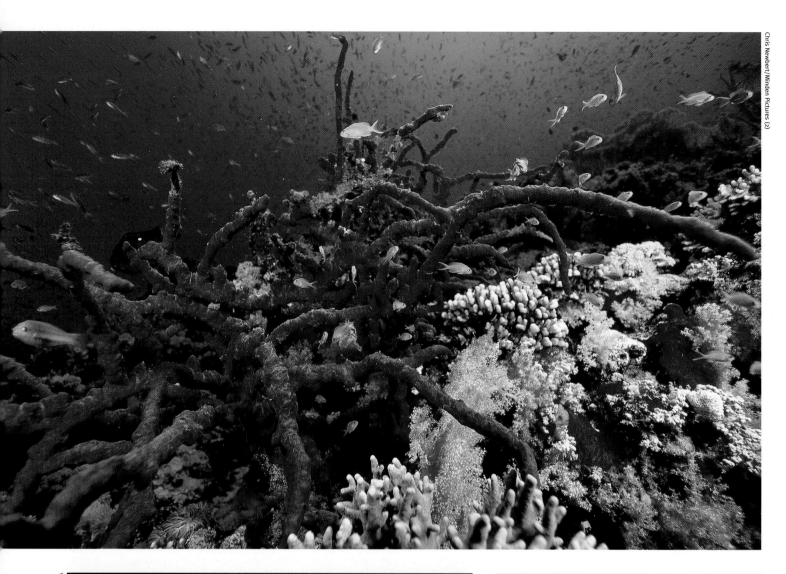

Chris Newbert/Minden Pictures (2)

Fred Bavendam/Minden Pictures

Clockwise from top: A Red Sea fire sponge branches out over soft coral as anthias swim about; an elephant ear sponge, 80 feet deep off New Guinea; a barrel sponge, spawning near the island of Bali. Crabs, shrimp and worms use this large sponge to get at plankton passing overhead.

The Sponge

For centuries, people—scientists most definitely included—were not at all sure just what sponges were. Many considered them plants, which isn't surprising if you judge by their looks, and even more understandable when you consider that most of the sponges being examined were of the freshwater sort, which often have within their tissue single-celled plants that give them a greenish tinge. In 1765 a linen merchant and amateur naturalist named John Ellis proved that because sponges could eject water, they must therefore be animals. Nevertheless, the debate stirred for many more years.

Today, there is no doubt: The sponge is an animal. In fact, it has been around longer than any other living animal, some 500 million years, and because sponges are, as scientists say, "morpholog-

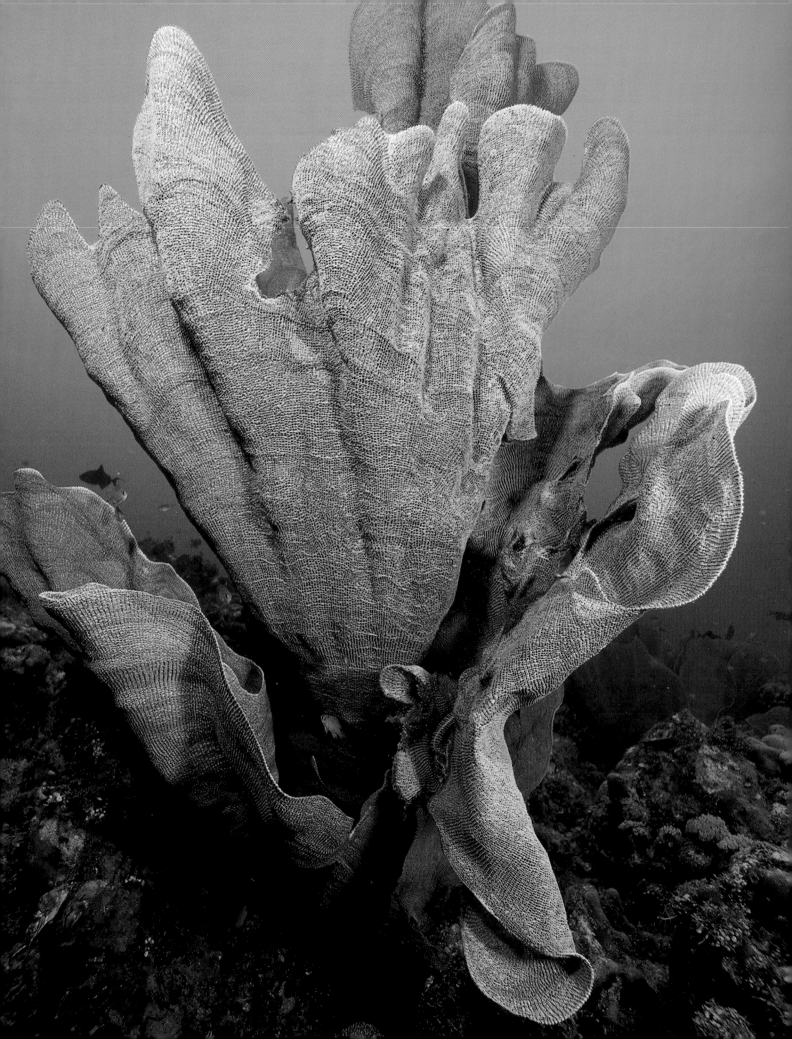

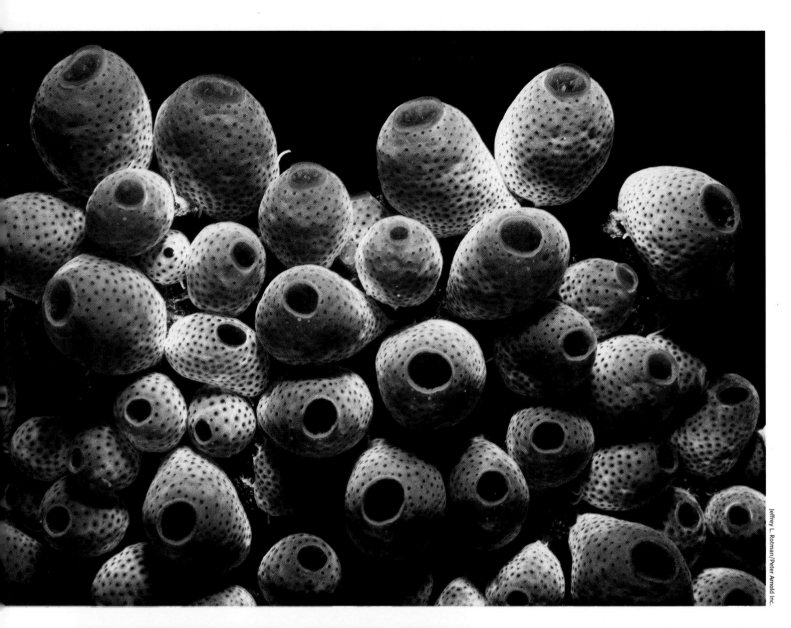

ically conservative"—which means they don't change much—what we have now closely resembles what existed all those years ago. It has even been posited that the precursor to all animals closely resembled a sponge.

There may be 15,000 different kinds of sponges, all of which live in water, mostly salt water. The vast majority of them are incapable of moving about, but like all other animals they cannot produce their own food, so they rely on water flowing through them for sustenance and oxygen, and for waste removal. Most sponges moderate the water by constricting their apertures, and by means of a canal system that employs whiplike appendages to propel the water. On a given day, liquid equal to 20,000 times its volume may be filtered by the sponge; some sponges can retain 90 percent of the bacteria

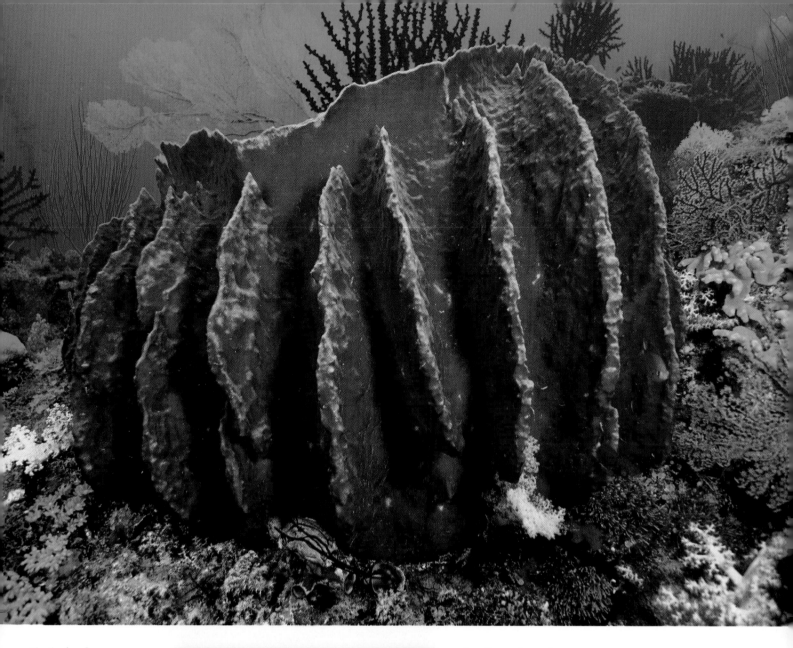

Clockwise from above: a barrel sponge on Moustache Reef in the Solomon Islands; a reef sponge in the Caribbean; a strawberry vase sponge in the Cayman Islands; a colony of sponges growing on Sipadan Island in Borneo.

Charles Seaborn/Woodfin Camp

that flows through.

Sponges come in many shapes, sizes and colors. Some of their names clearly describe the creatures. The bleeding sponge, when squeezed, emits a red liquid; the stinker sponge does just that; the do-not-touch-me sponge may burn and blister any who handle it. Sponges also have varying life spans. One species, the living fossil sclerosponge, may reach 5,000 years old, which makes it the oldest living thing on the planet.

This simplest of all animals has added amply to the beauty and wonder of our planet. It is an organism with few natural enemies (other than man and a certain fungus) even though it exists in nearly every marine environment. Given this, and its matchless longevity, one can safely say that the sponge is at one with its world.

A resplendent monarch butterfly attends to business atop a purple coneflower in the state of Washington. At right, a gathering of monarchs forms a Technicolor cloud amid the trees of Mexico.

The Monarch Butterfly

The butterfly's attractiveness derives not only from colors and symmetry: Other qualities contribute to it. We would not think them so beautiful if they did not fly, or if they flew straight and briskly like bees, or if they stung, or above all if they did not enact the perturbing mystery of metamorphosis: The latter assumes in our eyes the value of a badly decoded message, a symbol, a sign." These deft words from the celebrated author (and chemist) Primo Levi begin to explain the wonder that is a butterfly. Our subject is the king of the butterflies, whose name was provided by English settlers in North America who were reminded of William of Orange, the monarch.

Its life certainly begins as a commoner: an egg laid on the bottom of a milkweed leaf, an egg one eighth of an inch long. How soon the egg hatches depends on the temperature, but within 12 days a larva emerges, which feeds on the milkweed for a couple of weeks, becoming a full-grown caterpillar. The caterpillar molts four to five times, each time eating its old skin, until it grows to about two inches, at which point it will spin silk in order to attach itself to, say, a branch, in order to evolve into a stunning jade-green chrysalis. Inside this hard shell, the butterfly forms within two weeks, then emerges, inflates its wings with blood from its abdomen, and

Tom & Pat Leeson; top right: Nicolas Reynard/Gamma

Tom Kitchin/firstlight.ca (7)

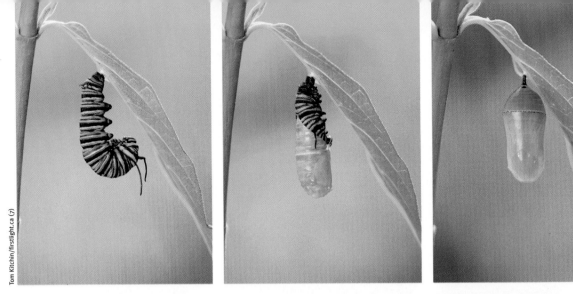

Having been deposited as an egg on the underside of a milkweed leaf (bottom), a monarch carries out its regal metamorphosis, at right. Below, munching on the monarch's staff of life, the milkweed.

Donald Specker/AnimalsAnimals

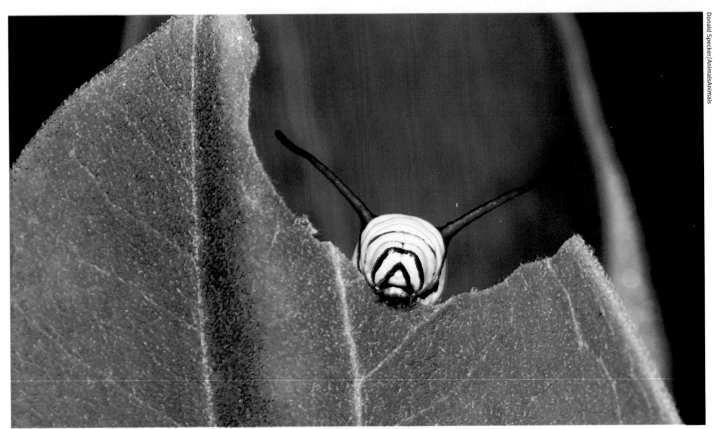

Breck Kent/AnimalsAnimals

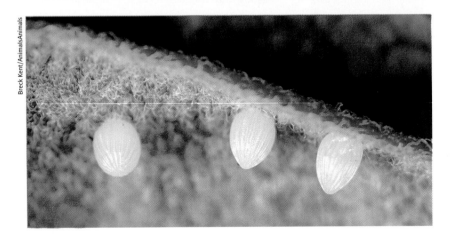

then waits, resting till its wings stiffen and dry, permitting it to finally take flight.

Before long, the monarch will seek out nectar from one of its favorite food sources, like milkweed, red clover, thistle or lilac. As with all butterflies, it sips liquid through its tubelike proboscis, which it unfurls to drink and then coils up when not in use. How does this spectacular creature avoid being immediately devoured? The seemingly bland milkweed it has been feeding on contains cardenolides, which are poisonous to vertebrates, such as frogs and birds. The monarch's coloration—its storied

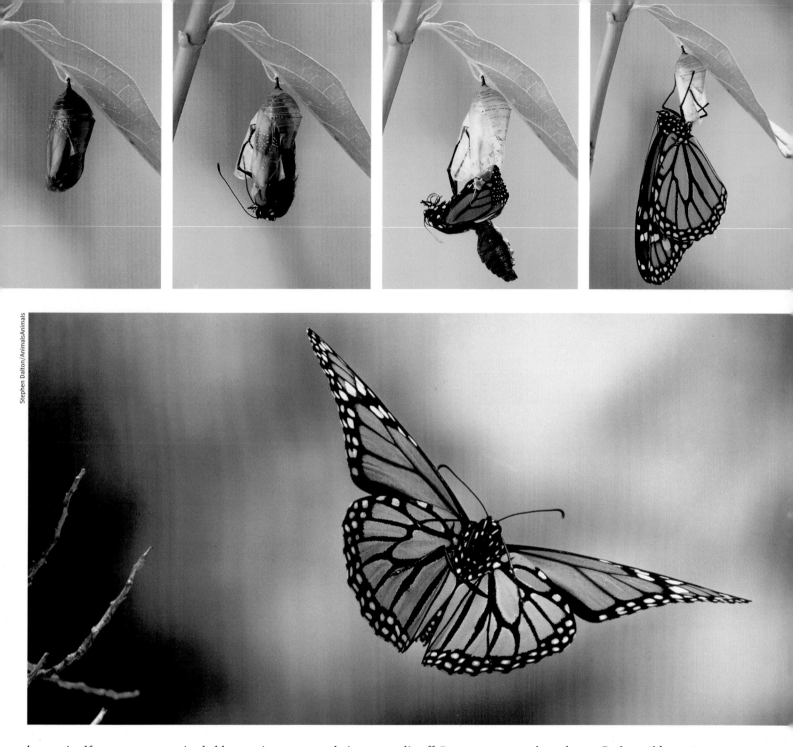

Stephen Dalton/Animals Animals

beauty itself— serves an unmistakable warning to these would-be predators. One occasionally sees a monarch with a bite-size section missing from a wing, a nip that has deterred further attack.

Some butterflies can overwinter in certain environments, but the monarchs that summer in Canada and the eastern U.S. cannot. So this tiny thing has learned to migrate more than 2,000 miles to southern states or to Mexico. The distance, so supremely vast for these creatures with four-inch wings, may require three generations. Females lay eggs along the route, and offspring take up the trek

as their parents die off. Best guesses as to how the insects find their way suggest they use the sun as a compass. It is a remarkable feat by any measure, and made that much more so because other monarchs, in other areas, do not migrate at all.

This master of aeronautics and master of self-invention is, as well, one of the great charmers of the universe. Who among us has not shared the sentiment of Wordsworth as stated in *To a Butterfly:* "Come often to us, fear no wrong; / Sit near us on the bough!" for the presence of this gentle Wonder is a garden of delights to all spirits.

Perhaps this creature is of such beauty that its average life span needs be confined to a mere five months. Perhaps this most delicate yet so sturdy of animals burns too bright to linger.

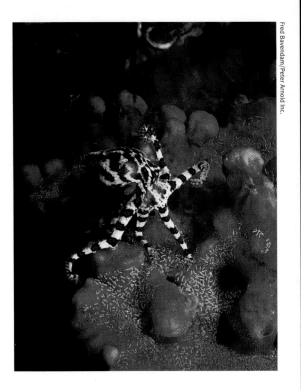

The octopus is nothing if not enterprising. Here, a giant Pacific, with tangible dexterity, scavenges on a dead spiny dogfish shark in Canada's Campbell River. At left, a southern blue-ringed octopus off South Australia.

The Octopus

Nothing else in our world matches the array of jaw-dropping abilities possessed by the octopus. One might think only computer animation could concoct such a plastic organism. From the same family as the incomparably drab clam, this mollusk comes in 200 varieties in all oceans and seas, although the largest and smallest, ranging from 18 feet to about an inch, occur in the waters off the United States.

The octopus has a pouchlike body and eight arms (they are not called tentacles). If it loses an arm to a predator or disease, it simply grows a new one. Each arm has two rows of fleshy suckers that draw food into the mouth, which features parrot-like beaks and an organ like a file that drills holes into the shells of its favorite meals, crabs and lobsters, and then rasps away at the flesh. The two eyes provide vision roughly equivalent to that of the human being. If it sees something it finds disturbing, it can very quickly change color from brown to red to white to green, or even combinations of these. The tough skin can also alter patterns from stripes to dots or solids.

In fact, this animal can change the entire shape of its body, becoming smooth or bumpy, round or

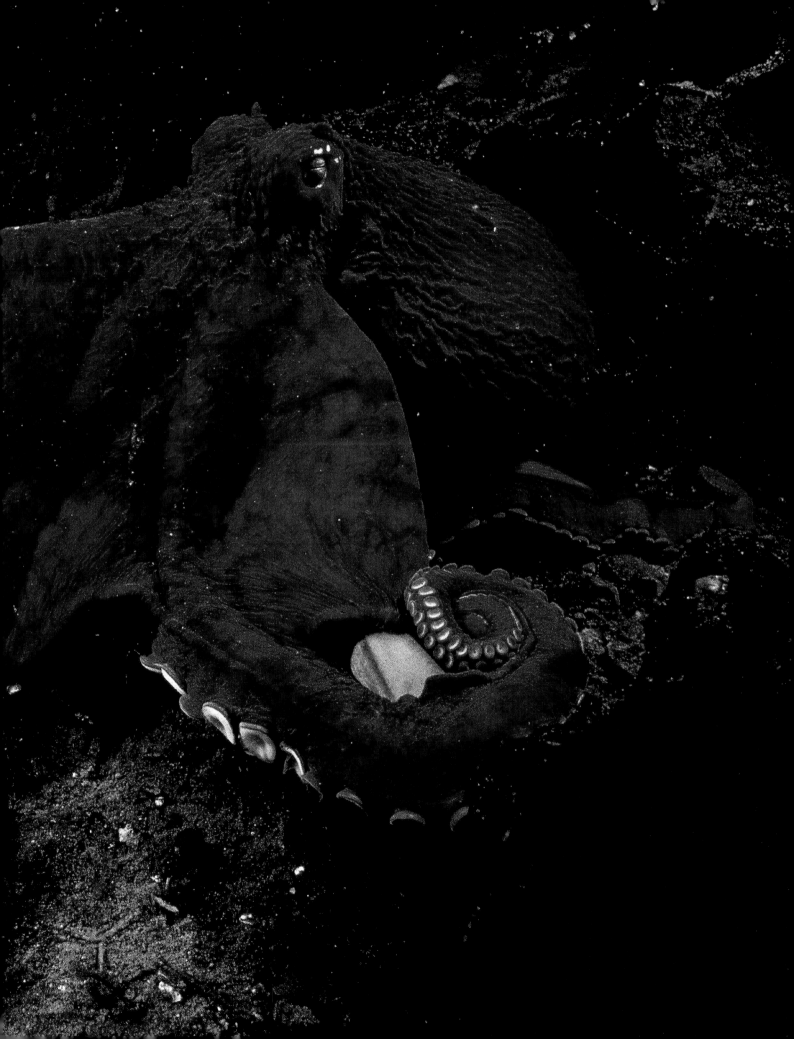

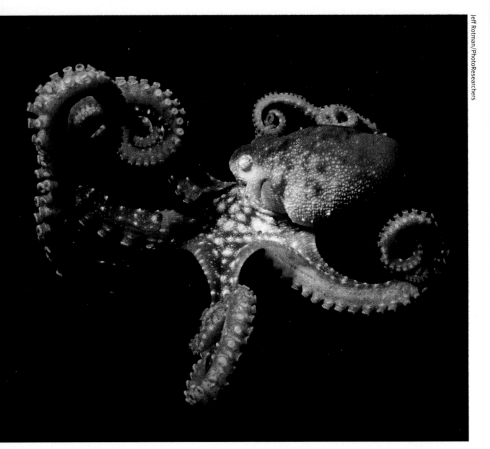

The attractive fellow above is a long-armed octopus in the Red Sea. They grow to about three feet in length. Below, eggs and newborns of a giant Pacific octopus. The female lays about 50,000 eggs; for the next six months she will not even eat as she devotes all her efforts to protecting her young.

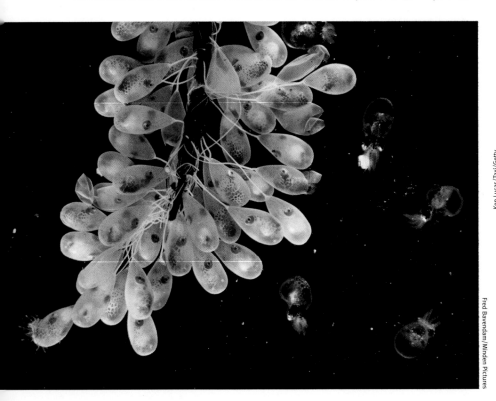

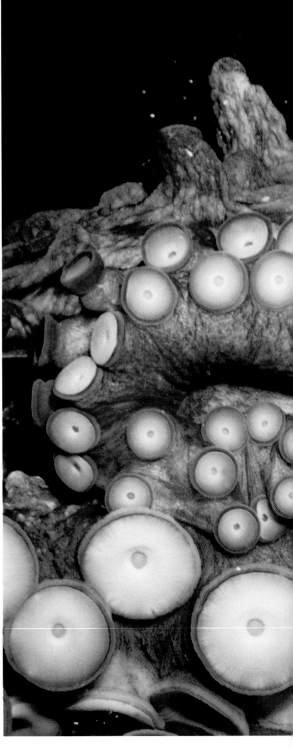

long, whatever is needed to hunt or to escape. Octopuses usually crawl along the floors of silent seas, but if necessary they can shoot backward with jet propulsion by forcibly ejecting water through a funnel. When they happen upon an enemy, they can emit a purplish-black inky substance that clouds the water. With some octopuses, the ink can paralyze the sensory organs of a foe.

As if all this weren't enough, the octopus is a

clever creature, the most intelligent of all invertebrates. They have long- and short-term memories and are able to solve problems by trial and error. Once the lesson is mastered, it's locked in. They can be taught any sort of trick . . . or they can learn one themselves. Not long ago, lobsters kept disappearing from Miami's Seaquarium, and employees and thieves from outside were all suspects. As was the night watchman, who on one occasion doubled back on his rounds and saw something happening in the lobster tank. It turned out to be a big octopus, who then grabbed a lobster, climbed out and scurried down a walkway to its own tank. When Seaquarium officials checked the octopus's lair, they found the shells of the purloined lobsters buried under some rocks. But this was nothing new. Similar heists have been perpetrated by octopuses in at least eight other aquariums, dating back to 1873.

The giant Pacific is the largest octopus in the world. It may have as many as 1,600 suckers in all.

Were the blue jay not among the most common of birds in eastern North America—and sometimes taken for granted—birders would venture far to catch a glimpse. Below, a raven prepares to land.

The Corvid

The family of birds known as corvids, a term that derives from the Latin word meaning raven, numbers more than a hundred different members, ranging in appearance from multihued to blacker-than-night. Most corvids are so commonplace as to excite little attention. But attention is just what these animals cry out for.

Through the years, crows, ravens, jays and magpies have drawn the interest of discerning people. The Roman College of Augurs predicted events based on clues given by corvids. The birds are rife in Norse mythology and Siberian and North American folklore; frequently, the tales have the practical joker Raven as the creator of the world. The blue jay was treasured by Mark Twain and Roger Tory Peterson, and Thoreau wrote of it, "What a neat and delicately ornamented creature, finer than any work of art in a lady's boudoir." Granted, for other folks, corvids have been the stuff of nightmares (Poe's *The Raven*) or agricultural worry. But the damage done by crows to grain crops is far outweighed by their consumption of mice and insects.

Corvids are considered by many the smartest of

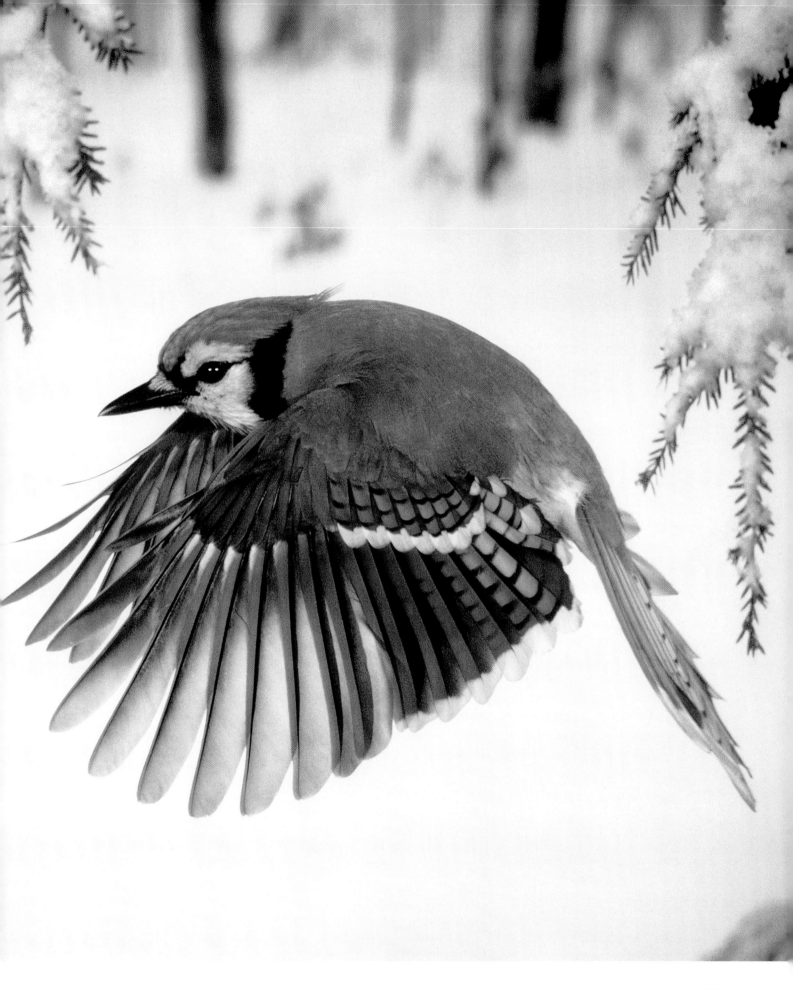

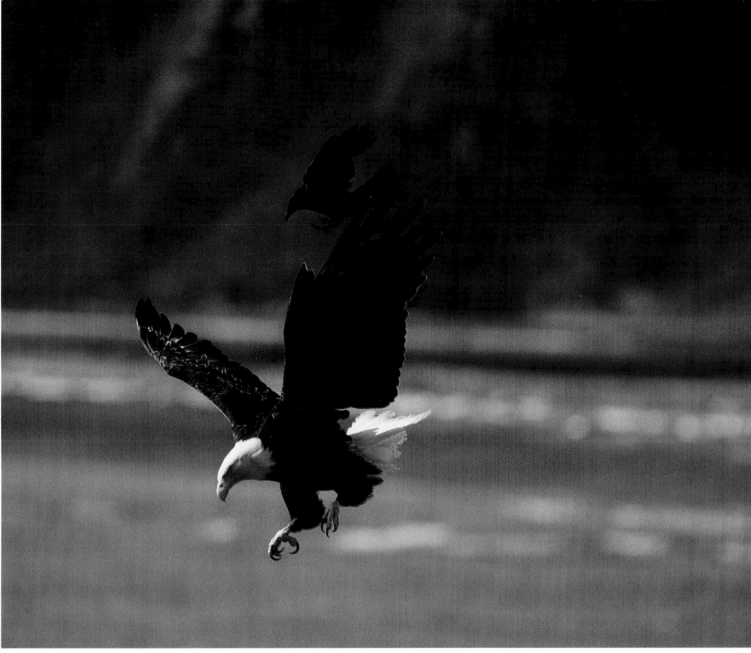

It is unclear what sort of threat the bald eagle above has presented, but that crow isn't having any of it. Acts of bravery can elevate a crow's social status. At left, two ravens mull over a matter of some importance.

birds. All corvids hide excess food for later use, and have a remarkable record of recovering these cached meals. Blue jays have shown themselves superior to monkeys in problem-solving tests. Jays and other corvids frequently employ tools, a common measuring stick of intelligence. What's more, researchers on an island off New Caledonia have seen crows using twigs and leaves to *make* tools—a rare observation of an animal in the wild putting one and one together in such a fashion.

These are very social birds. They mate for life, and young male corvids are renowned for showing off in ways that will secure a mate. The American crow is often seen "mobbing" hawks or owls that threaten nests. When crows call out for help (they have 25 different cries), every crow nearby rushes to their aid. Crows have also been seen feeding other crows that are infirm. And, there are indications that magpies may gather for funerals.

Corvids have highly developed vocal skills. Great mimics, blue jays are known to zoom toward a food source with an exact replica of a red-shouldered hawk's scream, thereby clearing the way for unfettered feeding. It is to be assumed that the bird enjoys this stunt not just for its obvious reward, since mischievousness is another hallmark characteristic of the magical corvid. They play zany games and steal bright things, and are elegant and alive at all times, in all ways. As the 19th century clergyman Henry Ward Beecher remarked, "If men had wings and bore black feathers, few of them would be clever enough to be crows."

A deft swimmer, the platypus is aided by its webbed feet. The forepaws supply the locomotion while the hindpaws are used for navigation.

The Platypus

In 1797 a group of British scientists had a good laugh. It seems that some wag in Australia had sent them a specimen of a mammal with the bill of a duck attached to it. They scoffed, of course, because there was no such animal. Actually, they had encountered their first platypus, so you can't blame them for being disbelievers. And had they been told further facts about the animal, they would have enjoyed an even gustier guffaw.

Found only in Australia and Tasmania, the platypus is a mammal, but one apart from the others. Beginning at the front, there is that snout, which looks like a duck's bill although it is really soft, leathery skin. The legs of the platypus extend outward like a lizard's, and the feet are webbed, which is invaluable because the platypus spends much of its time under water searching for worms, shrimp and insects. Below the surface it closes its eyes and relies on receptors in its snout to locate the electrical field emitted by the muscles in its prey. The platypus may dive as many as 80 times in an hour, although it can stay down for 10 minutes by remaining inactive.

As with all mammals, the mother feeds her young (usually two) with her milk, but she has no teats. Instead, the milk is secreted through tiny pores in her belly, coating the fur so that the young can suck it up. Furthermore, these young were born in eggs, yet another resemblance to reptiles.

Male platypuses also have their own way of handling things. On the inside of each hindpaw, they carry a little spur that can inflict a venomous sting capable of causing excruciating pain to people and potent enough to kill a dog.

Once heavily hunted for its soft, dense fur that was ideal for rugs and capes, the platypus is now shy and wary. It does poorly in captivity, mainly owing to its ravenous appetite. It weighs in at a maximum of five pounds, but the creature can consume its body weight in a single night. The platypus is a weird, wonderful thing, neither this nor that—yet wholly itself.

This happy family of seven posed in Fairbanks, Alaska, in 1964 for photographer Elliott Erwitt. The shag rug was a grace note for the pooch.

The Dog

Some 60 million years ago a creature walked the earth, a small mammal similar to a weasel, in the area now known as Asia. Although *Miacis* was not the immediate progenitor, doglike canids did evolve from it, and by 30 to 40 million years ago, the first true dog appeared. *Cynodictis* was of medium size, and had a brushy coat and a long tail.

No one knows for sure, but it appears that wolves, and perhaps in some cases jackals, are the ancestors of dogs as we know them. Dogs are considered intelligent animals, and about 13,000 years ago some dogs somewhere, maybe in China, made an unqualifiedly smart decision when they hitched their wagon to a star. Or is it that a star hitched his wagon to them? In any case, being best buddies with the future master of the universe was a canine coup. For the humans it was ideal having an associate that was fast and tough, with a powerful nose and a warning bark that could be heard from afar.

It proved a real advantage through the centuries that these animals were so willing and able—and so very flexible—to rise to any occasion. Today there are more than 400 different breeds of dog, and countless combinations thereof, although they are all genetically equal. In many cases, humans have molded them to their needs, resulting in tiny lapdogs and fearless terriers, swift hunters and massive guardians. While there are parts of the world where people might as soon eat them as treat them, dogs have elsewhere gained a place near, or much more likely inside, people's homes. Sometimes they have to work for their chow, but nothing in the world possesses the quality of eagerness in greater amounts than a dog. He is delighted to take on any task. Thus have they become indispensable, a beloved companion, defined by affection and loyalty. So while he will never be a member of the human race, the dog has found a place in the human family. There, the species thrives, secure.

Sebastião Salgado/Amazonas/Contact Press Images

Eliot Elisofon

The Human Being

Whether it came slithering out of some primordial ooze, crawling up from a churning sea, or swinging down from a lower tree branch, there was without doubt ferocious competition facing the first humanlike creature. He got successfully past the genesis period, and then, apparently, came a long, drawn-out affair, filled with links and missing links. After a further muta-

tion here and a straightening-up there, man finally emerged as king of the jungle.

Sure, dolphins are smart and giggly, but they're the ones jumping through hoops. There are 200 other primates besides, but they're simply not capable of, say, engineering a lunar landing or, for that matter, destroying their own habitats by incessant logging and agriculture. Even if mankind should thoroughly despoil his global domain, it seems likely, based upon evidence and past performance, that he'll devise some method of survival. Meantime, the mighty elephant, the shark, the tiger . . . going,

A Shilluk tribesman grasps his tools with opposable thumbs. Many predators, like man, have forward-facing eyes. People in Bombay stream from trains, mindful of the social contract. In Philadelphia, human communication flies through the air.

Brown Brothers

going . . . soon little more than footnotes.

The various aspects that made the human being master of all do occur in other animals, but never in the same potent combination. In these photos, the salient features are exhibited. Anything less than these physical and intellectual requirements, and this book would not be here.

Ladies and gentlemen, presenting the conqueror of space, the maker of pistachio ice cream, proud parent of Shakespeare (if also of Hitler), of forgiving if not forgetting, indeed of the future itself . . . *Ecce homo!*

Just One More

"Ladies and gentlemen, look at Kong...

... the Eighth Wonder of the World!" So declared King Kong's captor to a rapt—and soon to be run-amok—New York City audience. The reference in the classic 1933 film certified yet again the durability of the Seven Wonders concept, and brought many things full circle. The great King Kong came from Skull Island, which sure looked to be off Africa, which was, as we know, the land of King Khufu, whose pyramid was the original—and remains the only extant—Ancient Wonder of the World. And Kong's sad fate would be sealed on the Empire State Building, the ultimate Modern Wonder looming over Gotham, the ultimate modern city. The noble, tortured King Kong was a quintessential Wonder, the very definition of a Wonder: big, exciting, amazing, pulsating—definitely something you had to see to believe.